750

Secrets From An Oil Painting Diary

Secrets From An Oil Painting Diary

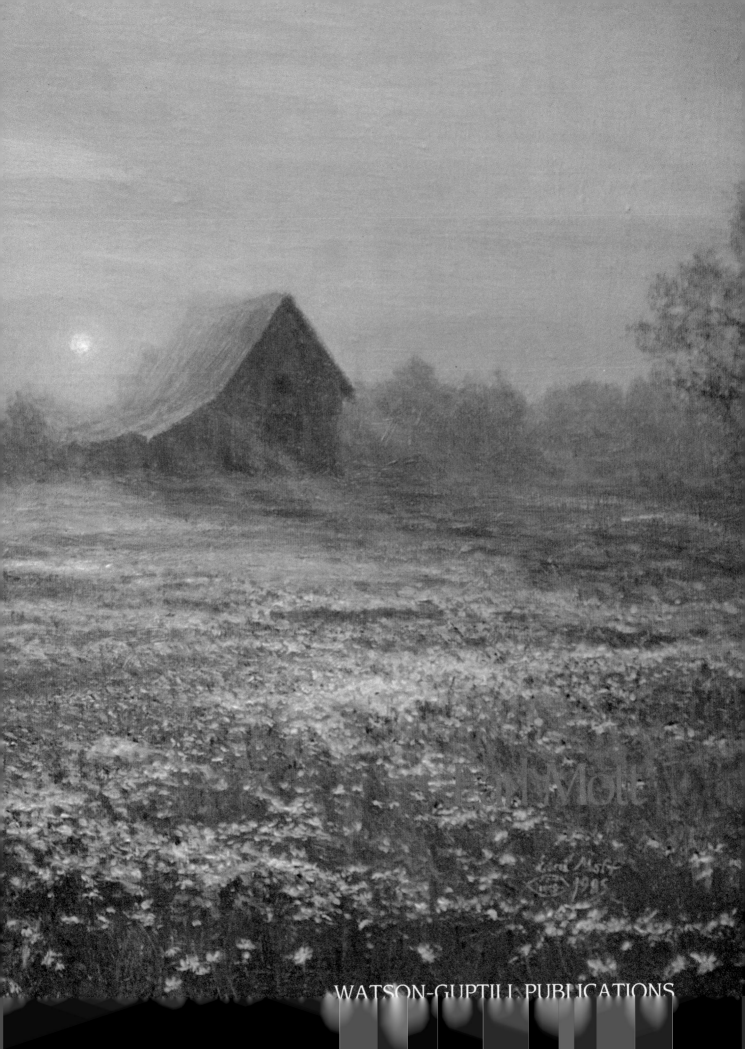

Title Page:
MORNING GOLD *Oil on canvas, 12″ × 20″ (30.5 × 50.8 cm),*
collection of Frances Mott

Page 6:
VIRGINIA BLACKMON PAINTING *Oil on canvas, 10″ × 8″*
(25.4 × 20.3 cm), collection of Earl Mott

Pages 10–11:
SPRING IN TEXAS *Oil on canvas, 16″ × 24″ (40.6 × 61.0 cm),*
collection of Earl and Frances Mott

Pages 18–19:
GOLDEN FIELDS *Oil on canvas, 16″ × 20″ (40.6 × 50.8 cm),*
collection of Earl Mott

Pages 38–39:
PAINTING THE NOEL FARM *Oil on canvas, 16″ × 20″*
(40.6 × 50.8 cm), collection of Earl Mott

Copyright © 1988 by Earl Mott
First published 1988 in the United States and Canada by Watson-Guptill
Publications, a division of Billboard Publications, Inc., 1515 Broadway,
New York, N.Y. 10036.

Library of Congress Cataloging-in-Publication Data

Mott, Earl.
 Secrets from an oil painting diary/by Earl Mott.
 p. cm.
 Includes index.
 ISBN 0-8230-4745-8
 1. Painting—Technique. I. Title.
ND1500.M667 1988 88-11922
751.45′436—dc19 CIP

Distributed in the United Kingdom by Phaidon Press Ltd., Littlegate
House, St. Ebbe's St., Oxford

Manufactured in Japan

First Printing, 1988

1 2 3 4 5 6 7 8 9 / 93 92 91 90 89 88

To my wife, Frances Katherene, for her understanding and for enduring the hardships of being an artist's wife during the struggling years.

In loving memory of my father and mother, J. B. and Lillie Mae Mott.

Thanks to all the friends and teachers who encouraged, inspired, and helped me in my career; to Travis Taylor for being a faithful collector of my work; and to everyone who allowed their paintings to be reproduced in this book. I would like to express my appreciation to Anda Erwin for her photography, to Joey Lou Tatum Block for her editorial assistance, and to the students who read the manuscript and offered their suggestions, encouragement, and incentive to publish this book.

And finally, my special acknowledgements and appreciation are given to "the God and Father of our Lord Jesus Christ" (Eph. 1:3, K.J.V.).

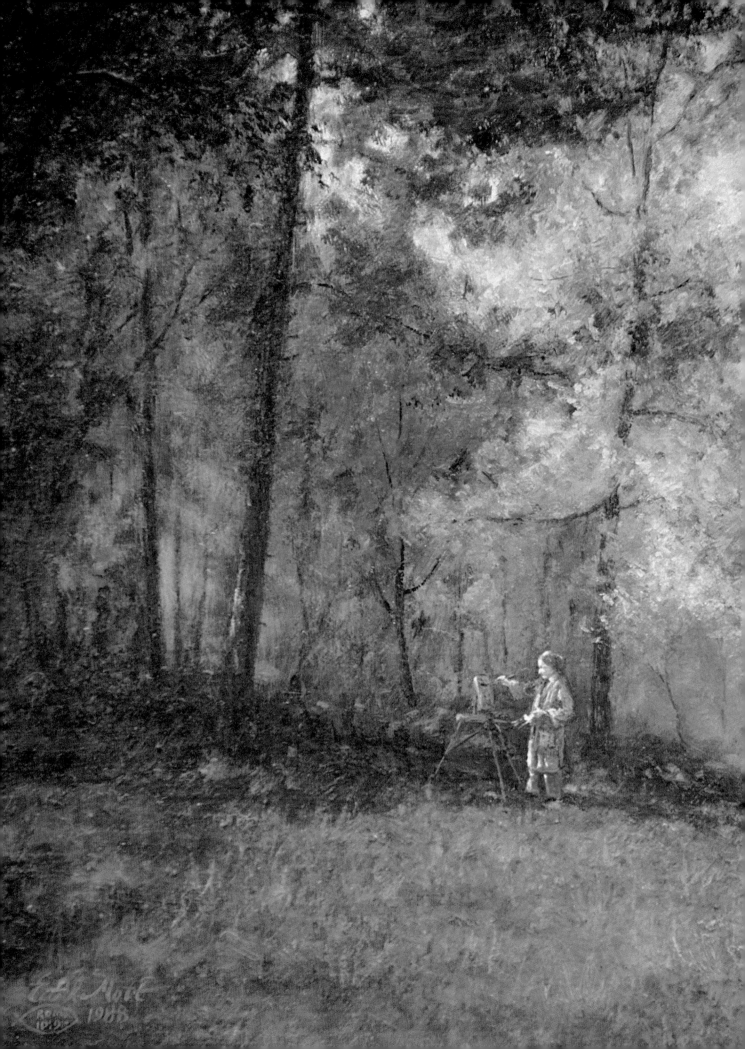

Contents

Introduction 8

Materials and Methods 10

Working Outdoors: Aesthetics and Ideas 18

The Diary 38
Purpose of the Diary 40
A Texas Spring 41
Morning Dew 52
After an Evening Rain 62
Autumn at Bear Creek 70
Central Texas Homestead 80
Symphony in Frost 90
The Forest Giant 100
Sunrise at Sam Rayburn Lake 108
Seasons of Change 118
Winter at the Barge Farm 126
Final Note 140

Bibliography 142

Index 143

Introduction

The question that is most frequently asked an artist (aside from "How long did it take you?") is "How did you paint that?" There are no easy, simplistic answers, but in this book I attempt to present detailed explanations of how I painted a variety of landscapes from the beginning concept to the finished painting.

From personal observation, I noticed that most explanations I had read of the painting process were very short and incomplete. Consequently, I decided to write a book that describes more of the actual day-by-day process of making paintings—a book that is a personal, up-to-date, comprehensive record of how paintings are put together. To accomplish this goal, I kept a daily record—a diary—of what I did each day while painting.

Through my diary, I share with you how paintings develop in the mind and on the canvas, with day-by-day accounts of painting the four seasons and various moods of nature, such as a frosty morning, fog, dew, and evening. For further depth and enhancement, I have included architectural subjects, aerial perspective, and painting figures in the landscape. Painting is the main theme of this book and, therefore, it is not a book of theory but gets down to the business of painting.

Two questions I asked myself when I first started thinking about writing an art book were: What do I expect from an art instruction book and what does the average student expect? I asked some students what they wanted in an art book. The answers were: color mixtures; color reproductions; clear, easy-to-read text; and more "how to" instructions. In writing this book, I have striven to include all these things as I share my personal painting experiences.

This is not a book to read through and place on a shelf. Rather, it is one you can refer to again and again as you encounter various painting problems. I offer no magical solutions. Learning to paint takes a lot of perseverance and determination in addition to using whatever talent you may have been blessed with. This book is suitable for all levels of painting, from the beginner to the advanced student. However, a beginner may want to use it in conjunction with a more basic oil painting book.

After covering materials used and my painting approach in Part I, I move on to Part II, where I present examples of work done on location and discuss aesthetics and the thoughts and feelings involved in the picture-making process. The outdoor work provides the mental images, skill, and experience necessary to work in the studio. In Part III, The Diary, I show the reference photographs and outdoor work I used for certain paintings. Please do not assume that I simply copy the photos (since I am an amateur photographer, there is no temptation). I rely on the experience of firsthand observation and painting on the spot, which inspires me and enables me to do the studio work. Close-up details are shown of much of the work to give you an idea of the brushstrokes and how the paint was applied. Some of the paintings are illustrated in different phases of development from beginning to end. All of the work in The Diary is accompanied by an in-depth description of how each painting was made.

I encourage you to take time to study the explanations of how I painted different landscape subjects. Get a magnifying glass and examine the reproductions in detail. See how the paintings are put together, then try similar projects of your own using the methods and steps I've revealed.

When I first started painting, I had no teacher—only a $1.00 art book. I knew absolutely nothing about oil painting. I didn't even know the canvas had to be sized or primed before painting until the art dealer informed me. All I knew was I had a deep hunger to paint. Growing up with some ability to draw, I had a desire to record things that interested me, but it wasn't until after graduating from high school and getting a job that I could afford to begin oil painting. I didn't expect to support myself by painting alone; unlike today, there were almost no shows, galleries, dealers or anything else related to art in my area. Still, I painted quite innocently and enjoyed it immensely.

After a short stint in the Navy, during which I did little artwork, I gradually got back into painting. Also, during this time I finished a course in illustrating and related art that I had started before entering the service. During this period, the lady who was to become my wife, Frances Katherene, was a great encouragement to me, as was my first fine arts teacher, Virginia Blackmon.

I was amazed at the beauty and depth of color in Mrs. Blackmon's work. She had studied with Frederic Taubes and other fine

teachers, and she worked in an old master technique; her paintings had a richness of color I had never seen before. From her I learned about underpainting and overpainting and working in glazes of color. My paintings greatly improved and a new dimension was added to my work.

Three years after completing my studies with Mrs. Blackmon, I felt a need to grow more and in a different direction. I decided to study with Foster Caddell. I was thrilled by his work in his first landscape book, and I knew I had to study with him. I had seen impressionist work before, but never any paintings done quite like his, which are filled with bits and pieces of color, deep shadows, and radiant light. My study with Mr. Caddell was very difficult. I was accustomed to working with sables, glazes, and medium, but now I worked with bristles, dry paint, and no medium on a rough, untoned canvas. The process was frustrating, but I learned, and from these diverse methods my own technique has come.

Following this period of study, I went through a difficult transition period, which lasted for several years. During this time I was working out my own technique. I liked both of the approaches to painting that were taught to me by my former teachers, plus what I had learned from studying books on the subject and from years of working on my own. Eventually, I came to dislike slick, smooth paintings, but I couldn't totally express myself with a lot of rough, textured paint. I wanted some texture, but not an abundance of it; some detail, but not too much; a surface that was not too shiny, but not dull. I became "hung up" on the technicalities of painting, and painting became a chore. I saw no one who worked like I did, nor could I find my method in art books. I went through a period of doubting and fighting myself and my way of painting.

After many visits to museums and galleries, and much study and contemplation, I came to the realization that there are smooth paintings and rough paintings, detailed and undetailed, shiny and dull, colorful and not so colorful. This is not what makes the paintings good or bad. The artists had the technical ability to express themselves, but feelings and aesthetics are interwoven in all the good paintings. Finally, after a long search, I came to this conclusion: Your methods can be judged by the results you get. I decided to pursue art by painting in a way in which I believed.

There are many correct ways to approach oil painting. In this book, I hope to give you my way. My desire is to give you a detailed, up-close look at how I put together paintings. I attempt to put myself into each painting in order to capture a special mood and feeling and to do each painting with love. Don't take what I say as "the" way. It's not. It's my way. In the end, you too must decide which way is best for you. You must be true to yourself and paint the way that's right for you. This involves a lot of work and a long period of growth. My desire is to assist you along the way.

Materials
and Methods

In the Studio

Since this book deals primarily with painting in the studio, most of my attention will be in this area. However, without location work, good studio work would be impossible.

When working outdoors, I use a Grumbacher combination sketchbox-easel, which is imported from France. In my opinion, this is the best easel for painting on location. It is sturdy and heavy enough to withstand the wind but light enough to carry easily. This easel folds into a compact shape and all the materials needed fit inside.

In the sketchbox I carry sizes 2, 3, 4, and 5 bristle flat brushes and a size 3 bristle round, along with a size 6 white sable round. I have available in the sketchbox all the colors I normally use in the studio. Sometimes I use all of the colors, but usually I limit the palette. I also take along a small bottle of turpentine and some paper towels.

My support is cotton canvas or mat board that I have prepared with acrylic gesso or rabbit-skin glue. The drawing is done with yellow ochre thinned with turpentine.

Following is a list of materials and their use in the studio and a brief discussion of my approach to painting.

Stretching the Canvas

Most of my studio work is done on the smooth (type 66J) or medium (type 144) texture linen canvas manufactured by Utrecht Manufacturing Corporation (33 Thirty-fifth Street, Brooklyn, New York 11232). I prefer these particular canvases because of their texture and because they are pure linen and have not been primed. I prefer to size and prime my own canvas. (This will be discussed in more detail later.)

To save time and for convenience, several canvases should be prepared at the same time. After assembling the stretcher strips for a painting, I use a knife, file, or sandpaper to smooth the outside edges. These edges are quite sharp and can produce a strain on the canvas when it is stretched over them. Then I square up the stretcher frame and drive tacks into the back of the frame at the corners to keep the strips in place when the canvas is attached. Staples can also be used for this purpose.

Tacks or staples can be used to attach the canvas to the stretcher; I use staples and an Arrow T-50 heavy duty stapler. I begin by fastening the middle of one side of the canvas and then each end of the same side to the stretcher frame, attaching the canvas to the side of the stretcher strip. Then I staple in between the middle and ends, placing the staples about one inch apart. I don't pull here except to the corners. One side of the canvas is now attached. I stretch the canvas tautly to the opposite side of the frame and repeat the stapling pattern, stapling the middle, then each end, then in between, all the time pulling the canvas tightly toward me, except when fastening the ends, which I pull diagonally toward the corners. Two opposite sides have now been fastened to the frame.

I then attach a third side just like I did the first one, tucking the corners under and stapling them into the stretcher bar. There is almost no stretching involved at this stage. If I am working with cotton canvas, I stretch the fourth side tightly and attach it in the previous pattern of middle, ends, then in between. When I am working with linen canvas, I handle it differently. Since linen has a tendency to loosen due to atmospheric changes, the pressure of applying gesso and a toned ground, and the sanding that's involved, I stretch the fourth side tightly and attach it with only three staples (for an average size canvas). Later, after the sizing, priming, sanding, and toning are completed, I remove these staples, pull the canvas tightly, tuck in the corners, and restaple it in the same manner as the other sides.

All wrinkles have now been pulled out and the canvas is taut. Canvases can easily be stretched by hand with this method, but stretcher pliers make the job easier.

The delay in stretching the fourth side should alleviate all problems with the canvas becoming slack. If it does become loose, it can be tightened by removing the staples at the back corners of the frame and driving keys into the slots in the stretcher to push out all four sides. I prefer another method: After removing the corner staples, I grasp the stretched canvas by the top bar and gently tap across the bottom bar with a hammer. I rotate the canvas and repeat the procedure until all four sides are done, then staple the corners again to prevent future movement of the bars and reloosening of the canvas. If further tightening is necessary, the staples can be easily removed along one side of the frame and the canvas pulled tightly and stapled again.

Stretching the Canvas

I usually stretch the narrow side of the canvas first. Begin by stapling the canvas to the center of the stretcher bar with a single staple.

Pull the canvas horizontally to the corners and staple it near the ends of the bar.

Staple in between the middle and the ends, spacing the staples about one inch apart.

Moving to the opposite side, pull the canvas tightly toward you and staple in the center of the bar.

Pull the canvas diagonally to the corners and staple.

Staple in between the middle and the ends, pulling the canvas tightly toward yourself.

Now begin attaching the third side by stapling the canvas to the center of the bar, as before. Do not pull the canvas.

Tuck the corners under. Pull horizontally to the corners of the bar and staple.

Staple in between the middle and the ends. Do not pull the canvas.

The fourth side of a linen canvas should be fastened with just three staples. That way, the staples can be removed and the canvas restretched after the ground is applied. Pull the canvas tightly toward you and staple it to the center of the bar.

Pull the canvas tightly toward you. Apply one staple about four inches from each end.

After sizing, priming, and toning the canvas, remove the three staples. Pull the canvas tightly and staple it to the middle of the bar. Next, tuck the corners of the canvas under, pull it diagonally to the corners, and staple each end. Pull the canvas tightly and staple in between the middle and ends. Trim off the excess canvas overlapping at the back.

Preparing the Canvas

After the canvas is stretched, it is ready to be sized and primed. Acrylic gesso can be used for both sizing and priming, or rabbit-skin glue for sizing and white oil paint for priming.

Most gesso is quite thick right out of the can, but it can be mixed to the consistency that pleases the artist. It can be used straight from the can, but I prefer to thin it slightly with water and apply three or four coats with a brush.

After the first coat, I give the surface a light sanding with smooth sandpaper, sanding any knots more vigorously. Sometimes I sand the surface again, very lightly, before the final coat of gesso. An alternate method that I sometimes use is to apply a thin coat of gesso with a brush, followed by two thicker coats applied with a painting knife. For the thicker coats I use gesso straight from the can. The entire canvas must be covered thoroughly, as this seals and protects it from the oil paint, which would cause the cloth to rot. The back side of the canvas is not covered.

I have read several different recipes for making rabbit-skin glue. It may be best to follow the instructions on the particular brand you buy. Like gesso, the glue can be applied with a spatula, a knife, or a brush. I prefer to brush it on while it is still slightly warm. When that has dried I apply a base coat of pure flake white oil paint.

Most of the time I use gesso, but whether I use gesso or rabbit-skin glue, I brush some around on the sides of the canvas. During the process of painting, the sides of the canvas usually come in contact with paint and need to be protected. Gesso brushed around the sides also prevents the canvas from unraveling and reduces the strain around the staples.

After the canvas is dry, I apply a toned ground that is a light or a middle tone in value. To make the ground, I mix white oil paint (preferably flake white) with a color and a small amount of medium. If I'm in a hurry for the paint to dry, I add a drop or two of cobalt drier. Good colors for a toned ground are raw or burnt umber, yellow ochre, and raw sienna. I have used Mars brown for a pink tone; burnt sienna will give similar results. Burnt umber and ultramarine blue make a nice gray.

Every color in an underpainting has some effect on the final painting, but the main reason I use a toned ground is to cover the interstices of the canvas, as I prefer this smoother painting ground to the canvas texture. I use a four-inch painting knife to apply the paint to the canvas. This knife is triangular and has a rounded tip and corners so it won't create lines in the paint. It is best to run the painting knife away from the stretcher strips rather than parallel to them. Pressing against the strips with the knife creates lines on the toned ground. A thin piece of cardboard can be inserted between the strip and the canvas to help prevent this halo effect. Another way to avoid it is to trim down the inside of the stretcher frame before stretching the canvas. It would be nice if the manufacturers would redesign the stretcher bars with a higher lip.

Instead of using oil paint for a toned ground, you can mix an acrylic color with your last coat of acrylic gesso. This gives a fast-drying surface that is ready for painting in about an hour. When this is done, I apply four coats of gesso. The third coat is either put on with a knife or brushed on and then smoothed out with the knife. The fourth coat has a color mixed with it and is applied in the same manner as the third. I find that when the first underpainting is on an acrylic ground, the oil colors tend to cover it more opaquely. On an oil ground, oil colors are more transparent in the first underpainting.

Whichever toned ground I use, I apply the paint rather thinly. I don't like a real slick surface, nor do I like a rough one. Again, this is something that can be done according to the artist's preference. After about three or four days, depending on the thickness of the ground and colors used, the canvas prepared with oil paint is dry and ready for painting.

Mediums

A basic recipe for painting medium is 1 part damar varnish five pound cut, 1 part stand oil, and 5 parts gum turpentine. I prefer about 3 parts turpentine, 3 parts stand oil, and 2 parts damar varnish five pound cut. The ingredients can be mixed in any proportion to please the artist, but I would advise against going too thick with oil and varnish or too thin with turpentine.

Damar varnish five pound cut is made by dissolving 5 pounds of damar crystals in 1 gallon of gum turpentine. To make a smaller amount of this varnish, place 1 pound of the damar crystals on a piece of cheesecloth or other suitable material (I use an old T-shirt), then bring the four corners of the cloth together to form a bundle and tie it with a long string. Holding onto the string, drop the bundle into a container of 26 ounces of gum turpentine. Within 24 to 36 hours, the turpentine will dissolve the crystals, and the result is damar varnish five pound cut.

Discard the remaining residue in the cloth and strain the varnish through another cloth into a clean container.

Using a medium makes the painting more luminous. When brushed over the picture before starting to paint, the medium makes the paint flow better from brush to canvas. It also helps to bond one layer of paint to another and gives deep, rich glazes of color. Brushing the medium over the picture is referred to as "oiling in" or "oiling out."

I keep my painting medium in a small jar instead of a palette cup. After oiling in with the medium, I screw the lid on tightly to keep the turpentine in the medium from evaporating. I do not dip my brush into the medium while painting unless I'm glazing.

A problem that may be encountered when working with a painting medium is the crawling or trickling (beading) of the medium on the paint surface. Instead of spreading over the surface, the medium contracts or crawls like water on a waxed car. It's been years since I've had any problem with trickling, but it can be corrected by brushing turpentine over the picture surface. After waiting a few minutes for the turpentine to evaporate, I brush the painting medium on again.

To make the paint more workable and to keep my colors fresh on the palette as long as possible, I mix a little stand oil with each mound of paint. With stand oil, the paint develops a nice soft, buttery texture and is very luminous and easy to manipulate.

Paint straight out of the tube is referred to as "short"; it is in a fairly solid state and the brush makes crisp, obvious impressions with sharp ridges. The paint becomes "long"—flowing and much more luminous—when mixed with copal or damar concentrate (a compound of copal or damar resin and stand oil). Stand oil mixed with the paint can also give this "long" characteristic, but I prefer just enough for a texture similar to that of soft butter.

Stand oil is a slow drier in itself, but sometimes I slow it down a little more by adding a drop or two of oil of cloves to about three ounces of oil. I usually do this during the summer, when colors dry faster. Stand oil acts as a binder. More should be added to fast-drying earth colors than to the slow-drying colors. Alizarin crimson has such a nice consistency that it doesn't need anything added.

Since I work on a painting over a period of several days and want my paints on the palette to remain fresh, I put my palette in the refrigerator or freezer when not in use.

The paint swatch is straight from the tube. The paint is stiff and the brushstrokes are crisp with sharp ridges. Paint of this consistency is referred to as "short" paint. I have added stand oil to the paint in the second row; this imparts a soft, buttery consistency. The brushstrokes are softer and less obvious than strokes made in short paint. Although I use all three kinds of paint illustrated here, I prefer this buttery consistency. More stand oil has been added to the bottom swatch; this permits me to string the paint out on the canvas. Paint with this viscosity is referred to as "long" paint.

This delays the drying process and keeps the paints more workable over a longer period of time.

Varnishes

Varnishing isn't really necessary when painting with a painting medium and stand oil, since these mediums can serve as a varnish in and over the paint. When the painting is finished, I apply a coat of medium over the surface. This removes all dull spots and gives the painting an even shine. A fresh painting worked with painting medium will have a shiny surface. In about a year this will mellow to a nice glow — a sign of a healthy painting that has sufficient binder.

If a painting is still available after a year, I give it a coat of medium or damar varnish. A painting should dry for six months to a year before being varnished, and the surface should be clean and dust-free. Varnishing protects the painting surface from dirt and other impurities in the air.

Brushes

I use bristle brushes primarily for the first underpainting. Sometimes I use them again, but most of the time I overpaint and refine with synthetic white sables; they are longer lasting and less expensive than the natural sables and work just as well.

I use sizes 1, 2, 3, 4, and 5 bristle flats, a size 3 or 4 bristle round, and sizes 2, 3, 4, 6, and 14 white sable brights. I also use a size 6 white sable round and sizes 4, 6, and 8 Langnickel royal sables.

Brushes should always be cleaned thoroughly after use; this can be done with solvents such as turpentine, mineral spirits, or the newer cleaning soaps. I rinse the brushes with clean water and then, with my fingers, reshape them to their original shape.

Colors

Cadmium Yellow Light	Burnt Sienna
Cadmium Orange	Burnt Umber
Naples Yellow	Permanent Green Light
Yellow Ochre	
Raw Sienna	Viridian
Cadmium Red Light	Cerulean Blue
Cadmium Red Deep (optional)	White (Flake is preferred)
Alizarin Crimson	Flesh

I usually have these colors out for every painting, arranged on the palette in the order given. Occasionally I like to substitute other colors, but these are the ones on which I rely. I always place each color in the same spot on the palette so I know where it is without having to search for it. Clean

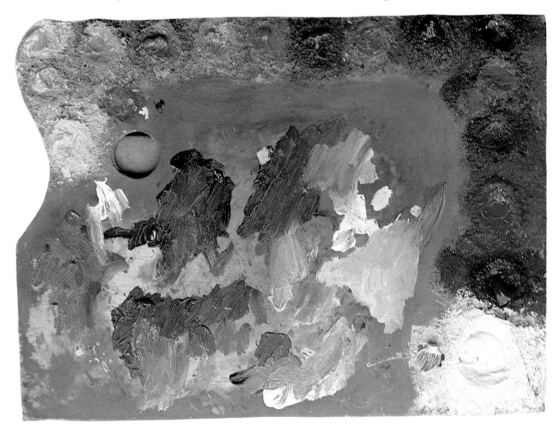

This is how my palette looked after the completion of the first underpainting for A Texas Spring (Page 47). You can see the orderly arrangement of the colors along the outside perimeter. I do my mixing in the central area of the palette, away from the pure colors.

colors should be placed around the outside perimeter of the palette and color mixing done in the middle. After a day's work, I clean the mixing area by scraping off the unused colors and wiping it with paper towels and a brush cleaner.

When mixing colors, most students put the colors to be mixed into one pile and then stir them with a circular motion. The result is one value and one color, which is usually muddy. Color mixing can be done with either a brush or a painting knife, but the colors should be placed a distance apart and gradually brought together to form a pool of color with many different values and hues.

It is assumed the reader knows that white is mixed with the colors to obtain the desired value. Most of the color mixtures given in Part III do not list white since it is used in almost every color mixture. The amount depends on the value. However, in some paintings, I will use an atmospheric or "mother" color as a lightener instead of white. This is composed primarily of white plus one or two other colors, mixed thoroughly to form one color that is light in value. Special notice will be given when an atmospheric or "mother" color is used.

—Painting Procedure—

I sketch the drawing in loosely with charcoal while thinking of the major patterns and designs; I try not to get too involved with detail at this stage. I redraw the charcoal sketch with yellow ochre thinned with turpentine, then dust the remaining charcoal off with a paper towel.

I'm now ready to do the underpainting, which is done using flat and round bristle brushes on a dry surface. I start a painting with bristles and finish with sables. This gives me some texture, whereas working with sables all the way through would produce too slick a surface. I also paint more thickly during this first stage. All the overpaintings are thinner as I refine the painting more and more.

Starting with the darker tones, I work rapidly back and forth from dark to middle and light values. At this stage I concentrate mainly on the larger masses and the total design of the painting. I prefer smaller brushes and use sizes 1, 2, 3, 4, and 5 bristle flats and a size 3 or 4 bristle round. If I want an area, such as the sky, to remain smooth in the final painting, I use sables throughout that area. This underpainting is completed within a few hours, depending on the complexity of the subject and size of the canvas.

Two or three days later, after the underpainting has dried, the first overpainting is begun. Before each overpainting, I brush the section of the painting to be worked on with painting medium. The excess can be wiped off with a paper towel. This buildup of paint and medium adds to the beauty and depth of color of the final work. Unless I want more texture, I use white sables for the overpainting—sizes 2, 3, 4, 6, and 14 brights and a size 6 round. I have found the Langnickel royal sables to be fine brushes at a good price. I use sizes 4, 6, and 8.

The early part of the work (after the first underpainting) is usually the hardest, but as more paint goes on, the painting gets easier. Some areas can be more refined than others, and some can be left in the underpainted state. The rough bristle underpainting can be easily scumbled over, and the medium permits glazing. A glaze is achieved by mixing a small amount of color with painting medium and brushing it over the painting. I usually work back over a painting three or four times in order to get the degree of refinement I want.

Sometimes I stand while working on the loose underpainting, but I prefer to sit while doing most of the studio work. Also, I don't have several paintings in progress at once. I do one at a time, finishing one painting before beginning another. All other potential paintings are kept in mind until the proper time for their release. This way, I can put all my effort and concentration into the work currently being done.

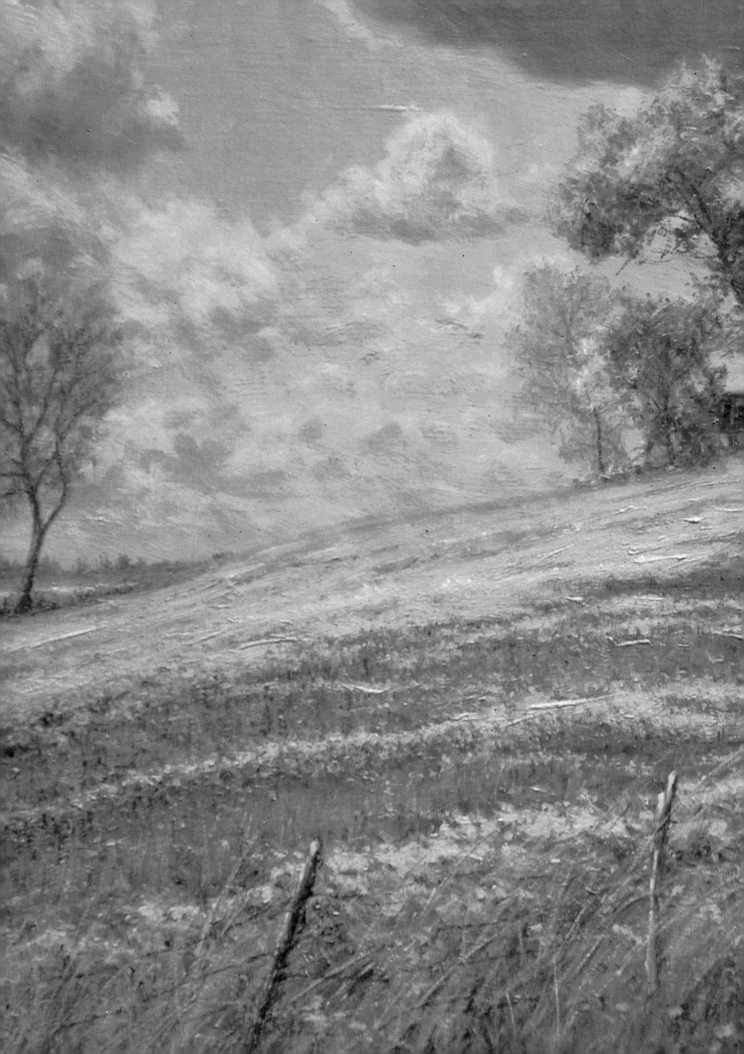

Working Outdoors: Aesthetics and Ideas

Outdoor Painting

The studio work presented in this book would have been impossible if I had not painted outdoors first. In order to paint landscapes in the studio, you must go outdoors to study your subject matter firsthand. Get to know the landscape well. Painting outdoors and becoming familiar with the intricacies of nature will equip you with a vast knowledge of the landscape without which your studio work will be limited and unsuccessful.

Paintings done outdoors can serve as the basis for larger and more detailed studio work. Constable worked this way. Bierstadt, Moran, Church, and a host of others painted outdoors but did their major work in the studio.

There are many ways to approach painting outdoors. Some people work entirely on location, underpainting and overpainting several times before the painting is completed. Others work alla prima (wet-in-wet) and complete the painting on the spot within a few hours. Regardless of your choice of procedure, the important thing is that you do get out on location and spend some time drawing and painting.

My choice when painting outdoors is to work alla prima on a small canvas. Working this way, I can retain the freshness and spontaneity of a fleeting moment. I leave overpainting and detail for studio work.

I begin by choosing the subject to be painted and the point of view. Next, I decide how I am going to portray the scene—the major light-and-dark patterns, the colors, and the mood.

I quickly draw in the major design with yellow ochre thinned with turpentine and begin the painting, starting with the darks, then moving on to the lighter values. Sometimes I cover the whole canvas with the dominant patterns and then work back into these. Other times I start with the center of attention, refine it, and then proceed to less important areas of the canvas. Generally, I paint from thin to thick, because it is difficult to work back into a lot of thick wet paint. (My studio work is done the opposite way, from thick to thin; the thicker underpainting is allowed to dry before being overpainted.) I use only bristle brushes for outdoor work except for a size 6 white sable round that I use for small lines such as tree limbs or foreground grass. I include very little detail as I attempt to capture my impressions of the scene. Since I paint rapidly and without detail when working on location, I prefer to stand while painting.

I take as few supplies as possible on location, and everything I carry fits into my French sketchbox-easel. There is no need to be burdened with a lot of extra supplies that won't fit into the sketchbox. Sometimes I mix stand oil with the thicker paints before leaving the studio, but I use most of the colors straight out of the tube. If too much stand oil is used, the colors will slide off the palette during transportation.

One or two canvases will fit on the front of the easel. I use both a toned and an untoned canvas. Most of the work is done on gessoed mat board. To make it stationary, the board is stapled at the corners to a piece of thin paneling.

There are distractions when working on location: bugs, mosquitoes, wind, rain, cold, heat, people. Snakes can also be a hazard. I was halfway through a painting once when I noticed a small ground rattler curled up near the back leg of my easel. He was the same color as the leaves and straw, and I had failed to see him. With a little on-the-job experience, you can learn how to deal with such obstacles.

You may be totally confused when first working on location. I know I was, and it took a long time to get over my confusion. At first, I tended to see all the little ''things' (such as all the tiny plants, leaves, limbs, grasses) that are impossible and unnecessary to include in a painting. Also, there is the pressure of having to complete a painting in a short time because of the constantly changing light. Many times I just wanted to leave and go back to the studio.

Eventually, I learned to give myself two hours in which to work; I knew from experience that I could complete a small painting within that time. This helped me to relax and aim for the overall design of the painting. After a time, I learned to go for the big, important masses first and follow with the smaller details if necessary.

Something else that can help you in your outdoor work is to think of the outdoors as a classroom. You're there for your own benefit. You're there to learn. It doesn't matter if you get a finished painting or not, but if you do, it's a bonus.

Conceptual Ideas

The environment should constantly provide the artist with ideas for paintings. The ever-changing weather and the different seasons provide a vast array of painting opportunities. Special light effects and atmospheric conditions can turn an ordinary landscape into a thing of beauty.

Working on location and using a camera enable me to capture the details of a particular scene and the fleeting effects of nature. I especially enjoy painting the transitory moods of early morning or late evening. Also, light bursting through clouds or obscured by atmospheric haze can add a special feeling to a painting. Observe the fragile beauty of a frosty morning and the glories of autumn and spring. Be especially aware of light-and-dark patterns and the designs in nature.

Possible subject matter is all around you. You may feel like you've run out of ideas and become disillusioned, but the fault does not lie with nature. Become observant and allow the landscape to inspire you. Under the right conditions, that dull landscape you've seen so many times can become a masterpiece.

The first painting of the LaGrange farm (pages 28–29) was done on the spot; the other two were done in the studio. The keys to working in this manner are working on location, learning to observe carefully, and being alert to picture possibilities. While I did use photographs when doing the studio paintings, I relied much more on memory and experience. I can't overemphasize the importance of painting outdoors. There's no substitute for firsthand observation. The knowledge gained outdoors will greatly enhance your studio work, and this knowledge is essential for successful studio painting. Also, traveling to new areas of the country to paint is fun, but it isn't necessary. I've done many paintings within a thousand feet of my studio.

Sometimes I use small outdoor paintings as a basis for larger studio work. Often a simple pen-and-ink sketch can be used as a starting point for a painting. Photographs are also very helpful. I usually make a few small thumbnail compositional sketches before starting a studio painting. The outdoor paintings, sketches, and photos can stir my imagination to develop the moods and feelings I will express in the studio work. In the studio, many of the distracting details can be forgotten and there is time to project any mood I desire onto my painting.

Sketches and photographs of trees, buildings, figures, skies, and other landscape elements can be combined in the studio for a composite painting. Sometimes a painting can be completely imaginary. You can't just sit in the studio all the time and work like this, however. You must get out and become acquainted with your subject matter.

I believe painting should be more than just applying paint to canvas. You should express your feelings, aesthetics, mood, and personality, as well as capturing the essence of the subject. Go beyond the facts—develop a mood and express how you feel about the subject being painted. I used to paint without giving it a great deal of thought. Now, I think things out first and let a painting develop in my mind until it is ready for the canvas. The best works are those that are formed within and released at the right peak of desire.

An artist must develop not only talent but also taste, and must learn to recognize and appreciate good work. You can have the highest degree of talent and the best technique in the world, but if you have poor taste, the result will be poor work. My advice is to go to museums and study the masters. Feel the goose bumps up and down your spine as you view works so moving you are swept up in the emotions of the artist. Study the good contemporary artists, of course, but visit the museums and study the masters as well.

Love is another essential ingredient for better painting. You must love to paint. It is a part of you and you are compelled to do it. You should also love your subject matter. The subjects I prefer to paint are the ones I love. When painting these, I can paint from the heart, with affection and passion as well as intellect and desire.

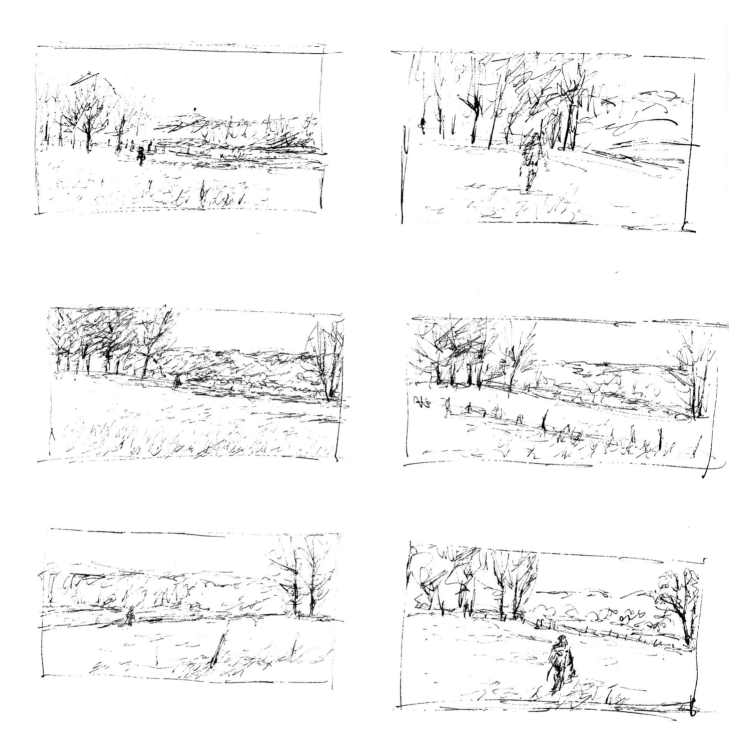

You can use thumbnail compositional sketches such as these to help formulate your mental conception of the painting you plan to do. Not every detail has to be worked out, but you should have an idea of how the finished painting will look before you begin.

For me, too much preliminary work quenches the desire to do the painting. A few of these sketches and a lot of thought help me to get the concept established in my mind. Then I'm ready to paint.

SUNSET OVER HAYFIELDS *Oil on canvas, 20″ × 24″ (50.8 × 61.0 cm), collection of Mr. Travis A. Taylor*

This is an example of a composite painting done using my imagination and outdoor painting experience. Without working on location and observing nature, I could never have combined the different elements to create the mood that you see here or painted it with such feeling.

I used my own photo for the sky. The field and hay bales are in another location and were actually photographed in the morning. I used my imagination to change the scene to evening.

Painting outdoors teaches you about nature and allows you to do what you want to with it while painting in the studio. Notice that the sweeping designs in the sky are repeated on the land and a multiple S pattern runs throughout the composition. The eye is drawn back into the painting by the fence coming into the picture on the right. Otherwise, the foreground fence would sweep the viewer right out of the painting. After traveling across the landscape and up into the sky, the eye is led right back into the painting by the cloud patterns to start the journey again.

EVENING AT THE GIBSON PLACE *(detail) Oil on canvas, 18" × 22" (45.7 × 55.9 cm)*

This close-up detail shows how the evening light affects the landscape and lends a feeling of quietness and mystery. I painted the sky in smoothly with subtle gradations of color, from a lighter, warmer hue on the left, nearer the sun, to a darker, colder tone on the right. As usual, I mixed the paint with stand oil for a soft consistency and applied the underpainting with bristle brushes and the overpainting with synthetic white sables. The house, windows, and figures are all suggested rather than rendered in detail. Even so, notice how the paint is applied with care and sensitivity.

THE LONG JOURNEY *(detail) Oil on canvas, 24" × 30"
(61.0 × 76.2 cm), collection of Mr. Travis A. Taylor*

*This detail reveals some of the emotions I painted into this
highly symbolic picture. Without going into the symbolism, the
painting is one that evolved into a depiction of the struggles I
was going through on the "long journey" of art.*

After selecting the subject, I decided to capture the feeling that was actually present—a windy autumn day with skies that threatened rain. I quickly blocked in the church building, then proceeded to paint the windblown clouds, using the brushstrokes to portray their movement. I painted the clouds down into the tree area, then painted the trees back up into the clouds. I brought the grays from the sky down into the landscape for unity. The shadow in the foreground guides the eye into the scene.

AUTUMN AT ROCKLAND CHURCH *Oil on mat board, 9" × 12" (22.9 × 30.5 cm), collection of James and Kathleen Baldwin*

MEADOW LIGHT *Oil on mat board, 7" × 12" (17.8 × 30.5 cm), collection of Burl and Mary Jane Griffin*

Spring is the time when artists flock to central Texas to see and paint the spectacular display of wildflowers, with bluebonnets being the star. From late March through most of April, the dazzling array of colors turns the countryside into a thing of beauty.

There was a terrific wind blowing in my face while I worked on this painting. Instead of beginning with the darks, I quickly painted in the elusive cloud formations, then I spotlighted the barn and trees to make them the center of interest and threw the foreground into shadow.

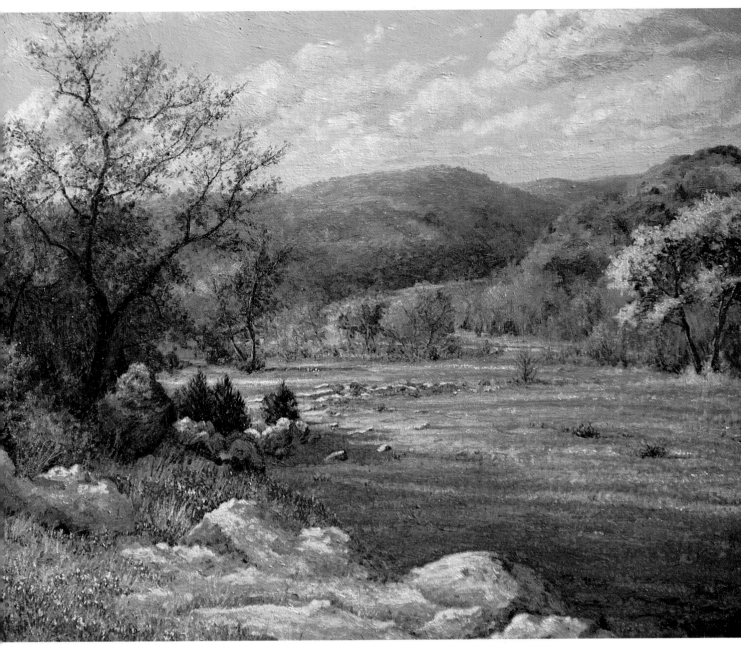

HILL COUNTRY SPRING *Oil on canvas, 20" × 24" (50.8 × 61.0 cm), collection of Georgia-Pacific Corporation*

In this book, I emphasize painting with feeling by developing a mood in a work. Although early morning and late afternoon naturally lend themselves to this type of painting, any time of day can be painted in an aesthetically pleasing manner and used to express many different moods. In this painting, the mood is bright and sunny as the viewer is led over the foreground rocks to the sunlit plane and on to the distant hills.

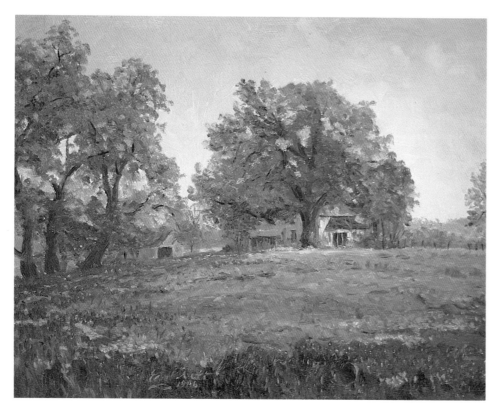

This was painted on location in early spring, while I was on a painting trip to central Texas. I had passed the site the day before and noticed the strong contrasts created by the late afternoon light. The next morning I returned to paint this picture. The morning was foggy; a soft light was hitting the front of the house.

LA GRANGE FARM *Oil on mat board, 11" × 14" (27.9 × 35.6 cm), collection of Mrs. Catherine C. Peckham*

This painting of the La Grange farm was done in the studio. The time of day in this painting is late afternoon, when I first saw the farm. I added billowing clouds and painted some sheep (which I had seen elsewhere on the trip) under the huge oak trees. Notice how the whole landscape is enveloped by the purplish color of the clouds.

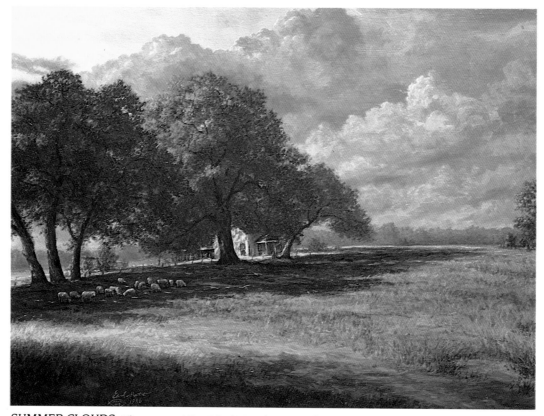

SUMMER CLOUDS *Oil on canvas, 18" × 24" (45.7 × 61.0 cm), collection of Mrs. Anda Armstrong Erwin*

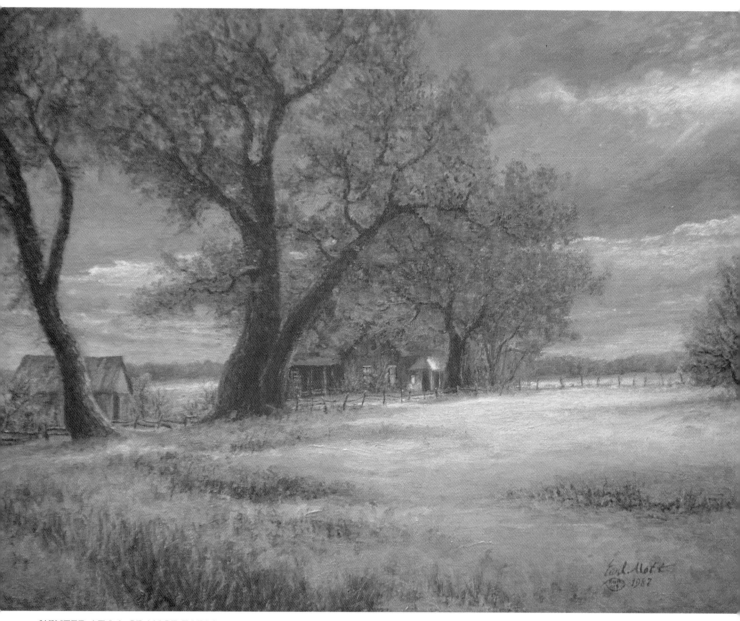

WINTER AT LA GRANGE FARM *Oil on canvas, 14" × 18" (35.6 × 45.7 cm), collection of Mr. Bill R. Griffin*

In this third painting of the same farm, I changed the time of day back to early morning and the season to winter; the cold, gray atmosphere of winter envelops the scene.

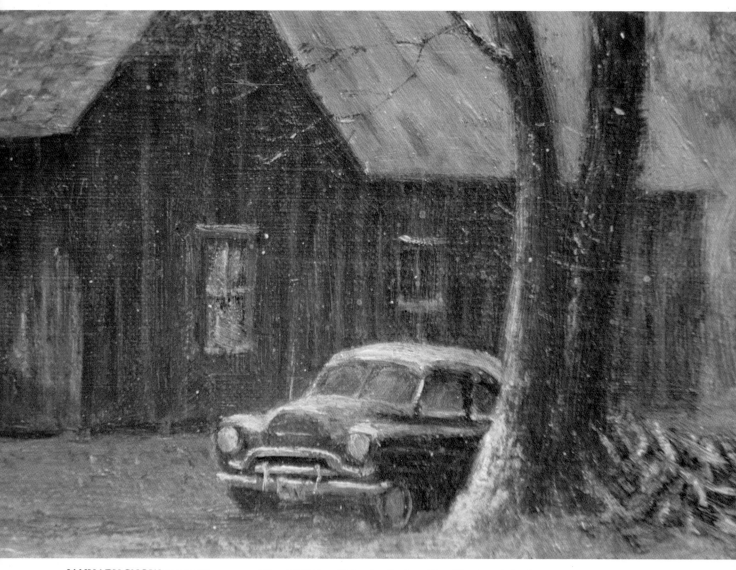

JANUARY SNOW *(detail) Oil on canvas, 20" × 24" (50.8 × 61.0 cm), collection of Donald and Lynda Byrd*

This close-up detail is from a composite painting in which I used the photograph of the old car in Central Texas Homestead *(page 88). You can reuse elements such as this without being repetitious. The elements in a landscape can be used in a variety of ways, and each painting can be done with a special mood and feeling.*

This is the first of three location paintings I did of this house. I selected this particular view because of the interesting chimney and the play of light and shadow on the wall. After blocking in the main shape of the house, I painted in a few of the characteristic details. The brushstrokes were kept light and lively to better capture the sparkle of the sunlight.

ROCKLAND HOUSE *Oil on mat board, 12″ × 16″ (30.5 × 40.6 cm), collection of Mrs. Joyce Hogue*

This is the back view of Rockland House. *It was morning when I painted this, and I was facing the sun as I worked. The backlighting made interesting shadow patterns on the trees and grass. I used these patterns to guide the viewer into the scene and toward the house, which was in shadow. The well-shed on the left points the eye into the picture, while the tree on the right acts as a stop and prevents the eye from leaving the painting.*

HOUSE AT ROCKLAND *Oil on canvas, 12″ × 16″ (30.5 × 40.6 cm), collection of Mrs. J. B. Hill*

BARN AT ROCKLAND *Oil on mat board, 10" × 14" (25.4 × 35.6 cm), collection of Mrs. Joyce Hogue*

The sky was actually blue the day I painted this, and there was very little atmospheric haze. I decided to paint a warm sky and bathe part of the barn in sunlight. The cast shadows form a strong contrast to the barn and, in the foreground, create a path that leads the eye to the barn. Bristle brushes were used for the entire painting except for small lines, such as the cornstalks, which were added last.

I was hoping for sunshine on the early morning in March when this painting was done. Instead, the sky was overcast and the air was damp and cool. Near the end of the painting, a gentle rain started falling; soon it covered my palette and ran down the front of my picture. Because of the rain and an appointment, I was in a hurry to complete the picture. Normally, I would have refined some areas more, but I was satisfied with capturing the essence of the place and decided to leave the painting as is. I had already painted a sunlight effect, but right before I finished, the sun popped out for about ten seconds, which helped me add a touch of authenticity.

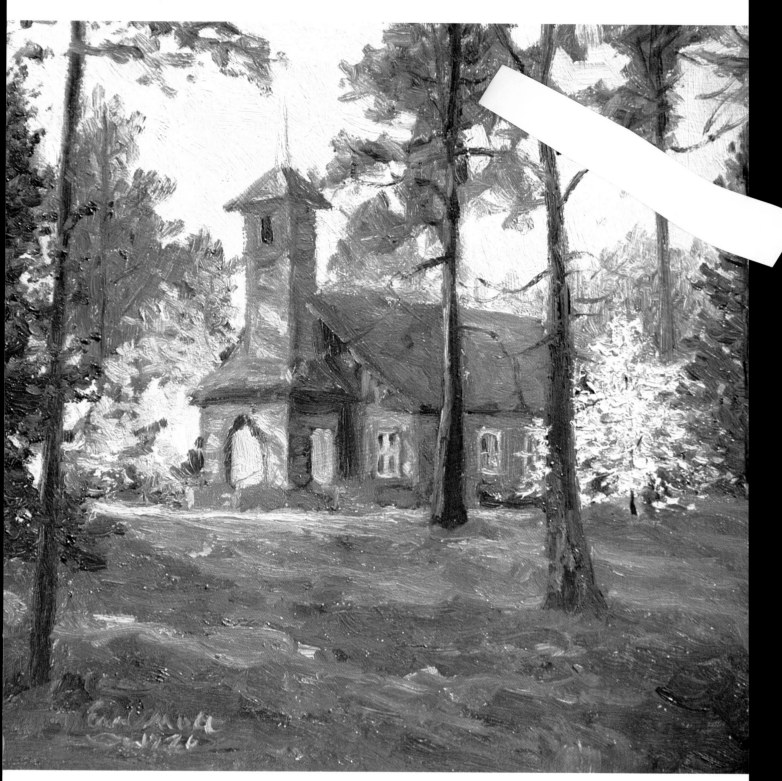

SPRING AT RYAN CHAPEL *Oil on mat board, 11" × 14" (27.9 × 35.7 cm), collection of Mr. Travis A. Taylor*

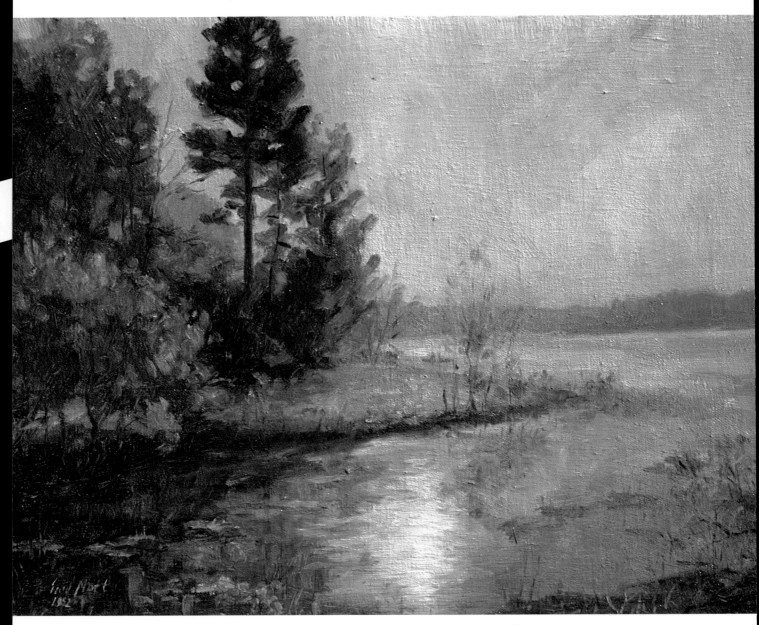

FOGGY MORNING AT RAYBURN *Oil on canvas, 12" × 16" (30.5 × 40.6 cm), collection of Mr. Travis A. Taylor*

You can see the great influence of the atmosphere in this painting. Of course, it's not always this evident, but atmosphere plays a big part in the color you see in a landscape. This painting was one of the hardest outdoor paintings I've done. The sun was shining in my eyes from the sky and its reflection was glaring from the water. I don't usually wear a hat, but I surely needed one that day! I was almost blinded and had to step back occasionally to see what I was doing. Nevertheless, this painting turned out to be one of my most satisfying; I feel that I captured the cool dampness of that October morning.

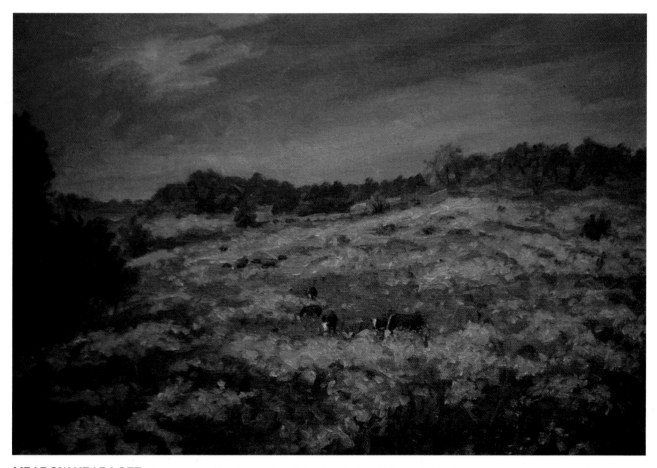

MEADOW NEAR LOTT *Oil on canvas, 12″ × 16″ (30.5 × 40.6 cm), collection of Mr. Travis A. Taylor*

I decided to include the rising sun in this painting, so I painted the sky first. Such a transitory effect lasts but a few minutes, and I worked quickly to capture my impression of the scene. Then I moved on to the rest of the landscape, using purples from the sky in the flowers, trees, and grasses. I did the entire painting on location except for the cows, which I observed on location but painted in the studio.

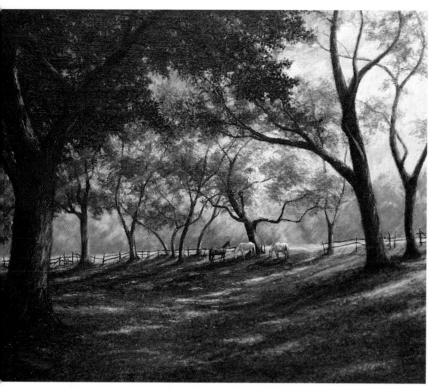

UNDER THE OAKS *Oil on canvas, 24" × 30" (61.0 × 76.2 cm), collection of Mr. Travis A. Taylor*

While thinking about this scene and how to paint it, I decided that horses in the cool shade of the trees would be a good center of interest. The horses were only suggested on the first day and almost obscured by the subsequent overpaintings. Near the end of the painting, I worked back over them and clarified the drawing. I used photos I had taken of one horse in three positions and painted each one a different color to produce three different horses.

Paint was dabbed onto the canvas with the end of an old, worn white sable brush in the foreground and middle ground, suggesting dirt and fallen leaves.

The remains of these old buildings reminded me of a Spanish mission from early Texas history. Actually, these are the ruins of an old sawmill that was left to decay after the land was stripped of trees. A victim of the forest and of time, it has a forsaken, spooky feeling about it. This mood was expressed in the painting.

The painting was initially laid in with bristle brushes and overpainted with white sables. During the series of overpaintings, the shadows were painted darker and the lights lighter. Several months after the painting was finished, I came back and scumbled even stronger lights strategically over parts of the building to enhance the sunlight effect.

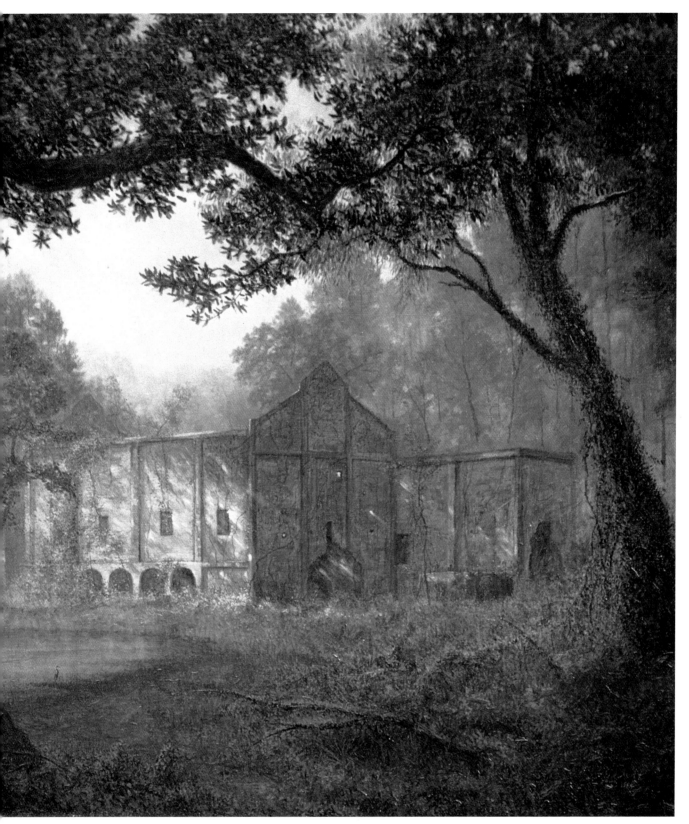

THE RUINS OF OLD ALDRIDGE *Oil on canvas, 30″ × 40″ (76.2 × 101.6 cm), collection of Mrs. Joey Lou Tatum Block*

The Diary

Purpose of the Diary

After a painting is completed, I find it almost impossible to go back and explain in great detail what went into making it. Even after a few days, just exactly what I did, how I did it, and what I was thinking become vague. This is especially true with regard to colors. Apparently other artists also have this problem, since there is a lack of in-depth information regarding how paintings are actually put together.

I know there are many things that go into a painting, such as feelings and aesthetics, that are difficult or impossible to explain. These come from within the artist. But I believe it is possible to give a much more accurate description of the day-by-day process of painting. This is what I will attempt to do in this section, which is the main thrust of this book.

My desire is to take you into the studio for each day's painting session. I will start at the very beginning of each painting with my concept and the photographs, sketches, or outdoor work that were used to formulate the mental image for the final work (not all preliminary work will be reproduced). Next, I will give a day-by-day account of the process of painting until the work is completed. Since it is impossible to remember each stage, I made notes after each day's work. Before I cleaned my palette and brushes, I recorded the colors and brushes I used and what I did that day.

In the early years of my painting career I often wanted someone to tell me clearly just how they put a painting together. I found most explanations were only a general overview of the work involved, probably written after the painting was completed. By giving a daily, up-to-date report, I hope to present a clearer picture of how one artist puts together paintings. My sincere wish is that all students of art will be helped by this *Oil Painting Diary*.

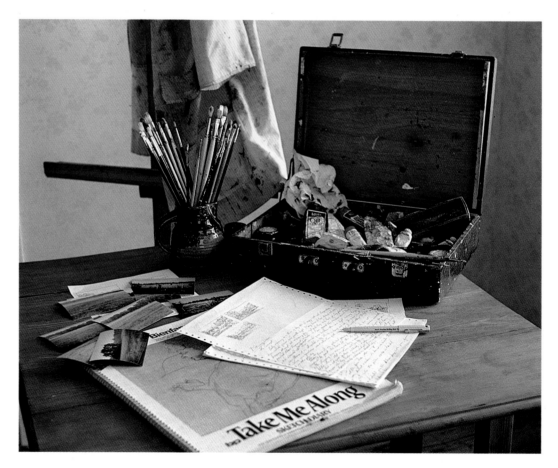

A Texas Spring

A few months ago, I returned from an inspiring trip to central Texas with two other artists. For a long time it had been my desire to paint bluebonnet flowers on location there. (The bluebonnet is the state flower of Texas and blooms in the early spring.) The trip resulted in five paintings done on the spot, a stack of photos, and a lot more knowledge.

One thing I wanted from the trip was a spring demonstration painting for this book. The painting shown, *View Near Marble Falls*, was done on location and will provide the inspiration and knowledge for the studio work. I'm changing the point of view and using photos of the area to develop another composition. As you can see from the photo below, the bluebonnets were actually scarce in this area. I simply imagined there were more.

My intention is to focus on the bluebonnet flowers, then move on into the scene to the hills and the distant horizon. The aerial perspective is strong as you look out over these hills. From here you can see how the cloud shadows affect the landscape. Some areas are thrown into shadow while other areas are spotlighted as the sun breaks through the clouds. My concept is to express these characteristics in the painting.

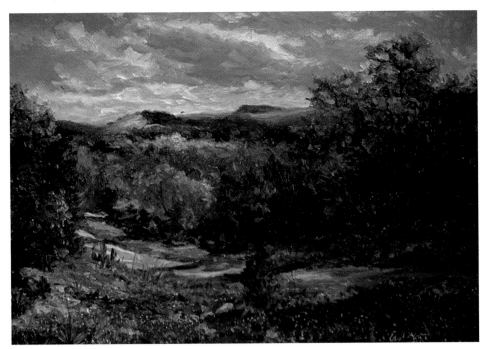

This photo was taken from the spot where I painted View Near Marble Falls; *I will use it as a reference photo for* A Texas Spring.

VIEW NEAR MARBLE FALLS *Oil on canvas, 14" × 20" (35.6 × 50.8 cm)*

This outdoor painting, along with photos of the area, will serve as the basis for the studio painting, A Texas Spring.

─Day One─

I rapidly sketch the drawing on the toned canvas with charcoal. As usual, my attention is focused on the overall design of the painting. I begin by indicating the placement of the hills, the horizon line, the row of cedars, and the patterns of the clouds and flowers, then redraw the sketch with yellow ochre and turpentine, dust off the charcoal with a paper towel, and start painting.

I mix viridian, alizarin crimson, and a bit of cadmium orange and add ultramarine blue to make the mixture darker. With a size 3 bristle flat, I paint the flow of the trees from the right side of the hill, down the valley, and up the other side, using a variety of strokes to paint in the general design. These trees are painted in shadow to contrast with the sunlit field that I will paint in the foreground and the hill in the background.

I stroke ultramarine blue and flesh on the shadow side of the large hill and the distant hill and plane. The greens in the valley are viridian, burnt umber, and raw sienna. I bring permanent green light into this. For a lighter, grayer green, I use Naples yellow; for a brighter green, cadmium yellow light and flesh. The colors are arranged on the palette in a color pool so I can go to any color I want. I don't lump the colors together and stir them up; rather, I bring them together gradually.

Cadmium red deep and raw sienna are brushed on the canvas for the red foreground dirt. Some purple (ultramarine blue and alizarin crimson) is stroked into the red earth color. Viridian, burnt umber, and permanent green light are used for the darker foreground greens. I use a size 4 bristle round to paint the bluebonnets in the foreground, using ultramarine blue, cerulean

Day One: The charcoal drawing. I always begin by indicating the major landscape elements and leave the details till later.

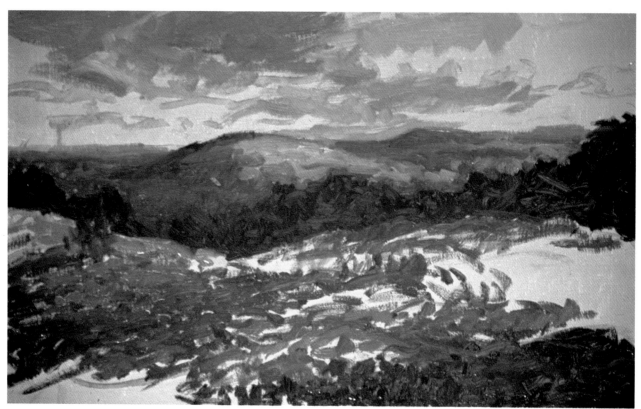

Day One: The half-completed underpainting. I'm working all over the canvas, laying in the basic designs. My brushstrokes are sketchy, and not all areas are completely covered.

blue, alizarin crimson, and flesh for the flowers in shadow and lighter values of these colors for the flowers in sunlight. The strokes are mostly vertical and very casual, with no attempt at detail.

Next, I paint the dirt area of the hill with yellow ochre and cadmium red light. A touch of the red earth from the foreground is stroked on the hill. Cadmium yellow light and white are brushed on to indicate sunlight.

Cerulean blue and alizarin crimson are mixed for the clouds. I gray this with a mixture of cadmium red light, raw sienna,

and flesh. I start with the dark clouds, then brush in some sky with cerulean blue and white. The clouds are highlighted with yellow ochre and white. A bit of burnt umber grays the sky in the distance. I'm painting with a size 5 bristle flat, using a variety of brushstrokes.

When the canvas is half covered, I stop to have the half-completed underpainting photographed. Notice that I'm working all over the canvas, laying in the basic designs. The different areas worked on are not solidly covered, but are covered in a sketchy manner.

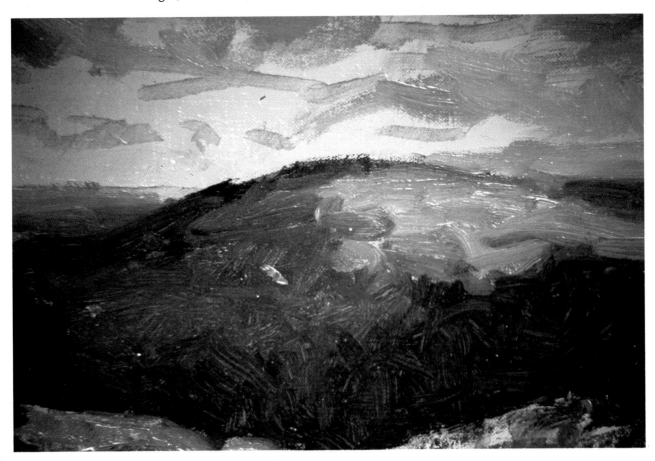

Day One: Detail of half-completed underpainting. I will keep the trees in shadow to contrast with the sunlit field and distant hill. The shadow side of the hill is painted with ultramarine blue and flesh, as well as a variety of greens; the patch of dirt is painted with yellow ochre and cadmium red light, with a touch of the red earth mixture from the foreground. Sunlight is indicated with cadmium yellow light and white.

When the sky is completely covered, I paint more lights into the hills. Some of the hills are in cloud shadow and some are in light. I keep the shadows cool with ultramarine blue. The warm colors in the light are Naples yellow, cadmium yellow light, and flesh. Keeping the shadows cool and the lights warm is a basic rule of landscape painting.

I use the same colors mentioned earlier to paint in the design of the various grasses and flowers, adding cadmium yellow light with a touch of cadmium orange for the black-eyed Susans. Cadmium red light, cadmium red deep, and yellow ochre indicate the Indian paintbrushes.

When painting a field such as this, use a thick application of paint to create texture. Later, other colors can be scumbled over the thick paint, allowing the colors underneath to show through. Use horizontal, vertical, and crisscross strokes. At this stage, remember to keep your brushstrokes casual.

I paint the dead winter grasses with vertical, upward strokes of cadmium red light, cerulean blue, raw sienna, and flesh, and also light mixtures of burnt umber and raw sienna, and use these same colors to indicate an outcropping of rocks on the left. A small tree is suggested near the rocks to act as a stop. The dead tops on the yucca plants are indicated. A gray of cerulean blue and cadmium red deep is brushed into the cedars to suggest dead branches.

The canvas is now covered. I hope you can see by the reproductions just how loosely this stage of the painting is handled and the variety of strokes used.

Day One: Detail of the completed underpainting. I use ultramarine blue to keep the shadows cool and Naples yellow, cadmium yellow light, and flesh to keep the light areas warm.

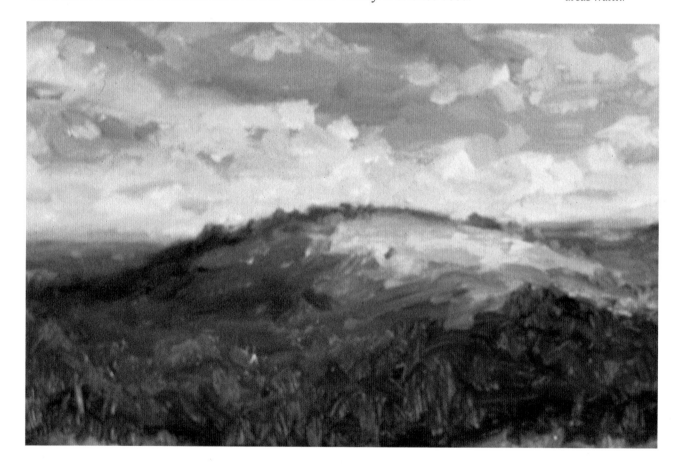

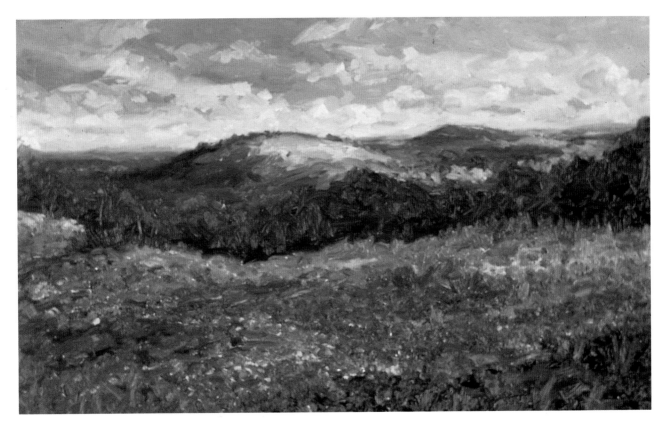

Day One: The completed underpainting. The entire canvas is covered. Notice the variety of brushstrokes; at this stage, I am handling the paint very loosely.

─Day Two─

After a couple of days, the first underpainting has dried and it's time to begin the series of overpaintings leading to the finished work. Some people don't realize that a painting must be built up gradually. Just as a house goes through various stages from a frame structure to the completed house, a painting also must go from a "frame" underpainting through various stages to the finished work. You shouldn't start at the top and finish a section at a time. Instead, work over the painting and finish it as a whole.

I oil the painting in with medium and, using a size 8 Langnickel royal sable, begin repainting the sky with cerulean blue mixed with flesh and lightened with white. On the right, I mix a light value of raw sienna into the light value of blue for a sunlit feeling. The darker cloud shapes are repainted with the same colors used on Day 1. I use a size 6 white nylon sable to work in the smaller cloud shapes. As they disappear into the distance there is a dappled appearance of light and dark shapes. Naturally, the darks become lighter in value and the lights lose their intensity and actually become darker as they recede. When this happens, they merge into one value on the horizon. I brush the sky colors lightly over the landscape that comes in contact with the sky.

With a size 2 white sable, I repaint the earth that shows through the bluebonnets in the foreground. More contrast is developed between the light area and the shadowed area. Throughout this first overpainting, I use the same color mixtures as I did on Day 1

I rework the bluebonnets, beginning with those in shadow, deepening their value. Then I repaint the designs of the other bluebonnets as I work a design flowing from the right corner over to the top of the hill on the left. The grasses are also repainted with small, choppy strokes. I make no attempt at detail; my concern here is with design, color, and value.

The dark cedars are restated with the same dark mixture of viridian, alizarin crimson, ultramarine blue, and cadmium orange, using a size 6 Langnickel sable. I can see the toned ground through the first underpainting, especially in this area, where mostly transparent colors are used. This is the main reason I give a painting a casual overpainting on the second day—to cover the canvas thoroughly and to establish a base on which to work.

I repaint the hill, valley, and distant plane and then come back to the foreground and rework the design of the yellow flowers, painting a flowing design from the right corner. The canvas has been covered a second time and now has a foundation for overpainting.

—Day Three—

I begin by brushing painting medium over the entire picture. The clouds seem to be attracting too much attention—all the small cloud shapes cause too much contrast and movement. I mix cerulean blue, flesh, and a touch of burnt umber for a gray-blue and brush it transparently over the entire sky. This reduces the contrast, pushes the sky back, and decreases its importance. I want the viewer's attention to be in the field of flowers, not in the sky. I brush a light value of raw sienna and white over the sky toward the right, which increases the intensity of sunlight, and follow this with a light value of the gray-blue mixture mentioned above. A size 6 white sable bright is used for this work.

With a size 6 white sable round, I start refining the foreground. A dark of ultramarine blue, cerulean blue, and alizarin crimson is mixed for the bluebonnets in shadow; this is lightened with flesh and white for the flowers in sunlight and the tops of the bluebonnets. I apply the paint with mostly vertical strokes as the various flowers and grasses weave together, forming beautiful patterns. Darks are generally put in first, followed by strokes of lighter color. I don't line the bluebonnets up straight and stiff, and there is no definite barrier or border around the designs the flowers make. There are flowers outside the main group, so I don't confine them but let them flow into the grasses and the grasses into the flowers. This will give a soft transition between the two. I try to create patterns that have

movement to them as the flowers seem to flow and dance over the hillside. Notice that the directional movement in the flower patterns forms an opposing movement to the design of the clouds. Also, the foreground shadow on the right balances the clouds in shadow on the left.

I alternate between working on the bluebonnets, the yellow flowers, and the grasses. The black-eyed Susans are mostly cadmium yellow light with a bit of cadmium orange; they are painted to flow with the designs of the bluebonnets but not to dominate them. Small bits of paint are flicked on to suggest petals without getting too involved in detail. The yellow flowers in shadow are painted with the darker earth yellow, raw sienna.

From a color pool of viridian, burnt umber, ultramarine blue (for darks), permanent green light, cerulean blue, cadmium yellow light, flesh, and raw sienna, I get the various greens in the field. The dead grass is cadmium red light, cerulean blue, raw sienna, and flesh; raw sienna and burnt umber; and yellow ochre and white. The red Indian paintbrushes are indicated with cadmium red light and yellow ochre. When painting a field of multicolored flowers and grasses such as this, I don't try to paint individual specimens; I think in terms of masses, not individual flowers. In the foreground, the bare earth is repainted with cadmium red deep and raw sienna darkened with alizarin crimson, ultramarine blue, and burnt sienna.

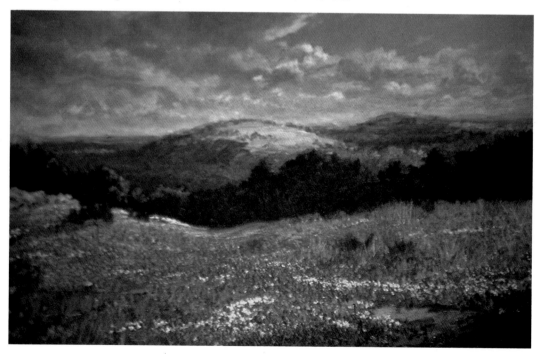

Day Three: I have painted over some of the hills with grayer greens, using atmospheric perspective to give a feeling of the depth of the landscape. I also subdued the sky with a gray-blue glaze and refined the foreground flowers quite a bit.

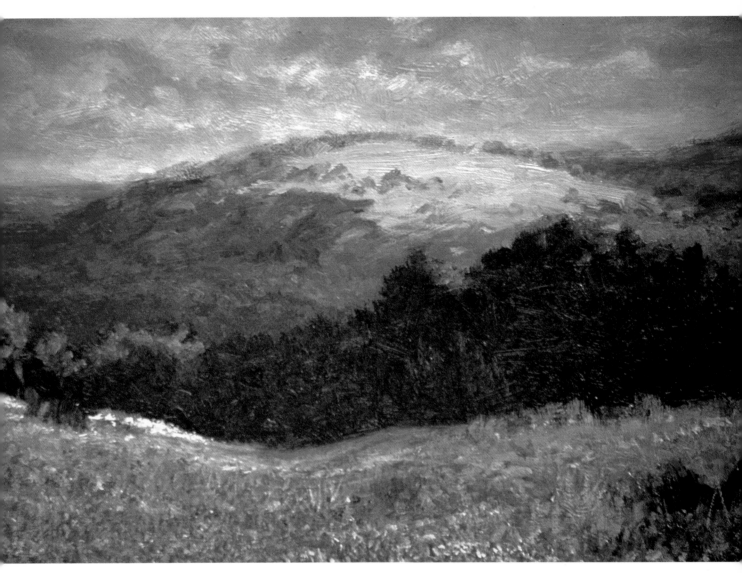

The cedar trees along the top of the hill are repainted with viridian, alizarin crimson, and cadmium orange. Grays of cerulean blue and cadmium red deep are lightly brushed here and there for dead branches. The sunlit areas of the cedars are touched with cadmium yellow light.

With colors listed on Day 1, I paint over some of the hills, using bluer and grayer, more atmospheric greens. I don't want to paint into the wet sky, so I will wait until tomorrow to paint the thin strip of hills up to the horizon line.

Day Three: Detail. I have repainted the cedars with viridian, alizarin crimson, and cadmium orange. I brushed in cadmium yellow light and white for the sunlight in the treetops and grays of cerulean blue and cadmium red deep for the dead branches. Notice how the hillside beyond the trees seems to recede now that it has been repainted with more atmospheric colors.

Day Four

The distant planes and hills are the areas of the painting that need to be refined first. I mix a bluish atmospheric color of ultramarine blue, flesh, and alizarin crimson, grayed when necessary with a bit of burnt umber. Different values of these blues are used for the most distant planes. I soften the area where the sky meets the hills by painting beyond the hills and brushing this area softly. I'm using a size 2 white sable bright and a size 6 sable round.

As I paint the nearer hills, I use darker values and begin to bring in greens: viridian, burnt umber, permanent green light, and raw sienna. For grayer greens, I add Naples yellow and flesh. I spend a great deal of time painting these very subtle color and value gradations, which help to give an illusion of great distance. Some areas are highlighted with warmer colors that are lighter in value as the sun pops through the clouds and touches the landscape.

I would like to emphasize that in most instances the effects of sunlight can make your landscape paintings much more interesting. Many people paint as if there isn't a sun in the sky, or as if it's always covered over with clouds. Sometimes a subtle, grayed effect is fine, but if you want your paintings to grab the viewer's attention, remember "the sun doth shine." To create this effect, you must learn to paint shadows dark enough to reveal the lights,

and paint the lights light enough to form a strong contrast with the darks.

The large hill is repainted with the greens, blues, and purples mentioned earlier and also with the raw sienna and cadmium red deep I used for the bare earth. The light side of the hill is touched with yellow ochre, cadmium red light, and white.

I scrub the cedars very lightly with the bluish atmospheric color I mixed earlier today, using a worn size 2 white sable (old, worn brushes work fine for this purpose). Then I move to the foreground area and begin the slow process of defining the flowers. I'm seeking a little more clarity of shape without getting too detailed. The mass of yellow flowers is too solid and needs to be broken up. To do this, I paint in more grass among the flowers. With burnt sienna and ultramarine blue, I apply the dark centers. The petals are then painted more clearly with little flicks of the brush.

I suggest a cloud shadow over the left edge of the field by painting in darker bluebonnets and grasses. This shadow complements the pattern in the field and prevents the eye from leaving the picture.

At this stage of the painting process, when I am refining what has already been stated, work goes very slowly. Many students hurry over this delicate phase of the work, but with a little patience and perseverance their paintings would be much better.

Day Five

There are many needed refinements to be done today. Basically, everything is there and the painting just needs some refining and adjusting. With a size 6 white sable round, I mix raw sienna and cadmium red deep for the earth; I darken the mixture with ultramarine blue, alizarin crimson, and burnt sienna. Using these mixtures, I deepen the shadow of the earth in the right corner. These darks are stroked up into the bluebonnets to form a more indefinite edge between dirt and flowers. Some darks are touched into lighter areas with the tip of the brush to suggest stones.

I quickly move on to the bluebonnets and bring a touch of light into the shadows for a more dappled appearance. I repaint the yucca plants with a dark of burnt umber, viridian, and raw sienna. The darkest darks are ultramarine blue and alizarin crimson, which are applied under the plant and on the shadow side. I paint only enough detail to identify the yuccas. Yellow ochre is used to

highlight these plants, and their cast shadows are painted also.

I work over the field with little stabbing strokes of various greens made of viridian, burnt umber, and raw sienna and permanent green light, cerulean blue, cadmium yellow light, and flesh. Grays made of cerulean blue, cadmium red light, raw sienna, and flesh are stroked in for the dead winter grasses.

I repaint the cedars with a size 6 white sable round, using the flattened end of the brush instead of the pointed tip. The greens are made up of viridian, alizarin crimson, ultramarine blue, and cadmium orange, and for this final work raw sienna is added to the mixture. Ultramarine blue and alizarin crimson are used to give the trees a more atmospheric haze. I paint lighter and grayer greens into the dark shadows of the cedars. To suggest their rugged character, I carefully rework the edge of the foliage for a more ragged look. Most of the trees are painted in

shadow to contrast with the sunlit field and distant hill. For the sunlit areas, I bring a touch of cadmium yellow light into the greens.

A small tree on the left is painted by indicating sparse green leaves. Limbs are suggestively painted into this foliage. I repaint the rocks with the same mixtures used in the dead grasses and stroke in a touch of earth red. For the dead tops of the yucca plants, I use burnt sienna and ultramarine blue for shadow and yellow ochre and white for light. I repaint the dead grasses on the right and bring them up over the bottom of the cedars, which helps to create more depth. Another yucca plant is painted on the right to fill an empty spot. I work back and forth between the grasses and flowers with the colors I used in the underpaintings. Yellow ochre and white highlight the dead grass. I clarify the forms of the yellow flowers by showing a stronger suggestion of petals and spot more dark centers onto the flowers. The shadow on the left side of the field is darkened.

I deepen cloud shadows on the large hill and some of the valley. A grayer and more bluish atmospheric color is painted over the distant hill. White and flesh highlight the distant area of bluebonnets. This lighter

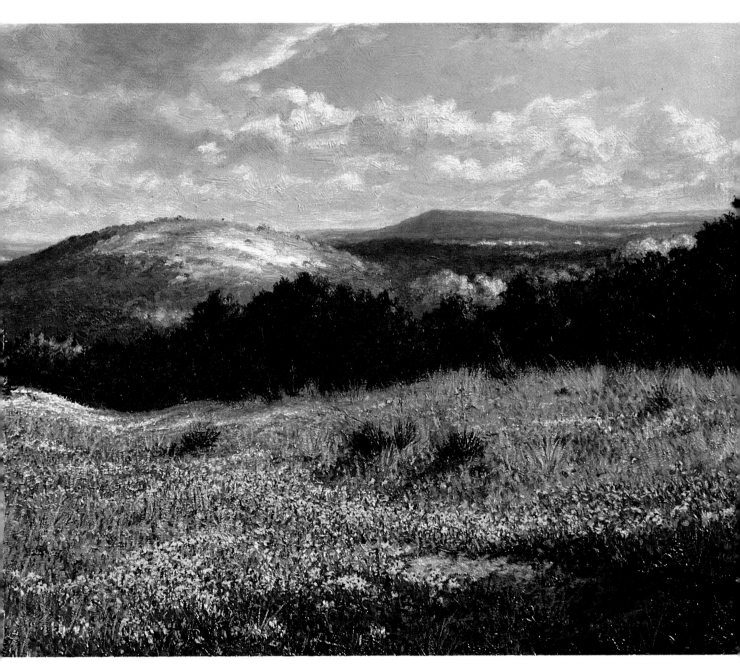

A TEXAS SPRING *Oil on canvas, 12" × 20" (30.5 × 50.8 cm), collection of Mr. J. Val Smith*

color highlights the other bluebonnets and brings them up a bit in light intensity. Cadmium yellow light, flesh, and white bring in the final lights for the yucca plants. The distant lights in the valley are heightened with Naples yellow and white.

With the same cloud colors I used in the underpainting, I paint a small shadowed cloud to the right of center. After viewing the painting as a whole, from a distance, I decide the lights of the bluebonnets need to be more intense. I use cadmium yellow light and flesh mixed with white to heighten the light that strikes the bluebonnets on the distant knoll at left. I sprinkle these lights over the tops of the dominant patterns of the bluebonnets.

The painting is now finished. I hope you can see how a painting is developed from a vague, casual underpainting through several steps to a sharper, clearer, more refined completed work.

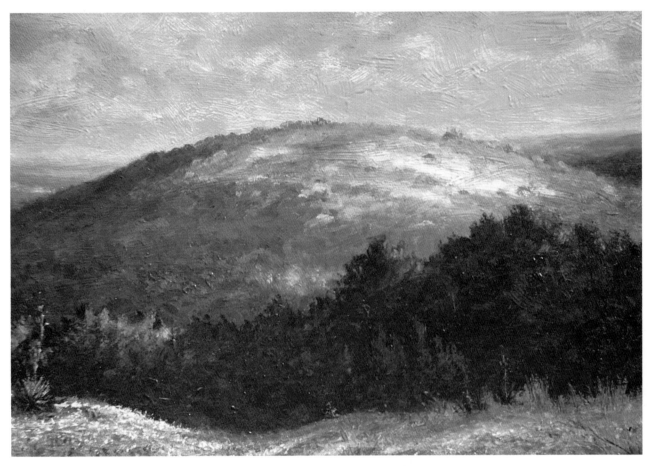

Day Five: Detail of finished painting. I have repainted the cedars once more, reworking the edge of the foliage for a more ragged look. I have added raw sienna to the mixture I used previously for this area; once again, cadmium yellow light indicates sunlight. The cloud shadows on the large hill have been deepened, but the effects of atmospheric perspective are still evident.

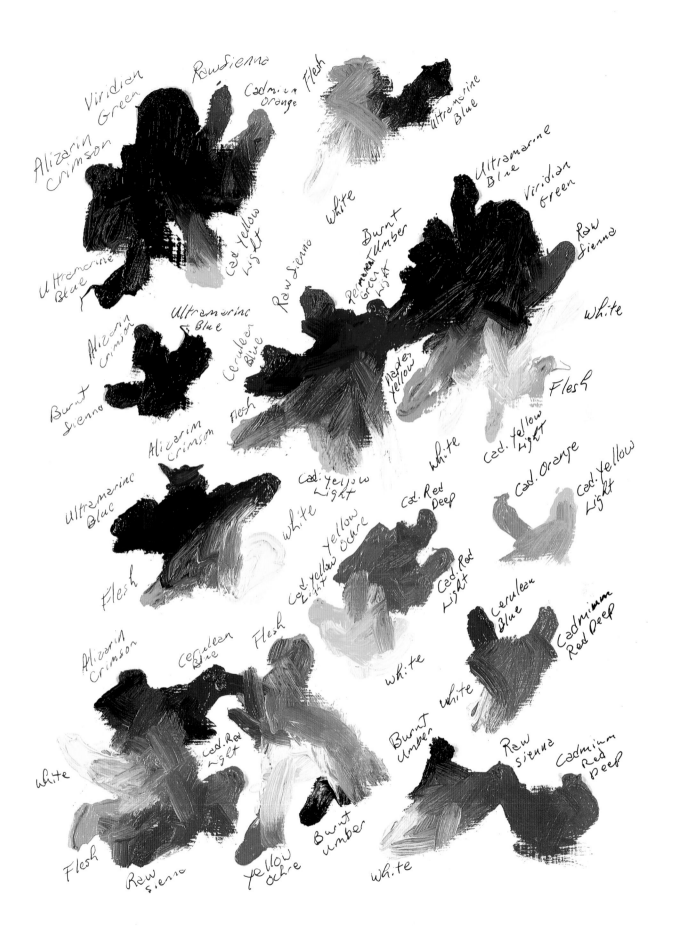

Viridian
Green

Alizarin
Crimson

Raw Sienna

Cadmium
Orange

Flesh

Ultramarine
Blue

White

Ultramarine
Blue

Viridian
Green

Raw
Sienna

White

Raw Sienna

Burnt
Umber

Permanent
Green
Light

Ultramarine
Blue

Ultramarine
Blue

Cerulean
Blue

Cad Yellow
Light

White

Flesh

Cad Yellow
Light

Alizarin
Crimson

Burnt
Sienna

Alizarin
Crimson

Maders
Yellow

Flesh

Flesh

Ultramarine
Blue

Flesh

White

Yellow
Ochre

Cad. Yellow
Light

Cad. Red
Deep

White

Cad. Yellow
Light

Cad. Orange

Cad. Yellow
Light

Cad. Yellow
Light

Cad. Red
Light

Cerulean
Blue

Cadmium
Red Deep

White

Alizarin
Crimson

Cerulean
Blue

Flesh

White

Burnt
Umber

White

Raw
Sienna

Cadmium
Red
Deep

Cad. Red
Light

White

Flesh

Raw
Sienna

Yellow
Ochre

Burnt
umber

White

Morning Dew

Early morning is a time of day that I enjoy—the cool temperatures, the dew-covered grass, and the gentle light. Many times I have observed the early morning sun burning through the fog, mist, and haze, and I have photographed and painted these transient moods of the morning. Several times I have passed by the meadow that I will use in this painting and observed the delicate beauty of the dew-covered grass. Sometimes there is a light morning haze; sometimes the scene is shrouded in fog. The air is damp and cool. The grass is wet. There is a quietness about this hour of the morning that I will attempt to capture in this painting.

I often see potential paintings like this when I am not prepared to paint. For times like these, it's good to have a camera available.

After stopping one morning and doing a quick sketch, I stopped again for some photos. The photo shown here will give you an idea of the place. The barn (which is out of the picture) is actually a modern metal building. I will paint it to appear older and borrow the hay bales, fence, and gate from another area. The mood will be a typical early morning as described above.

Compositional sketches for Morning Dew

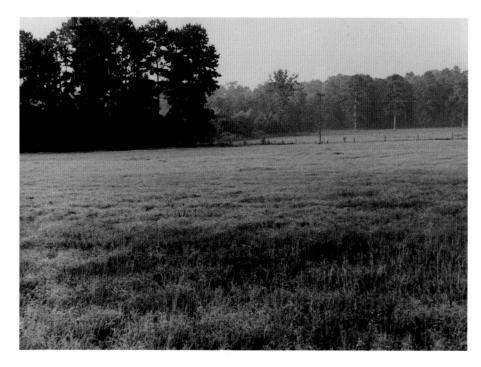

Reference photograph for Morning Dew

Day One

With charcoal, I divide the painting vertically at the pine trees and horizontally at the fence across the distant meadow. The division is similar to the golden section, in which the picture space is divided in a ratio of 1 to 1.618. Although I make no effort to follow this formula strictly, it does help in achieving a well balanced composition. I sketch in the trees, the design of the grass, the fence, hay bales, and barn. This is done, not with a hard outline, but with broad strokes of the charcoal.

After redrawing with turp and yellow ochre, I mix viridian, burnt umber, ultramarine blue, and raw sienna for the pines on the left. With big strokes of a size 5 bristle brush, I begin blocking in the basic colors and values. The trees are almost a silhouette; the fog obscures most of the different values as well as the local (actual) colors of the trees. I don't identify branches or even trees but paint them all as a mass.

Adding permanent green light to the mixture, I move over to the trees on the right. Using lighter values of color, I establish the distant trees. The sense of depth is achieved by lightening the values until the trees in the distance are shrouded in fog. There is no detail to this work as I'm only establishing an approximation of the colors, values, and designs.

With a size 14 white sable bright, I begin laying in the basic colors and values of the fog-covered sky. The colors are ultramarine blue, burnt sienna, and yellow ochre. The sky is cool with very little light. In a sky such as this, there is not as much warmth as there is in side lighting. Direct front light would be uninteresting because it eliminates most shadows. In this painting however, the sun is behind and to the left of the viewer, so the light is not direct front light.

I begin establishing the patterns and designs in the dew-covered grass, using mixtures of viridian and white; viridian and flesh; viridian and cadmium red light; cerulean blue and alizarin crimson;

permanent green light, raw sienna, and burnt umber; and permanent green light, raw sienna, and Naples yellow. These patterns will sweep the eye to the right, back to the hay bales on the left, and then to the barn. I stroke ultramarine blue, alizarin crimson, and raw sienna on the shadow side of the hay bales. The canvas is now about half covered.

Since I have established the basic colors and values throughout the picture, I now completely paint in the sky with the colors previously mentioned. For the sky showing through the fog, I mix cerulean blue with the gray used in the grass (viridian and cadmium red light) and brush this mixture on the upper left.

Then I go back to the trees and paint them in with soft gradations of values, without detail. Sky holes are painted into the pines with darker versions of the sky colors.

With a size 3 bristle flat, I paint in the barn using viridian and cadmium red light and a mixture of cerulean blue and cadmium red light. The shadow is ultramarine blue, alizarin crimson, and raw sienna. Yellow ochre indicates light on the barn. I use cerulean blue and alizarin crimson on the roof, with raw sienna and alizarin crimson worked in for rust. The fence posts and gate are painted with alizarin crimson, ultramarine blue, and raw sienna.

Using a size 4 bristle round, I continue working in the patterns in the grass with very loose mixtures of the colors listed previously. I also use viridian and Naples yellow; cerulean blue and cadmium red light; and the darks used in the trees. I concentrate on the patterns and not the individual blades of grass as I use vertical, diagonal, horizontal, and looping strokes. Naples yellow is used for the gentle light on the grass.

I paint the hay bales with darks of ultramarine blue, alizarin crimson, and raw sienna, with touches of the greens used in the grass. Yellow ochre indicates sunlight.

—Day Two

After the painting dries for a couple of days, I brush painting medium over the surface. Using a size 8 Langnickel royal sable and mixtures of ultramarine blue, burnt sienna, and a bit of yellow ochre, I repaint the fog-covered sky, working carefully as I mix and apply the subtle color and value gradations. The sky is painted slightly darker on the right because it is farther from the sun. Yellow ochre is added for more warmth on the left, nearer the sun. A small amount of cerulean blue is worked into the gray fog colors on the upper left as the sky shows through.

I drybrush the fog colors (ultramarine blue, burnt sienna, and white) over all of the trees to create soft transitional areas, and I paint more fog hovering right above the earth.

With a size 4 white sable bright, I very casually restate the dew-covered grass. The colors here are the same ones I used on Day

When painting a foggy morning, I make the edges of objects much softer than they would be on a clear day. Some objects are even obliterated, depending on the amount of fog. Scumbling the fog color over the picture surface will help achieve this soft effect.

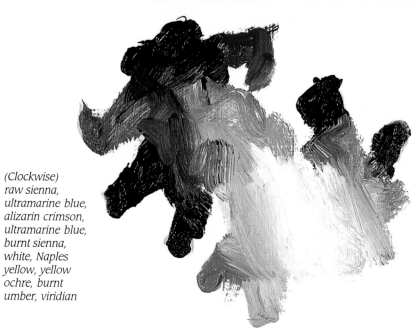

(Clockwise) raw sienna, ultramarine blue, alizarin crimson, ultramarine blue, burnt sienna, white, Naples yellow, yellow ochre, burnt umber, viridian

1. I am not painting details of the grass now but reworking the patterns created by the dew, the sunlight, and the natural design of the different grasses. I don't repaint the hay bales, fence, or gate. Instead, I scumble colors over them, leaving a vague image.

I repaint the barn and then stroke the gray fog color over it with a size 8 Langnickel brush.

By now, I have laid down a good foundation of the basic colors, values, and designs that will be evident in the final work. When this dries, I will begin the slow process of overpainting with layers of color until I get the desired degree of refinement. Underpainting and overpainting enhance the work, giving it depth and beauty that are sometimes missing in paintings that have only one layer of paint.

(Clockwise) burnt umber, viridian, permanent green light, white, alizarin crimson, cerulean blue, flesh

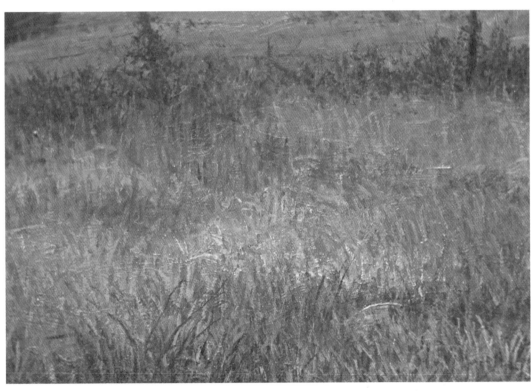

Grass grows at all kinds of angles, so when you paint it, don't line the blades of grass up like tin soldiers. Also, there is no need to paint every blade of grass; often a suggestion is sufficient.

Using the same colors and brush as on Day 2, I rework the sky. The very gradual transitions in value from left to right are carefully repainted in order to build up the depth of color. The transition of values in a sky such as this must be soft and gradual. In fact, the fog softens and obscures almost everything in the landscape.

I begin to restate the most distant trees with a size 2 white sable. These are painted mostly with the fog color and a touch of green derived from mixtures of viridian, burnt umber, ultramarine blue, raw sienna, and permanent green light. I work my way over to the right, gradually clarifying shapes as I pull the trees out of the fog by using more green in the nearer ones. All of the trees are greatly influenced by the fog color and most are painted in silhouette. I bring burnt sienna and flesh into the colors just listed. The edges of the trees are kept soft and indistinct. With a size 6 white sable round, I suggest a few tree trunks and branches using ultramarine blue, burnt sienna, and yellow ochre. The pines on the left are not repainted today.

I move on to the field and, with the colors I used on Day 1, casually rework the various patterns, using a size 2 white sable bright. In the lower left foreground, I begin more detailed work using a size 6 white sable round, twisting and turning the brush in various ways to paint the different directions in which the grass grows.

In the early stages of the painting process, I don't paint around objects. For instance, the fence, hay bales, and barn have been painted over, leaving an obscure image.

Roof:
(clockwise)
cerulean blue,
alizarin crimson,
raw sienna, white

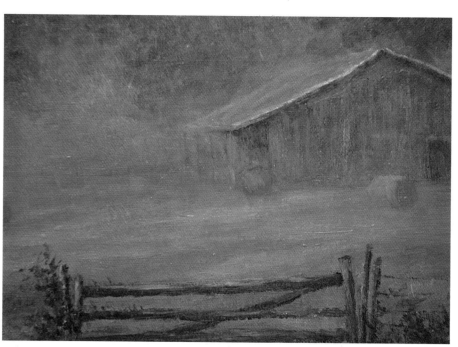

Barn:
(clockwise)
viridian, cadmium
red light, cerulean
blue, white, Naples
yellow, yellow
ochre, white

The barn was casually painted on Day 1 and restated on Day 2. On Day 3, I scumbled it with the fog colors to obscure it even more and to soften the edges. I reworked it on Day 6, then scrubbed fog color over it again on Day 7 and touched it with Naples yellow.

Day Four

I oil in the pine trees and the meadow. I rework the pines with a color mixture of viridian, burnt umber, and raw sienna and a mixture of ultramarine blue and burnt sienna, using a size 2 white sable bright. The designs and patterns formed by the trees against the sky are painted more carefully. No details are emphasized, as they are blanketed over by the fog. A touch of sunshine (more raw sienna) is worked into some of the pines. I brush darker versions of fog color into the greens as I redesign the sky holes. Tree trunks and limbs are stroked in with ultramarine blue and burnt sienna.

Work in the foreground grass, which I started yesterday, continues. The colors are permanent green light, burnt umber, and raw sienna; burnt sienna and permanent green light; viridian, permanent green light, and flesh; cerulean blue and cadmium red light; cerulean blue and alizarin crimson; and viridian and burnt umber. I use these various colors as I alternate between the darks and lights. I can use these dark-and-light patterns to lead the viewer's eye wherever I wish.

I use a size 6 sable round for this detailed work in the foreground, applying the paint with upward strokes in various curves and straight lines in different directions. Notice, at the lower edge of the painting, that the grass doesn't all enter the picture plane at the same height. I have seen some artists paint grass entering the picture straight and stiff and all the same height, but of course it would never happen this way. Grass enters the sphere of vision at various lengths and angles and is not lined up like a row of tin soldiers.

I repaint the distant meadow very delicately with scumbles of the lighter blues and greens. The strokes here are more horizontal. Naples yellow is used in the sunlit passages.

With a worn size 4 white sable, I scrub the lower part of the distant trees with fog color.

Day Five

I continue working with the well-worn size 4 white sable as I scrub the fog color over the pines. The pines are obscure but not completely hidden; I permit colors underneath to show through by allowing very little paint on the brush. I use more paint as I scrub in the heaviest concentration of fog just above the ground.

With the colors used previously and a size 6 white sable round, I resume work on the foreground grass, weaving the various patterns into the grass to lead the eye to the gate, then over to the hay bales, and on to the barn. Different values are worked against each other in order for these patterns to register. I lay in some darker values, then come in with lighter values, or vice versa. I apply the paint in small strokes, and the work goes very slowly. I'm not attempting to create a photographic image, but I am trying to capture a poetic, artistic interpretation. My goal is to capture the feeling of a wet meadow in the morning, as if you would get your feet wet if you stepped into the grass.

This foreground field of dew-covered grass will be the most detailed part of the picture. Into the colors already listed, I stroke in raw sienna and burnt sienna to suggest dead grass and Naples yellow to suggest the subtle morning light.

I repaint the gate with a mixture of cerulean blue and cadmium red deep and a mixture of ultramarine blue and burnt sienna, then pull the grass back over the bottom section. The fence is restated softly as I change the placement of some of the posts. Taller grass and bushes are suggestively painted along the fence row. I use the same greens as before, along with viridian, burnt sienna, and cadmium yellow light. Morning glories are indicated on the fence with cerulean blue and alizarin crimson.

Day Six

I brush painting medium over all the canvas except the foreground grass and immediately begin repainting the bales of hay with ultramarine blue, alizarin crimson, and raw sienna; ultramarine blue and burnt sienna; and touches of green from mixtures of permanent green light, burnt umber, and raw sienna. I paint the near bales and indicate the placement of the others, then go back and refine, change positions, and lighten values. It's easy to mistakenly paint the bales smooth and round like barrels. But they aren't perfectly round—they collapse somewhat after being baled and sit on the ground with flattened bottoms. Also, it is evident where the hay has been rolled by the marks on the side and end.

I realize that I've painted too many hay bales, so I stand back and, stretching out my arm, hold my index finger over certain bales to determine which ones to eliminate. I wipe off a couple of the larger ones that were painted on the first day and restated today, then repaint these areas. Several of the smaller bales are also eliminated. The field is now lightly scumbled over with colors used previously.

The barn is painted again, but it is still left obscured. I restate the bush on the left with viridian, burnt sienna, and permanent green light and a mixture of ultramarine blue and alizarin crimson, using a size 6 white sable round.

With a size 2 white sable bright, I restate the patterns of the tree on the right. Fog color is scrubbed over parts of the trees and distant meadow with a size 4 white sable bright. With the same brush, I lightly scrub yellow ochre mixed with fog color over the left part of the sky.

Day Seven

I brush painting medium over the entire picture. With a size 2 white sable bright, I very softly repaint the hay field. The colors I use are permanent green light, viridian, alizarin crimson, and cerulean blue; viridian and cadmium red light; and permanent green light, viridian, and flesh. I apply the colors very lightly as now is the time to just barely touch the brush to the canvas. Fog colors are worked in and edges are softened. I subdue the light on the meadow with viridian, cadmium red light, and Naples yellow, then restate the light very softly with Naples yellow and flesh. More light and texture are suggested on the larger hay bales.

I scrub fog (ultramarine blue, burnt sienna, and white) rising off the distant meadow. The fog is hovering above the ground, and as it rises into the air, it is blown by the wind and looks like smoke. Edges are very soft. I lightly scrub this fog color over most of the pines and distant trees and obscure the barn even more by scrubbing this color over it.

Using the same scrubbing technique, I indicate clouds rising and breaking away at the top of the picture. Subtle value changes occur in the sky as I suggest more clouds.

I rework the vines and grasses on the fence and lightly scumble in the wire again. I paint more morning glories from memory; I have observed them while driving. Also, there are some behind my studio.

Naples yellow strengthens the light on the barn and hay bales. The tree trunk on the right is painted more distinctly, and a fence in the far distance is barely indicated. The painting is now finished.

Burnt Umber
Viridian Green
Raw Sienna
Burnt Sienna
Ultramarine Blue
Ultramarine Blue
Yellow Ochre
Permanent Green Light
white
white
Cad. Red Light

Viridian Green
Flesh
Viridian Green
Cerulean Blue
White
Raw Sienna
Permanent Green Light
Alizarin Crimson
Ultramarine Blue
Naples Yellow
white
Naples Yellow
Burnt Umber

Yellow Ochre
Cad. Red Light
Cerulean Blue
Cad. Red Deep
Raw Sienna
Raw Sienna
Naples Yellow
Burnt Sienna
Viridian Green
Cad. Yellow Light
white

Permanent Green Light
Viridian Green
white
Burnt Sienna
Naples Yellow
Flesh
Cerulean Blue
Permanent Green Light
Ultramarine Blue
White
Alizarin Crimson
Alizarin Crimson

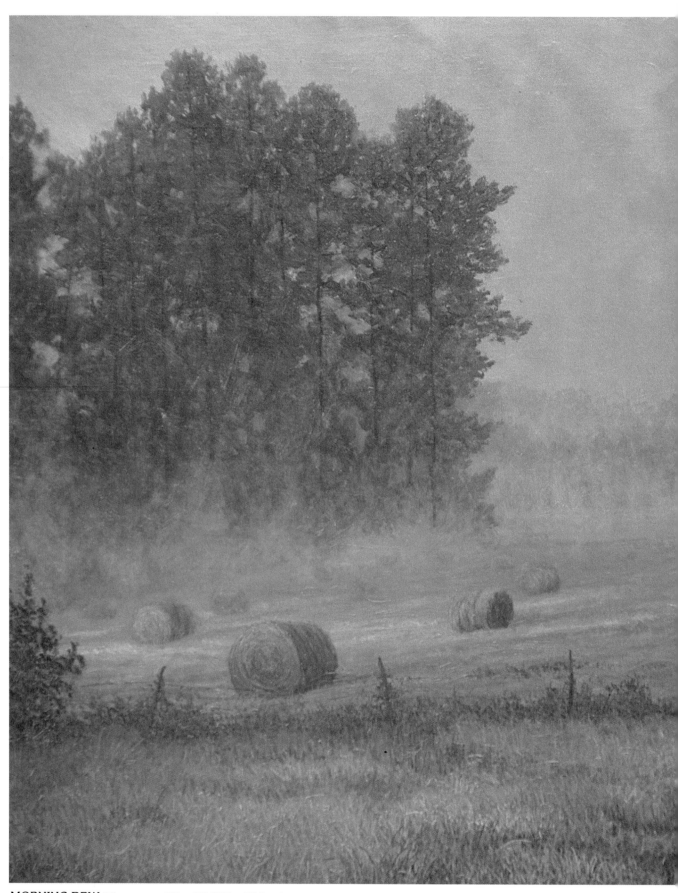

MORNING DEW *Oil on canvas, 18″ × 30″ (45.7 × 76.2 cm)*

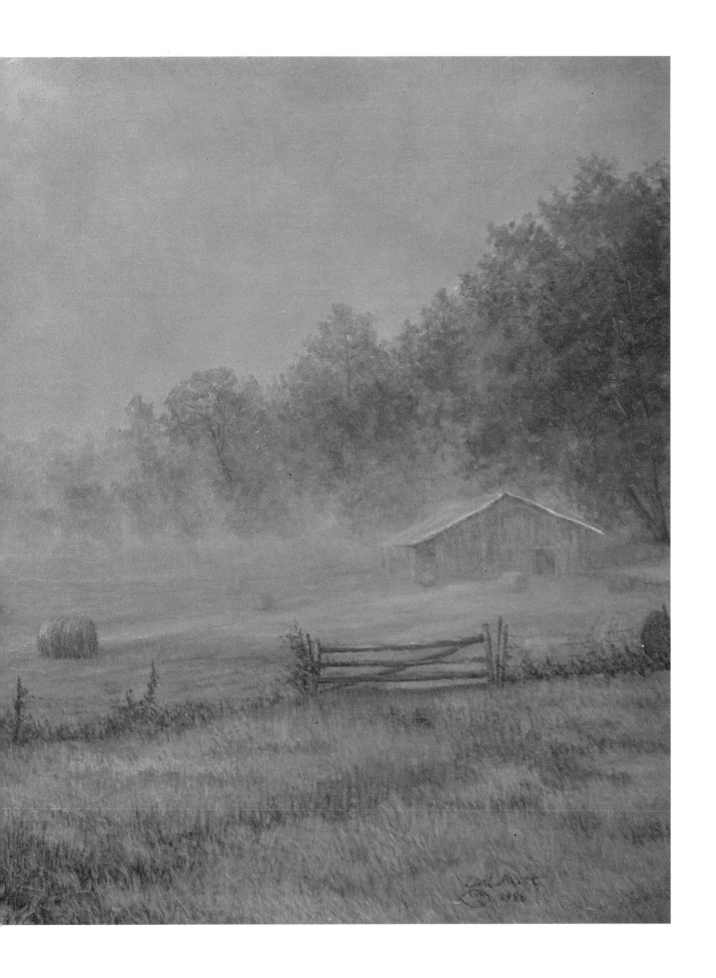

After an Evening Rain

I got the idea for this painting after a shower one winter evening, as the sun was breaking through the clouds; the atmosphere was laden with moisture and presented some interesting effects. I did not do any sketching, but I did take some photos. I will be working mostly from one of the photos, plus my imagination, memory, and experience.

As usual, I visualized what I wanted and experimented with several compositional ideas, one of which is shown. I wasn't satisfied with any of these, but I did like the backward S or question-mark design formed by the road and clouds; consequently, this will be used and modified to eliminate too many horizontals. To help relieve the straight-across look of fence, hill, and trees, and to give the painting more depth, I will paint the fence going from the foreground to the background and the distant trees disappearing behind the foreground ridge.

This is one of those mood paintings where a unifying atmospheric color can be used throughout. In this case it will be a warm gray that I mix by adding cadmium orange and flesh to a light gray composed of black and white. The black used in this painting is made from ultramarine blue, burnt sienna, and alizarin crimson.

This compositional sketch is one of many small sketches I did to help develop my concept for the painting.

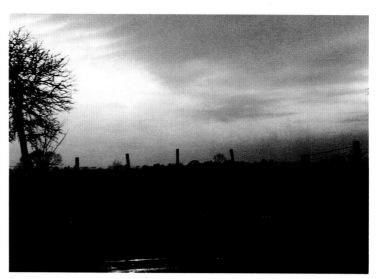

Reference photo for After an Evening Rain.

—Day One—

After sketching the patterns formed by the sky, road, hill, and trees, I outline the drawing with turp and yellow ochre. Using a size 5 bristle flat and combinations of black, ultramarine blue, and cadmium red light, I begin to block in the large triangular cloud shape. I work freely and spontaneously as I brush on the first underpainting with a variety of brushstrokes. No painting should be painted like a flat wall. A size 3 bristle flat is used for the lighter portion of the sky. The lighter the value, the thicker I apply the paint. Naples yellow, cadmium orange, flesh, and yellow ochre are worked into a gray of black and white for these lighter values. Naples yellow and white are brushed in for the sun and the light area around it. Below the sun, this color goes into a peachy gray consisting of cadmium orange and flesh worked into a gray of black and white.

The basic shape of the tree is lightly indicated with black and cadmium red deep, along with the light colors from the sky. The trunk and a few branches are brushed in before the sky is entirely covered. The brushes used are a size 5 bristle flat and a size 1 bristle flat. I then go back with the sky color and completely cover this area.

I paint in the distant trees, using these same sky grays with more atmospheric blue. Then I proceed to paint the foreground area using the very same colors and mixtures of ultramarine blue, alizarin crimson, and raw sienna; ultramarine blue and burnt sienna; viridian and yellow ochre; and cadmium red deep and raw sienna. I use a size 4 bristle flat for this and work in more texture for the rough field and road. The grasses are brushed in broadly with no attempt at detail. Trickles of water are indicated and the fence posts are casually painted. After viewing the painting in a frame, I make a few more adjustments and then set the canvas aside so the paint can dry.

—Day Two

I mix a light gray of black and white, then add cadmium orange and flesh. This will be used as the atmospheric color throughout the painting and to lighten colors instead of white.

I brush medium over the entire painting. With a size 8 Langnickel sable, I rework the sky, using the same colors as on Day 1, with the addition of cadmium yellow light. I develop the patterns more, and this reworking also helps build up the paint strata, which adds to the beauty and depth of the finished work.

Immediately around the sun, in the lightest area, cadmium yellow light is worked into Naples yellow and white. At the top this gives way to yellow ochre. The area below the sun is painted with more orange (cadmium orange and flesh worked into the atmospheric color).

I restate the distant trees with a size 4 Langnickel brush without going into detail. The foreground field and road are then repainted loosely, the paint scrubbed on with the side of a size 6 white sable round. The patterns are gradually taking a more definite shape. I try to retain these large masses as I work into them with more detail.

Sky:
(clockwise)
ultramarine blue,
flesh, yellow ochre,
cadmium orange,
Naples yellow,
atmospheric color
(black, white,
cadmium orange,
flesh), cadmium
red light, black
(ultramarine blue,
burnt sienna,
alizarin crimson)

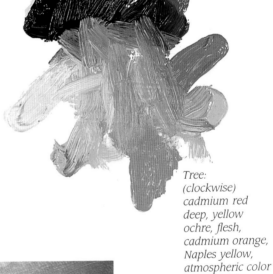

Tree:
(clockwise)
cadmium red
deep, yellow
ochre, flesh,
cadmium orange,
Naples yellow,
atmospheric color
(black, white,
cadmium orange,
flesh), black
(ultramarine blue,
burnt sienna,
alizarin crimson)

I hope this detail will give you a better idea of how I paint trees in winter. I scrub the masses in with an old brush, then pick out limbs and twigs with a size 6 white sable round. I drag the brush across the canvas to get broken lines and work into the trunk and limbs with short, stabbing strokes. With these techniques, I create the appearance of thousands of small branches without painting each individual twig.

This picture is held together by repeated colors and by an atmosphere that envelops the scene. A light gray of black, white, cadmium orange, and flesh is used in every mixture that needs to be lightened. Edges are kept soft in the evening mist. The softness of the sky is achieved by overlapping edges; I brush the darks into the lights and the lights into the darks for a soft transition and an indefinite edge. The crisp edges of the geese make them stand out against the sky.

Observe the effects of aerial perspective on the geese as well as on the landscape. Those nearest the viewer are more detailed. The more distant ones become less defined and get lighter in value until they are not much more than specks.

(top row, left to right) black (ultramarine blue, burnt sienna, alizarin crimson), cadmium red light, ultramarine blue

(middle color) atmospheric color (black, white, cadmium orange, flesh)

(bottom row, left to right) cadmium orange, flesh, Naples yellow, yellow ochre

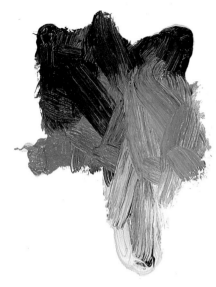

Geese:
(clockwise) black (ultramarine blue, burnt sienna, alizarin crimson), ultramarine blue, atmospheric color (black, white, cadmium orange, flesh), cadmium red light

I indicated the placement of the geese with vague gray shapes. After the positions were determined, I went back with lights and darks and enough details to identify them as geese. I suggested feathers without trying to paint them all.

Notice the brushmarks of the underlying sky showed through the geese. I didn't paint around the geese but rather painted the geese over the sky.

Day Three

Using the same color mixtures as before, I continue to refine the sky, using a size 6 white sable bright and a size 8 Langnickel royal sable. I paint the delicate shades of color and keep the edges very soft. Lighter colors are brushed over darker ones and darker over lighter to achieve a soft effect. I don't just paint up to the edge of a shape and stop; I overlap for softness.

I restate the background row of trees and paint the grove of trees on the right in more detail while indicating some trunks and branches. The brushes I use are a size 2 white sable bright and a size 6 white sable round. In the little remaining time, I rework some of the grass. This work will continue tomorrow, and if the sky dries, I hope to paint in the large tree.

Day Four

Black, cadmium red deep, and ultramarine blue are scrubbed on for the mass of the large tree with a size 6 white sable round. I keep old worn-out brushes for this purpose. Using a good size 6 white sable round, I work back into this mass to indicate limbs and twigs. I like to drag or scumble the paint to get broken lines. Too oily a medium or too slick a surface would result in a continuous line that would be too stiff-looking. The textured underpainting enables me to scumble colors on, just touching the top layer of paint and allowing the colors underneath to show through.

I also work into this mass and over the limbs with short, stabbing strokes. The beginning and end of most limbs are not shown. I don't try to paint all the limbs, even though it may seem that I do. Cadmium orange and flesh are stroked in among the branches for a sunlight effect. Work on the tree takes most of the day. The smaller trees and bushes at the base are painted next. The posts of the fence are brushed in, with a slight indication of wire. I finish the day's work by doing some work on the field.

Day Five

With a size 6 white sable round, I work in the grasses, dirt, and road, developing patterns to lead the eye into the painting. The paint is scrubbed on and some blades of grass are indicated. Trickles of water are worked into the field and the road. These are reflections of the sky colors. The bushes and small trees around the large tree are unsatisfactory, so I remove one and paint over the rest. (Paint that isn't thoroughly dry can be easily removed by brushing it with medium and scratching it off.) I narrow the trunk of the tree by about an eighth of an inch by painting over it and then restating the side of the tree.

At this point, I decide to add geese departing from beyond the hill. I use a good size 6 white sable round for the detail after painting in the basic shapes with a worn size 6 round. In this situation, the geese will acquire the colors of their environment. Five geese are painted; more may be added later.

Day Six

All the other geese are added now. First, I paint in a gray shape where each goose will be placed. This is a suggestion of a bird for placement purposes only. When I am satisfied with their placement, I go back and define the shapes more and refine the different colors and values. I soften some of the geese by touching my finger to the surface and removing some of the paint.

I work on the sun with a size 2 white sable bright, using Naples yellow, cadmium yellow light, and white to lighten both the sun itself and portions of the surrounding area. This same color is used to indicate a faint ray of light emanating from the sun. The wispy clouds are darkened somewhat.

I scrub a blue-gray over the entire field and distant trees. The tree at the far right is painted. Lights are heightened here and there. The wire fence is painted in on the left; it is only suggested, as the colors are lost in the evening mist. I give the large tree trunk a finishing touch with lights from the sky and glaze the area below the sun with cadmium orange and flesh. A darker gray is glazed over a small section at the top of the sky near the center.

After the first underpainting, the gray atmospheric color was used to lighten colors. White was used only in the lightest part of the painting—the sun and the surrounding area.

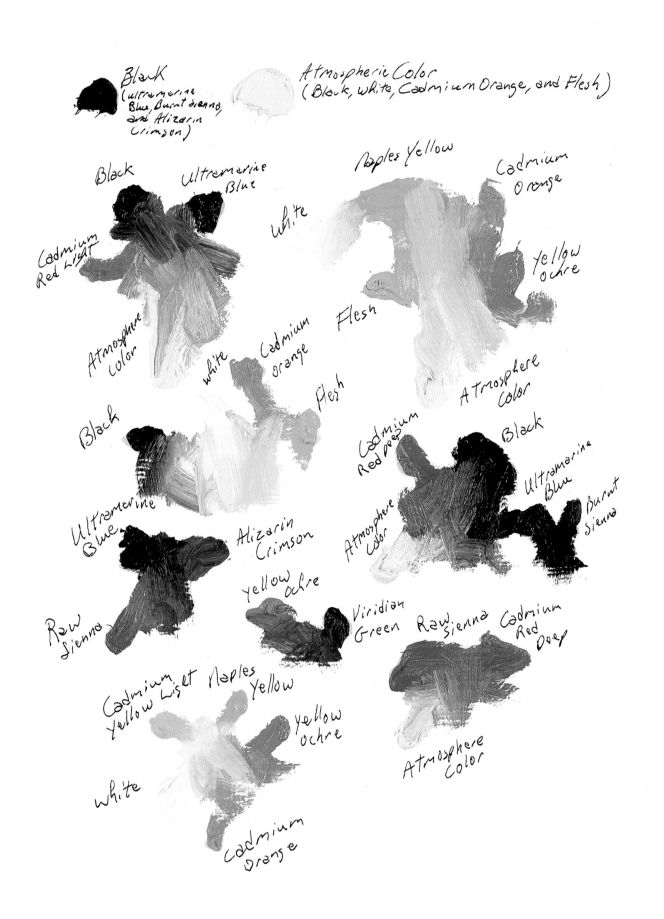

Black
(ultramarine
Blue, Burnt sienna,
and Alizarin
Crimson)

Atmospheric Color
(Black, white, Cadmium Orange, and Flesh)

Black Ultramarine
 Blue

Naples Yellow Cadmium
 Orange

White

Cadmium
Red Light

Yellow
ochre

Atmosphere
Color

white Cadmium
 Orange

Flesh

Flesh

Atmosphere
Color

Black

Cadmium
Red Deep

Atmosphere
Color

Black

Ultramarine
Blue

Burnt
Sienna

Ultramarine
Blue

Alizarin
Crimson

Yellow
Ochre

Viridian
Green

Raw Sienna Cadmium
 Red
 Deep

Raw
Sienna

Cadmium
Yellow Light Naples
 Yellow

Yellow
ochre

Atmosphere
Color

White

Cadmium
Orange

AFTER AN EVENING RAIN
Oil on canvas, 22" × 28" (55.9 × 71.1 cm),
collection of Mr. Travis A. Taylor

Autumn at Bear Creek

The outdoor painting *Spring at Bear Creek* is the basis for the studio work I'm now planning. The painting was done in early spring, but as you will see, I will change the season to autumn. I wanted to include a painting of a stream in this book, and this outdoor work provides the opportunity. I will be working mostly from memory and imagination, with very little photographic help.

My concept is to paint a hazy autumn morning with the center of interest being the old oak tree and the stream. The lighting will be similar to that in the outdoor work, with the sun illuminating the distant bank and trees. The trees on the left and most of the water will be thrown into shadow. Diffused light will keep the contrasts soft in this painting; the area of greatest contrast will be the oak tree. The sky will have an influence on the landscape, but I will paint it in a subdued manner so as not to upstage the center of interest.

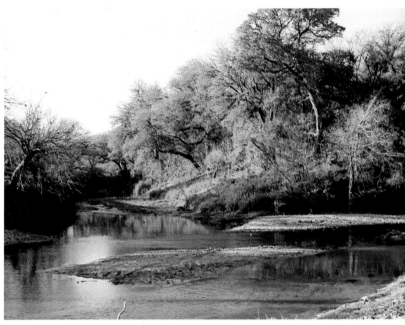

Photo of Bear Creek

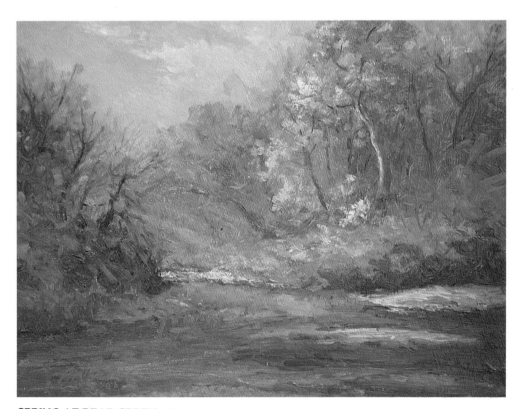

SPRING AT BEAR CREEK *Oil on mat board, 9" × 12" (22.9 × 30.5 cm)*

I did this painting on location in early spring. For the studio painting, I will use photos, memories, and experience to transform the scene from spring to autumn.

—Day One—

I'm working on a light-value toned ground made of yellow ochre and white, as described in Part I. I sketch the main shapes and designs with charcoal and then redraw them with raw sienna and turp. The darker color must be used in order for the drawing to be visible on the toned ground. This raw sienna and turpentine drawing is shown in the illustration.

Using a size 3 bristle flat and mixtures of ultramarine blue, alizarin crimson, and raw sienna, I begin blocking in the dark, shadowed creek bank on the left. I move over to the right bank and the trees in shadow and establish their base colors and values with the same dark colors, which I also stroke into the water. Cerulean blue and cadmium red deep are brushed into the left bank. I brush purples (ultramarine blue and alizarin crimson) and some cadmium orange and burnt sienna into the trees on the right. I also brush cadmium red light and yellow ochre, lightened with cadmium yellow light, into the large tree. Greens made up of viridian, burnt umber, permanent green light, yellow ochre, and cadmium yellow light are stroked into the trees and water.

Using a size 5 bristle flat, I paint the sky with cerulean blue, cadmium red deep, and yellow ochre. A bit of alizarin crimson is added on the right. These colors are brushed down into the tree area. The value is lighter and warmer on the left side of the sky, which is nearer the sun.

Darks mixed from ultramarine blue, alizarin crimson, and raw sienna and from cerulean blue and cadmium red deep are stroked on the small islands with a size 1 bristle flat. Mixtures of yellow ochre and flesh and mixtures of cadmium yellow light and flesh are used in the light passages. Sky and tree colors are stroked into the stream with a size 3 bristle flat. At this stage, I stop to photograph the half-completed underpainting.

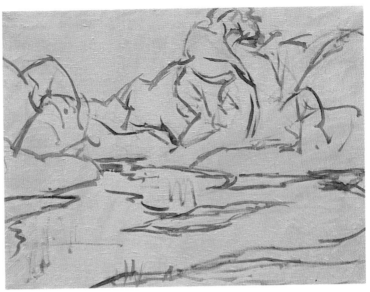

Day One: The raw sienna and turpentine drawing. I usually outline the charcoal drawing with yellow ochre, but it's too light a color to register on the toned ground, so I used raw sienna instead.

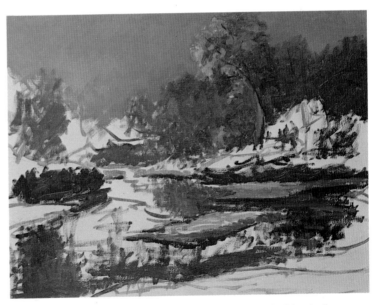

Day One: The half-completed underpainting. I begin blocking in the major shapes. Mixtures of ultramarine blue, raw sienna, and alizarin crimson and mixtures of cerulean blue and cadmium red deep are used for both banks, the distant trees, and the small islands. I brush various greens, yellows, and oranges into the trees. The sky is painted with cerulean blue, cadmium red deep, and yellow ochre, with a bit of alizarin crimson added on the right. I stroke sky and tree colors into the water to indicate reflections.

I resume painting, alternating between the trees, water, rocky islands, and the foreground area. The greens mentioned earlier are brushed into the trees and water along with grays composed of cerulean blue and cadmium red light. An atmospheric mixture of flesh and ultramarine blue is brushed into the trees. The trees on the left are painted with the same colors used in the dark creek bank — a mixture of ultramarine blue, alizarin crimson, and raw sienna and a mixture of cerulean blue and cadmium red deep. Autumn colors are suggestively painted into this. The dark, rocky shore on the left is also painted with these dark colors, and an additional dark of burnt sienna and ultramarine blue is used as needed. I paint these rocky areas with a size 1 bristle, dragging it horizontally and turning it between my fingers as I apply the paint roughly. The end of the brush is used to dab on the paint to suggest small rocks.

Sky colors are brought down into the water as it runs over the rocks in the distance. The sunlit rocks are composed of raw sienna and flesh. I suggest rocks in shadow with the same darks I used elsewhere. The water is now completely painted. My strokes are casually applied horizontally and vertically, using broken colors reflected from the sky and trees. Grasses are vaguely suggested on the near shore. Darks mixed from ultramarine blue and burnt sienna and from cerulean blue, cadmium red deep, and burnt umber suggest the tree trunks and limbs.

The canvas is now covered. A foundation has been established on which to work. I am dissatisfied, however, and major changes may follow in the days ahead.

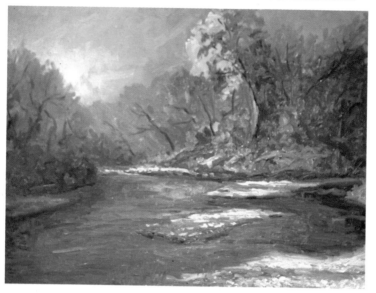

Day One: The completed underpainting. I continue painting with the same colors until the canvas is completely covered. The underpainting is now complete, but I am dissatisfied with what I have established and will make major changes in the days ahead.

—Day Two—

I have decided to change the sky from clear to overcast and the time of day to an earlier hour. The painting will be done in a style similar to that of the nineteenth-century American landscape artists. The atmosphere will be heavier than I had originally planned and will greatly influence the color of the picture. I oil in the painting with medium and begin these revisions.

I mix ultramarine blue and cadmium red light to obtain a dark purple, then gray it with Naples yellow, a complementary color. Using a size 8 Langnickel royal sable, I brush some darks on the right side of the sky. I stroke a lighter value to the left of the main tree, then a still lighter, more golden color on the left side of the sky. This establishes the basic values and colors I will use. I begin painting these colors over the bluish underpainting that was done on Day 1. Cloud formations are very softly suggested. A purple with less Naples yellow in the mixture is painted in above the trees left of center. Cerulean blue grayed with cadmium red light indicates some sky showing through the clouds near the top of the picture.

With a size 3 bristle flat, I bring these sky colors down into the water. They are not painted solid, but are done in a broken manner along with the tree reflections. I work over the dark bank on the left with the colors I used on Day 1. A green mixed from viridian, alizarin crimson, and cadmium yellow light is touched into this. I work back and forth between the trees and the water, basically restating what I did the first day, covering the canvas with a second, freely executed underpainting with no detail. Color mixtures are the same as the ones I used on Day 1 except for the sky and its reflection in the water.

The sky has been brushed over the upper portions of the trees, so I don't repaint them now. I also do nothing to the near shore and the islands, as they were thickly painted on the first day.

Today's work is done very quickly since I am not getting involved in detail at this point. My goal is to always have a clear concept before beginning a painting. However, if changes are to be made, it's best to make them during the early stages.

Day Three

Today I will continue the revisions that I'm making in the sky. These will affect the entire painting. The sky is not just a colored background for the landscape. The sky lends its colors to the earth as it reaches down and envelops the land.

I begin with the same colors I used yesterday (ultramarine blue, cadmium red light, and Naples yellow) and the size 8 Langnickel royal sable. Starting with the darker color on the right, I work my way over toward the left. I apply the colors a shade darker and soften the edges of the cloud patterns. The paint is again brushed over the treetops. I am keeping the sky very subdued because the trees and water will be the center of interest.

Work is now begun on the upper central area of the stream. Even though the trees are not finished, I know the colors they will be reflecting. The water is flowing, so the reflection will not be a mirror image. All the colors used above the water will be repeated in the water—ultramarine blue, alizarin crimson, and raw sienna; cadmium orange,

burnt sienna, cadmium red light, and yellow ochre; ultramarine blue, cadmium red light, and Naples yellow; cerulean blue and cadmium red deep; and viridian, burnt umber, permanent green light, and raw sienna.

I capture the movement of the water by applying the paint in small, choppy, horizontal strokes. Bits and pieces of the colors are applied by working color into color. I begin this work with a size 6 white sable flat, then change to a size 6 white sable round. Occasionally I brush color downward in vertical strokes. I don't paint a definite reflection of anything but break up the reflections to show the water's movement. Reflecting water is similar to a mirror. When the water is still and calm, the reflections are clear, as in a mirror. But if the calmness of the water is disturbed, there will be broken reflections similar to those in a broken mirror.

I change the rock formations across the stream into a small dam with a waterfall. Most of the water here is in shadow; it

Day Three:
In order to change the sky from clear to overcast, I go over the bluish underpainting with mixtures of ultramarine blue and cadmium red light, grayed with Naples yellow. For the sky that shows through the clouds at the top of the picture, I use cerulean blue grayed with cadmium red light. As I brush these mixtures over the sky, I let them cover parts of the treetops; these areas will be restated later. I also brush the sky colors into the water.

repeats cool colors from the sky but is highlighted with the warm sky colors. I decide to make this area the center of interest, with the oak tree playing a supporting role.

Next, I restate the area of water on the right, using dark colors reflected from the trees. When water is flowing like this, it can carry reflections in broken pieces for a long way across its surface. In between pieces of the reflection of an object there are the reflections of sky, trees, or whatever is above or behind the water. Some of these reflections are painted by pulling the brush downward in a zigzag manner.

The water in the center and at left is now repainted with the same concept and technique. Burnt umber and raw sienna suggest wavy patterns of sand seen through the water. The rocky distant shore is repainted with the same colors that I used before.

—Day Four—

I increase the golden glow of the picture by mixing a small amount of raw sienna with painting medium and brushing this over the painting. The mixing is done right on the palette by dipping the brush into the paint, then into the painting medium. I scrub this around on the palette until I get the desired consistency and color. This glazing effect can be seen most clearly on the sunlit shore in the foreground.

Using a size 2 white sable flat, I begin work on the dominant tree. I'm working with a mixture of burnt sienna with cadmium orange and a mixture of cadmium red light and yellow ochre. Purples and grays from the sky are touched into the leaves. I work on down the row of trees, painting in sky colors and grays mixed from cerulean blue, cadmium red light, and yellow ochre. Also, I add touches of green—viridian, burnt umber, raw sienna, permanent green light, and cadmium yellow light. Into this I work darks of ultramarine blue, alizarin crimson, and raw sienna. With the size 6 white sable round, I suggest tree trunks and limbs in the mass of foliage, using mixtures of cerulean blue, cadmium red deep, and burnt umber and burnt sienna and ultramarine blue.

With a size 4 Langnickel royal sable, I go back to the foliage and refine the various patterns. I work back over the large tree and the mass of trees to the right. The designs painted the first day are restated and refined. As I work, I am aware of the light coming in from the left, and I develop the foliage with the right side of the trees in shadow and the left side in light.

Grays derived from the sky colors of ultramarine blue, cadmium red light, and Naples yellow, and cerulean blue mixed with cadmium red deep, are brushed into the trees on the left shore. The crooked tree is restated with a mixture of ultramarine blue and burnt sienna and a mixture of ultramarine blue, alizarin crimson, and raw sienna, using a size 6 white sable round. I dash in the rugged shapes of the trunk and limbs with little flicks of the brush, suggesting the limbs without trying to outline each one. Two other trees are suggested in the background. The shadowed bank is reworked with a size 2 white sable bright, using the same darks mentioned previously. I don't try to identify "things," but keep the forms very generalized, as this area is very subdued.

Day Five: From Day 4 on, I begin painting each day by oiling in with a raw sienna glaze; this gives the whole painting a golden glow.

I restated the trees on Day 4. Today, I repaint the sky with a grayed purple mixed from ultramarine blue, cadmium red light, and Naples yellow, scrubbing this mixture over the most distant trees and brushing it lightly over the near ones. Then I rework the trees again, using the end of an old size 2 white sable bright to dab on oranges, yellows, and brown in a suggestion of leaves.

Day Five

I oil the entire painting in again with the gold-tinted glaze. In my efforts to play down the sky, I have made it uninteresting; today I will correct this situation as I intensify the sunlight without distracting from the stream.

Ultramarine blue, cadmium red light, and Naples yellow are mixed to produce a grayed purple, which I scrub over the most distant trees with an old size 2 white sable. I begin repainting the sky with a size 6 white sable bright. The purple at the lower part of the clouds is grayed and darkened with this combination of primary colors, and the same mixture is lightly brushed over the edges of the trees. The sky is painted more golden, using almost pure Naples yellow. The other cloud patterns are redesigned and stated more strongly. The darker clouds to the right are painted more purple, and the light is painted lighter in value. I paint the clouds over parts of the large tree, altering its design.

With Naples yellow and cadmium orange, I softly restate some of the foliage. The grays are darkened with the sky mixture, and the tree limbs are also repainted with a dark version of the sky colors. I'm working very gently as I touch the tattered end of an old size 2 white sable bright to the trees to create the impression of leaves. Cadmium red light, yellow ochre, cadmium orange, and burnt sienna are also used.

I use a size 4 Langnickel royal sable on the large tree, along with the worn size 2 white sable, as I rework the light-and-dark patterns. Sky colors are worked into the foliage. Ultramarine blue, alizarin crimson, and raw sienna are used in the shadows. I suggest leaves by stippling the paint onto the canvas and rework the dark, shadowed trees on the right. The green bush is painted in the same manner, using viridian, burnt umber, permanent green light, and raw sienna. Autumn colors are worked into this.

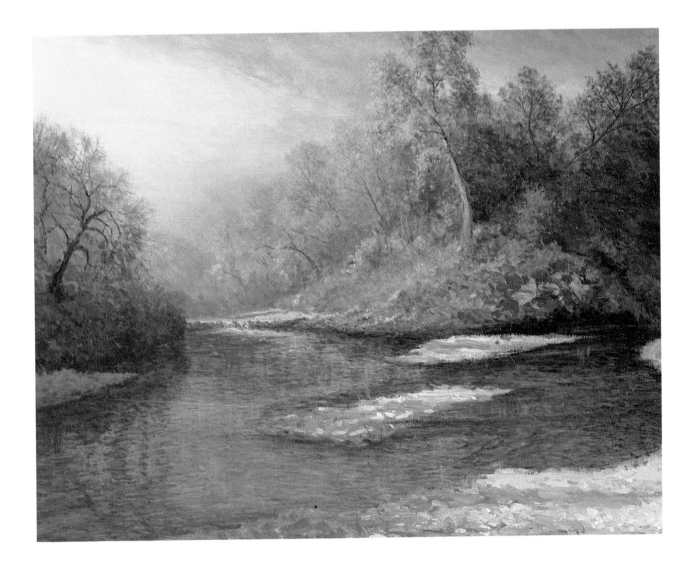

Day Six

I brush the medium mixed with raw sienna over all the painting except the sky, which is still wet from yesterday. With the size 6 white sable round, I stroke a grayed purple, composed of the colors used in the sky, over the distant foliage. A darker mixture of this color indicates the waterline of the stream. These purples are brushed vertically over the water beyond the falls. Over this, I stroke Naples yellow and cadmium orange, first vertically, then with a lighter, horizontal stroke. The waterfall is touched with highlights of white. Notice how raggedly these are applied. The rocks are darkened slightly with alizarin crimson, ultramarine blue, and raw sienna. Darker sky colors indicate the foaming water at the base of the falls; these are just little touches of paint here and there, applied very lightly and gently. I have painted on location several times at a nearby creek and am now using the experience in the studio.

I stroke sky colors into the water, along with more of the cadmium red light mixed with yellow ochre and Naples yellow mixed with cadmium orange that were used in the trees. The wind ripples receive more sky color.

The islands are repainted with mixtures of cerulean blue and cadmium red light; cerulean blue and cadmium red deep; ultramarine blue, cadmium red light, and Naples yellow; ultramarine blue, alizarin crimson, and raw sienna; ultramarine blue and burnt sienna; and flesh, raw sienna, and Naples yellow. I darken the near edge, where the sand and rock are wet. The shadows are not painted as blue now as in the first underpainting because I've changed the color of the sky. The sky colors are now repeated in the shadows on the island and on the near shore. The lights are flesh, raw sienna, and Naples yellow. I use the end of the brush to indicate stones as I work one value of color into another. Some of the paint is dragged on horizontally. The size 6 white sable round is jabbed to the canvas and zigzagged almost recklessly to suggest rocks. The edges of the islands and shore were obscured when I painted the water over them on Day 2; now they are painted back into the water. Painting beyond the edges helps to create soft edges. Raw sienna is brushed in the water near the shore as the sand in the stream bed is seen through the water.

The distant shore on the left is refined slightly, leaving it in shadow. The intruding bank on the right is suggestively painted in, along with the log in the water. These two areas are not emphasized as much as the near shore and islands.

I rework the designs of the foliage above the water on the right, using a worn size 2 white sable to suggest leaves; the colors are ultramarine blue, alizarin crimson, raw sienna, cadmium red light, and cadmium orange. I indicate the limbs and strengthen the highlights on the tree trunks and rocks. Dead grass, limbs, and twigs are suggested. The green bush is toned down with autumn colors.

Day Seven

The entire painting is glazed with the painting medium tinted with raw sienna. With a size 2 white sable, I touch Naples yellow and white to the clouds for their lightest light. With almost pure Naples yellow, I increase the intensity of light in the area of the sky above the trees on the left, scrubbing the paint very thinly into the raw sienna glaze. The intensity is increased still more by adding a bit of cadmium yellow light and white to the mixture.

A grayed purple is scrubbed in vertically over the distant water. I rework the distant trees with this atmospheric color, then with diagonal strokes of Naples yellow, I indicate the effect of the sun shining through the mist.

Naples yellow and cadmium orange highlight some of the tree foliage. I work wherever necessary over the water with a size 6 round, which I barely touch to the canvas. I paint more sky reflections in the lower left portion of the stream, keeping the value down much lower than the sky because this area is in shadow. Naples yellow is lightly dragged horizontally across portions of the water on the upper right. This is not a reflection but the effect of the sunlight hitting the water. Cadmium orange heightens the reflections near the upper right bank. I lighten the wind ripples with color from the sky, then reduce their intensity again because they compete too much with the islands.

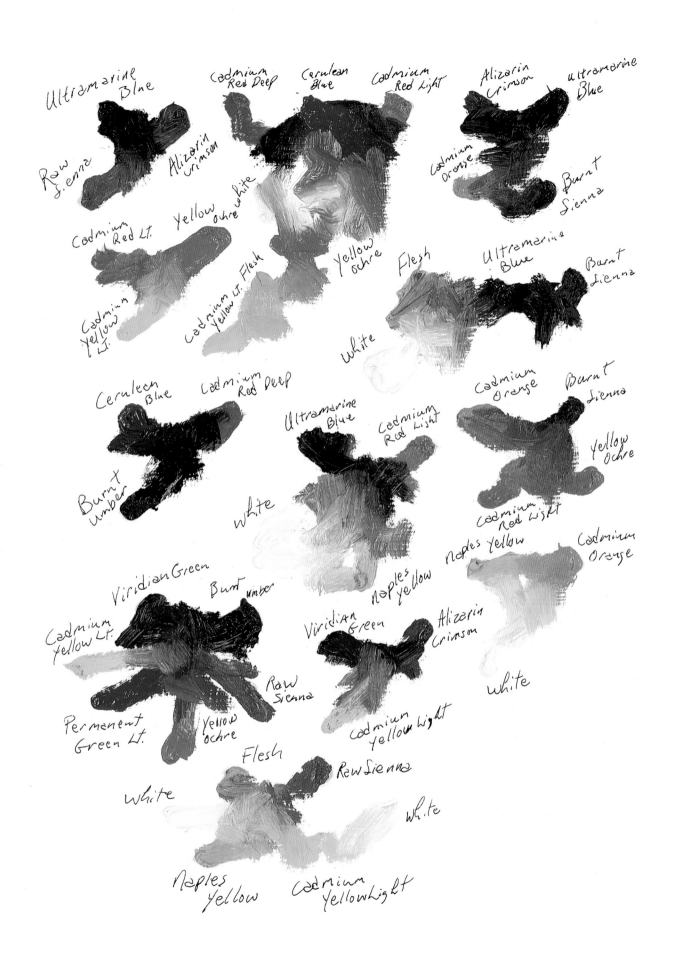

Ultramarine Blue

Cadmium Red Deep

Cerulean Blue

Cadmium Red Light

Alizarin Crimson

Ultramarine Blue

Raw Sienna

Alizarin Crimson

Cadmium Orange

Burnt Sienna

Cadmium Red Lt.

Yellow Ochre

White

Cadmium Yellow Lt.

Cadmium Lt. Flesh Yellow

Yellow Ochre

Flesh

White

Ultramarine Blue

Burnt Sienna

Cerulean Blue

Cadmium Red Deep

Ultramarine Blue

Cadmium Red Light

Cadmium Orange

Burnt Sienna

Burnt Umber

White

Yellow Ochre

Naples Yellow

Cadmium Red Light

Naples Yellow

Cadmium Orange

Viridian Green

Burnt Umber

Viridian Green

Alizarin Crimson

Cadmium Yellow Lt.

Raw Sienna

White

Permenent Green Lt.

Yellow Ochre

Cadmium Yellow Light

Flesh

Raw Sienna

White

White

Naples Yellow

Cadmium Yellow Light

Fallen leaves are indicated on the water and islands with the tip of the brush, using alizarin crimson, ultramarine blue, raw sienna, and cadmium orange. Dead grasses are indicated on the right bank and the near shore. The limbs of the tree on the left are clarified somewhat but still kept soft. A few Naples yellow lights are touched in, and the large tree on the left is highlighted with Naples yellow and white. Dark sky colors are painted into the shadows.

I scumble darks (ultramarine blue, alizarin crimson, and raw sienna) over and around the wind ripples. Little specks of these darks and Naples yellow are touched to the canvas. Still stronger cadmium orange reflections are lightly stroked into the stream. The final highlights on the large tree are cadmium yellow light, flesh, and white. This warm color is touched on the rocky area near the waterfall and the highlights on the falls. I then use white to highlight the falls again.

The painting is now finished; you can see in the illustrations the great changes in mood and feeling this painting went through from Day 1 to Day 7. I usually have my concept down clearly before I begin, but this time I didn't. I decided to include this painting to show that sometimes paintings don't go as planned.

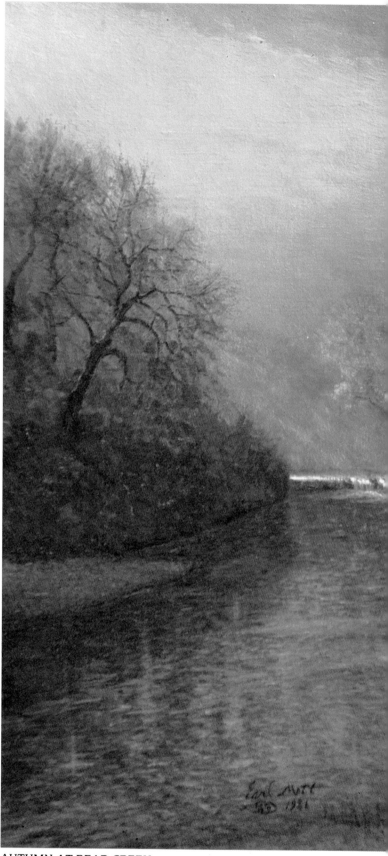

AUTUMN AT BEAR CREEK *Oil on canvas, 18" × 24" (45.7 × 61.0 cm)*

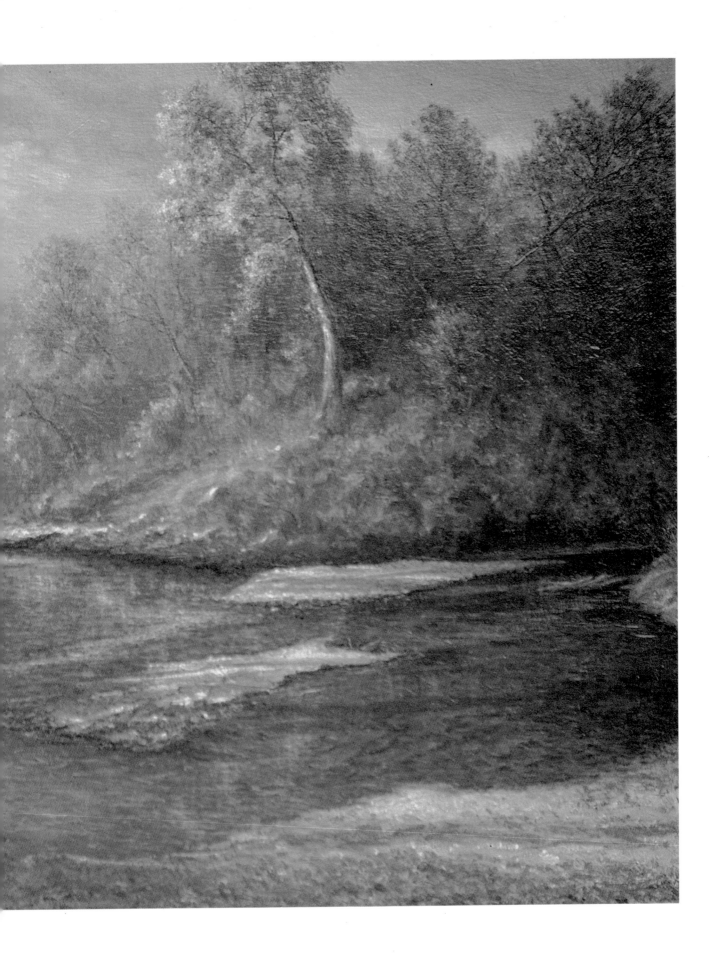

Central Texas Homestead

While traveling through central Texas one summer, I passed by a most interesting homestead. The house was very low and squatty, and strung out behind it were several outbuildings and an old car. In the yard were a picnic table, a barbecue pit, and other objects that seem to collect in backyards. I took several photos of this old homestead, one of which is shown here.

After letting the idea build for several months, I decided to tackle the project. Although the front of the house was intriguing, the backyard scene held most of my interest. I mentally pictured a person feeding chickens in this natural setting. My idea is to lead the eye in from the right with the road. The tree on the left will act as a stop. The eye will go to the figure with chickens first, then to the car, and across the yard to the various buildings. One of the problems will be developing an interesting pattern of lights and darks in the tree masses and creating a sense of depth.

Green earth is a special color I am adding to the palette for this painting. Also, I will use black made of ultramarine blue, burnt sienna, and alizarin crimson to mix some of the greens. From Day 2 on, I will use a "mother" color instead of white to lighten colors. This is used primarily to gray the greens, and it also helps to unify the painting.

Compositional sketch

Reference photo for Central Texas Homestead

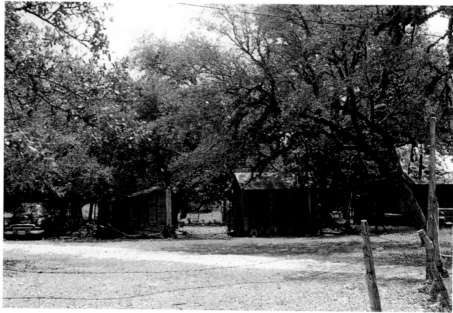

Day One

I sketch the drawing loosely on the canvas with charcoal, concentrating on the large shapes and patterns: the distant horizon, the diagonal thrust of the road, the upward thrust of the trees, the foliage patterns, the buildings, the car, and the light-and-dark patterns on the ground. I don't rush over this stage, but I don't get too involved in small details, either.

I outline the sketch with turp and yellow ochre and dust off the excess charcoal, and I'm ready to paint. To begin with, I mix several combinations of gray-green: burnt umber, viridian, raw sienna, and ultramarine blue; green earth and yellow ochre; green earth and raw sienna; green earth and burnt sienna; permanent green light, cadmium yellow light, and flesh; black and yellow ochre; black and raw sienna; and black and Naples yellow.

Using a size 3 bristle flat, I begin blocking in the design of the green foliage overhead with burnt umber, viridian, raw sienna, and ultramarine blue. After a few strokes, I go to a grayer, more atmospheric, middle-distance green mixed from the same colors but lighter in value, with more blue. The foliage of the large foreground tree is painted with black, cadmium yellow light, and flesh. Then I stroke in a few atmospheric blues (ultramarine blue and flesh) for the most distant plane.

A pattern of lights and darks is developed on the ground underneath the trees on the right, using the other green mixtures. I work back and forth between the trees and the ground as I bring along the painting as a whole. Before these areas are covered, I brush in the tree trunks and main limbs with a size 2 bristle flat, using a mixture of burnt umber, viridian, and ultramarine blue, and a mixture of cerulean blue and cadmium red deep. The house and outbuildings are painted with the same brush. Cerulean blue, cadmium red light, and cadmium red deep; viridian, alizarin crimson, and raw sienna;

and alizarin crimson, ultramarine blue, and raw sienna are used here. For the roofs, I use a mixture of cerulean blue and cadmium red light and a mixture of burnt sienna, cadmium yellow light, and flesh. Everything is kept loose; anything can and probably will be changed.

I return to the development of the patterns in the grass and trees. At this point, my concern is with the patterns and designs formed by the grass and trees and not with individual items. Some of the road is painted in with cool purples and gray-blues—mixtures of ultramarine blue and alizarin crimson and mixtures of cerulean blue and cadmium orange. The warm, sunlit sand and rock is mostly raw sienna and flesh. The sandy area on the left, near the large tree, is painted with these same mixtures. A size 3 bristle round is used in the grasses and the road area. I go back to the trees and continue developing them. Some grays (cerulean blue and cadmium red light) are brushed in for a suggestion of moss. After this area is covered, I paint in the sky with a size 3 bristle flat, using mixtures of cerulean blue with flesh and Naples yellow with white. A little purple is dashed here and there. I do not paint the sky stiffly around the trees, but brush in the color casually up to and into the foliage. Working cautiously around the foliage, being careful not to get into it would produce a hard, cut-out effect.

The old car is painted in vaguely with some darks (ultramarine blue, alizarin crimson, and raw sienna) and rusty reds (burnt sienna and yellow ochre). An outhouse is lightly indicated beside the car. Finally, a faint indication of a figure is painted. There is no need to go beyond a ghostlike suggestion now. After viewing the painting as a whole, I decide to raise the middle building, so I cut into it at the bottom with the colors used in the grass and also raise the bottom of the roof. This reduces its size and importance.

Day Two

Instead of using white to lighten colors in this painting, from now on I will be using flesh mixed with white. This is a solid tone of light pink, which is a distant complement to the greens. This color will help gray and subdue the greens.

The paint has now dried, and I brush medium over the entire canvas. The light-and-dark patterns in the foliage need more development, so this is where I begin. Using

a size 2 bristle flat and the same color mixtures as before, I paint in some dark greens. I am thinking not about leaves but about design. Some lights are brought in, but not the lightest lights—these will come later. I develop a pattern that leads down to the place where the figure will be. The side of the brush is used, instead of the end, to make mostly crisscross strokes; the brush is used like a knife. I dash a few moss grays

into the green foliage. Ultramarine blue and flesh are scrubbed over the distant trees. Into this I work some cooler, darker green for the shadows and cadmium yellow light and permanent green light for the lights.

I rework the patterns on the ground with a well-worn size 2 white sable, using the same colors as before. Stronger cool blues are used in the shadows of the road and dirt areas on the left. The buildings, car, and major tree trunks are all restated. I don't repaint the fence posts, and at this point they are barely visible.

I like to restate the first underpainting on the second day. This gives a more solid base on which to work and helps increase the depth of color. A small degree of refinement is achieved, but basically, my work today is just a loose restatement of what was done the first day.

Sky:
(clockwise) cerulean blue, flesh, Naples yellow, white, alizarin crimson

Sky:
(clockwise) cerulean blue, mother color (flesh, white), flesh, yellow ochre, alizarin crimson

I painted the basic design of the foliage on Day 1, then dashed in the sky without worrying about getting into the greens. On Day 3, after the sky had dried, I repainted it, attempting to finish it. I painted over some of the foliage, leaving a ghostlike image, and let it dry. I came back on Day 5 with the tattered end of an old size 2 white sable and suggestively painted the texture and appearance of leaves, keeping the edges soft and letting the sky show through the holes in the foliage. A size 6 white sable round was used to paint the foliage on the left foreground tree. Notice the difference in technique. Limbs were stroked over the greens on Day 6. On the eighth day, I intensified the lights on the foliage on the left.

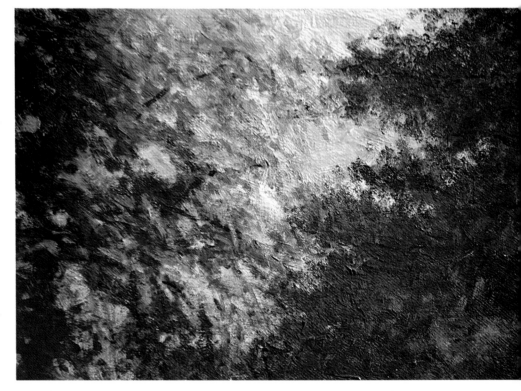

Day Three

I allow the second underpainting to dry and oil in the picture again. Mixtures of cerulean blue lightened with the "mother" color of pale flesh, then mixed into yellow ochre and flesh, are brushed into the sky with a size 6 Langnickel royal sable. A dash of cerulean blue mixed with alizarin crimson is used here and there. Very little sky is showing through the trees, but I actually paint in more than will be seen in the final painting, brushing it casually over the edges of the surrounding green to achieve soft edges and avoid a harsh effect. The sky is not totally separated from the trees, and it should be incorporated into them.

I use a well-worn old size 2 white sable and combinations of viridian, burnt umber, ultramarine blue, and raw sienna for the green foliage. The colors are placed a distance apart on the palette in a circular arrangement and gradually brought together. This way, I can control the color mixtures. Work is done only on the lower section of the trees, as I don't want to work into the wet sky. The design of the foliage is basically there, and now I go back and refine it. I attempt to suggest the appearance of these oaks by using this worn-out brush,

which can be used the same way some use a sponge to create the appearance and texture of leaves. A little ultramarine blue and flesh are introduced for atmosphere. Using a well-worn size 6 white sable round, I repaint the grass with the following colors: Naples yellow and black; yellow ochre and black; green earth and yellow ochre; green earth and raw sienna; green earth and burnt sienna; and permanent green light, cadmium yellow light, and flesh. Cadmium orange and cerulean blue are used for the earth. Mixtures of alizarin crimson, raw sienna, and ultramarine blue and mixtures of burnt sienna and raw sienna are used for the earth and dead leaves.

In the middle ground, horizontal strokes of the various colors (along with blues and purples in the shadows) indicate the patterns created on the ground by the sun shining through the trees. A clear difference between light and dark creates a sparkling sunlight effect. Edges are kept soft. Under the trees and in the foreground a variety of strokes are used to represent the growth patterns of the grass. Lights are contrasted against darks. Some of these greens are scumbled over parts of the buildings.

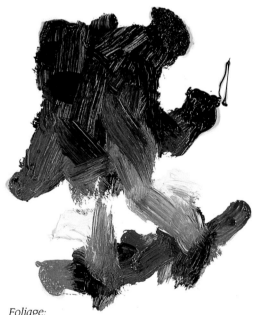

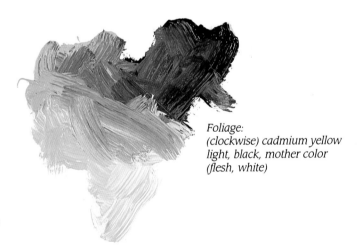

Foliage:
(clockwise) cadmium yellow light, black, mother color (flesh, white)

Foliage:
(clockwise on top swatch) viridian, burnt umber, ultramarine blue, raw sienna Grayed with:
(clockwise on bottom swatch) mother color (flesh, white), alizarin crimson, cerulean blue, cadmium red light, mother color

Tree limbs:
(clockwise) burnt umber, ultramarine blue, mother color (flesh, white), viridian

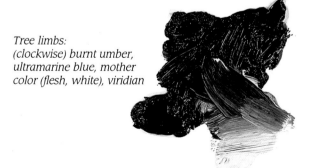

Day Four

Medium is brushed over the road and dirt area, the buildings, and the car. The same warm and cool grays used for the ground in the first and second underpaintings are used again. The colors are scumbled over one another, developing the patterns of shadow and light. A stippling effect is used in the foreground road. Generally, a darker color is brushed on, then lighter colors are stippled over it for the pebbles.

The distant building requires very little work: a few dark accents along the side, lights in the front, and strokes of blue-gray for distance. I do the same type of work on the middle building next. The strokes are mostly vertical. I don't try to paint every board but suggest them with darks and lights. The house is treated in the same manner. A door on the side and windows in the back are indicated.

I would advise you not to become too involved with windowpanes. Generally, it is sufficient to suggest some detail and then leave them alone. At the end of the painting, if they need more detail, go back and do only what is necessary. Most of the time you will find no additional work is needed other than a few highlights or accents.

The house has been painted as a solid mass up to the tree on the right. As I look at it, I decide a porch there would be more interesting, so I cut into the front and make a porch by painting background trees and grass over the house.

The yard clutter (table, barbecue pit, etc.) and the distant trunk shapes are painted. The roofs on both buildings are reworked, with the emphasis on light-and-dark patterns. The chimney is painted with mostly ultramarine blue, alizarin crimson, and raw sienna. Darks are worked in first, then lighter earth tones and cool blues and purples. I don't try to paint every rock when only a suggestion is sufficient. The outhouse is finished and kept very simple; it's not the main theme. Next, the old car is clarified and detailed. Darks are stroked in, then lighter colors to bring out the shape. Edges are kept soft and are allowed to fade out into the foliage. The colors used are: black, burnt sienna, and yellow ochre; alizarin crimson, raw sienna, and ultramarine blue; and cerulean blue and cadmium red light. The light values are put on last. A size 6 white sable round is used for the more detailed work.

I worked on this section of the painting every day, gradually building up the paint and detail. On Day 1, the painting was worked with bristle brushes, then the forms were casually restated on Day 2 with sables. Different areas were repainted on subsequent days. Notice the lost-and-found edges and the way the paint is scumbled on the ground, allowing various colors to show through.

Day Five

The sky has now dried, and today I will work on the foliage, using the same colors as before. As on Day 3, the well-worn size 2 white sable will create the texture and appearance of leaves. I seldom use this technique, but it can be used tastefully. It is not just a mindless dabbing at the canvas. The tattered end of the brush is twisted and turned and stroked on the picture surface.

A pattern has been developed to lead the eye down into the painting where the figure will be placed. Some cool purples are stroked in occasionally and some gray moss is suggested. The large tree on the left is painted differently: Slashing strokes of color are dashed onto the canvas with a size 6 white sable round. Cadmium yellow light

and black lightened with the light pink are used for highlights.

When you are painting foliage or any other subject and you want to keep the edges soft, a good way to do it is to paint beyond the edges. For example, when I painted this foliage on Day 1, the sky was painted into the trees. After the sky dried, I painted the trees back over it. I allowed some of it to show through and scumbled over the sky hole edges to avoid a harsh effect. Notice that the right-hand corner is left almost in the underpainted state while other areas are more developed.

I have time left to do only a small amount of work on the limbs of the leaning tree near the center.

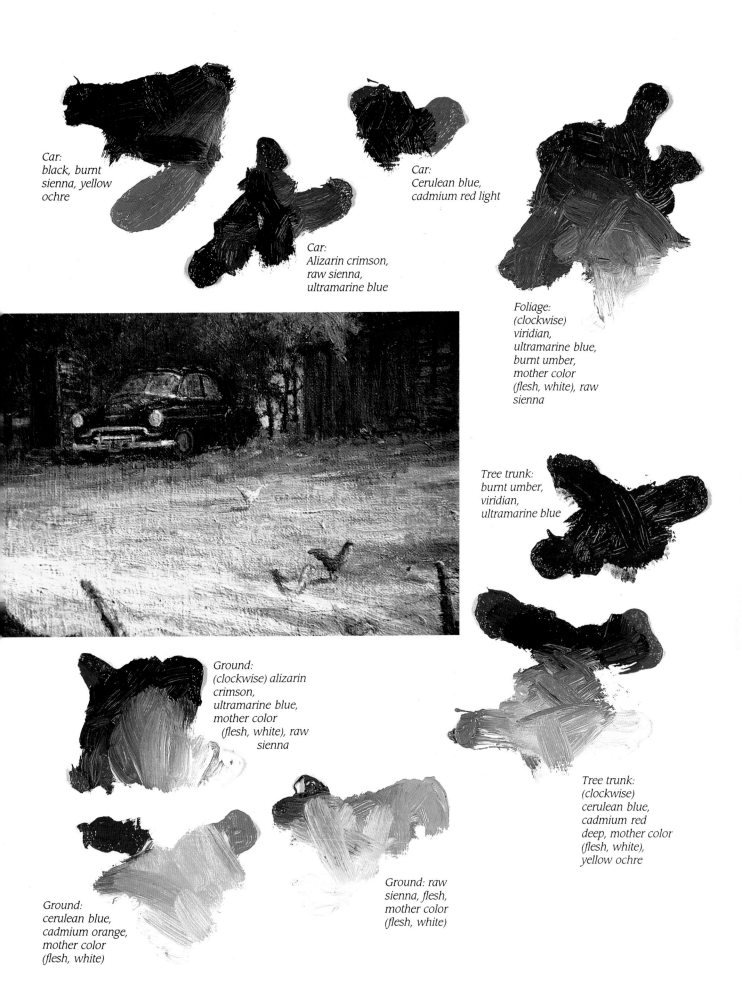

Car:
black, burnt
sienna, yellow
ochre

Car:
Cerulean blue,
cadmium red light

Car:
Alizarin crimson,
raw sienna,
ultramarine blue

Foliage:
(clockwise)
viridian,
ultramarine blue,
burnt umber,
mother color
(flesh, white), raw
sienna

Tree trunk:
burnt umber,
viridian,
ultramarine blue

Ground:
(clockwise) alizarin
crimson,
ultramarine blue,
mother color
(flesh, white), raw
sienna

Tree trunk:
(clockwise)
cerulean blue,
cadmium red
deep, mother color
(flesh, white),
yellow ochre

Ground:
cerulean blue,
cadmium orange,
mother color
(flesh, white)

Ground: raw
sienna, flesh,
mother color
(flesh, white)

Figure:
(clockwise) raw sienna,
cadmium red deep, cerulean
blue, burnt umber,
ultramarine blue, mother
color (flesh, white)

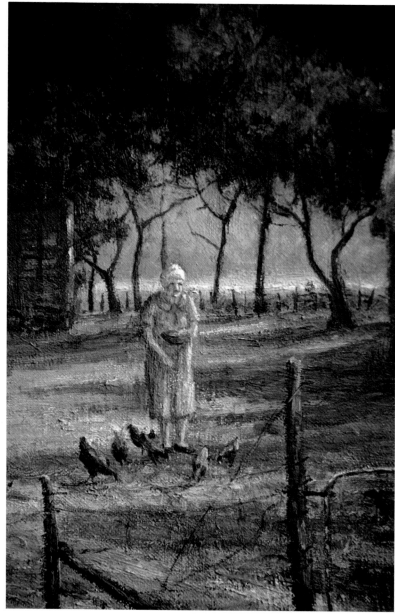

The figure was left very indistinct
throughout most of the painting process;
I didn't attempt to work around her but
rather painted right over her, leaving a
vague image. Finally, on Day 7, I defined
the figure clearly, using similar colors for
her skin and clothing. Then the chickens
were dashed in, with the main concerns
being form and gesture.

Distant greens:
(clockwise) cadmium yellow
light, permanent green light,
raw sienna, viridian, burnt
umber, raw sienna, flesh,
cadmium yellow light, white,
ultramarine blue, mother
color (flesh, white)

Day Six

I begin where I left off—painting in the limbs and tree trunks. I use burnt umber, viridian, and ultramarine blue in one mixture and cerulean blue and cadmium red deep (with yellow ochre in the lights) in another. I don't try to show every limb; rather, the limbs are selectively placed over the green foliage and allowed to fade out into it. The trunks spread out at the base of the trees, and some root formation is shown. Don't place trees in the ground like poles. As they go into the earth, the earth reaches up to receive them. The tree colors are used, along with raw sienna, for the fence posts. Cadmium yellow light is

brought in for the lights. Lights and darks are placed up and down the posts to indicate the tree shadows. Cerulean blue and cadmium red deep are used on the gate. Burnt sienna, ultramarine blue, and cadmium red light are scumbled in for the wire on the gate and fence. Only a suggestion is sufficient. A detailed study of wire would certainly distract from the more important aspects of the painting.

Sometimes work goes slowly, and today has been one of those days. However, the painting has moved a step closer to completion.

Day Seven

With a size 6 white sable round and mixtures of raw sienna and cadmium red deep, I begin to paint in the figure of a woman feeding chickens. I gray and darken these colors with cadmium red deep and cerulean blue. I also use burnt umber and ultramarine blue for darker tones. Only a suggestion of facial features is needed. I block in the basic figure, then go back and pull out the details and adjust the drawing. Most of this is done from imagination as I pose myself in the gesture one might have while feeding chickens. The chickens are each placed with a spot of color and a vague form; then I go back and apply lights and darks and a minimum of detail.

The distant trees and field are reworked. The same underpainting colors are used,

with more of the bluish atmosphere; this area is softened for a distant effect. The tree trunks now have to be repainted, as I have overlapped them with the background tree mass. The shape of one tree trunk near the center building is unsatisfactory and must be completely redone. The distant field in front of the house is lowered and a fence is painted. I touch up the grass patterns near the chickens and in the foreground and along the fence row. I paint in more grass up around the bases of the trees and posts to give them the appearance of belonging. More green reflections are dashed in the windows. These little adjustments to the established forms are important, but they take a long time. At this point, the painting is almost finished.

Day Eight

I will be working all over the picture, so I oil in the entire canvas. Using the old size 2 white sable and the same green mixtures, I rework the patterns of the trees right above the house. Other areas are lightly touched with these greens to subdue the limbs. The highlights are heightened on the foliage of the left foreground tree and on the upper right with cadmium yellow light and light flesh. A few dark accents are placed on the figure. Pure white is stroked on her hair and the highlight is placed on the chrome bumper of the car. These are the only areas that have received pure white.

A size 6 white sable round is used for this smaller work. More darks are placed at the bottom of the fence posts. The distant meadow is highlighted with light pink, cadmium yellow light, and white. A few strokes of light grass are added in the foreground. Lights in the windows are intensified. Some more wire is suggested on the fence and gate. A great deal of time is spent standing back and analyzing the painting. Work now mostly involves light and dark accents, softening edges, and minute adjustments in patterns and values. The painting is finished.

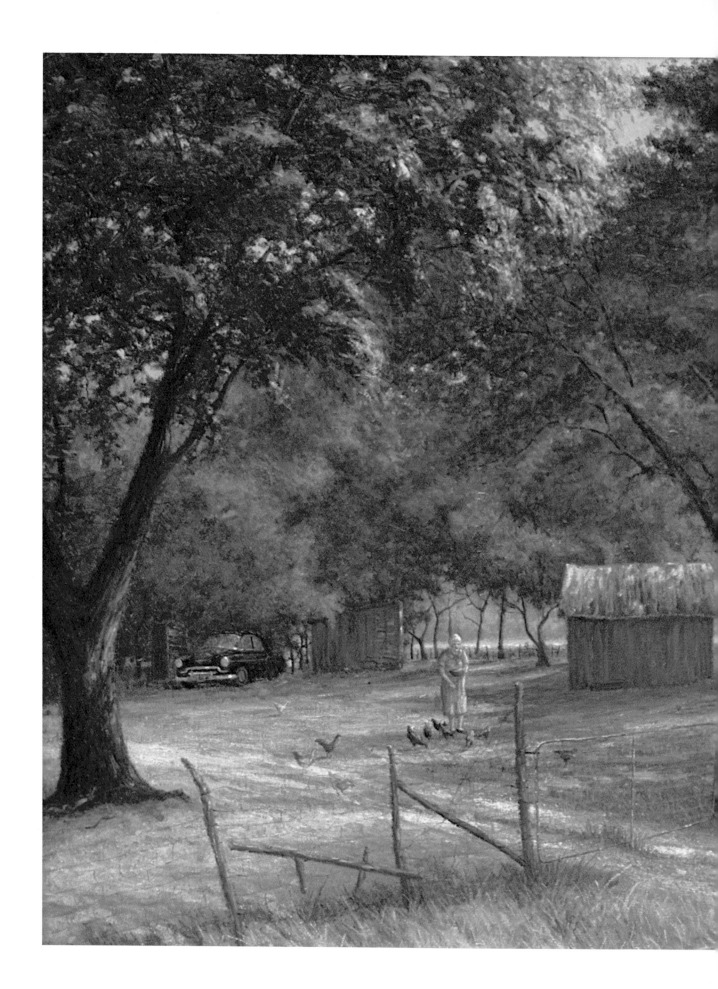

CENTRAL TEXAS HOMESTEAD
Oil on canvas, 22" × 28" (55.9 × 71.1 cm),
collection of Art Tailored, Ltd.

Symphony in Frost

We don't get much snow here in east Texas, but we do get frost. I have found frost to be largely neglected by artists, although it can beautify a landscape as much as snow. I took this photo from a bridge near our house. The lovely patterns and the distance melting away into light and atmosphere intrigued me, so I did a couple of compositional ink sketches to work out some of the designs. I want the painting to be very elusive and indefinite while flowing with beautiful patterns and designs. Cobalt blue and rose madder will be added to my usual palette.

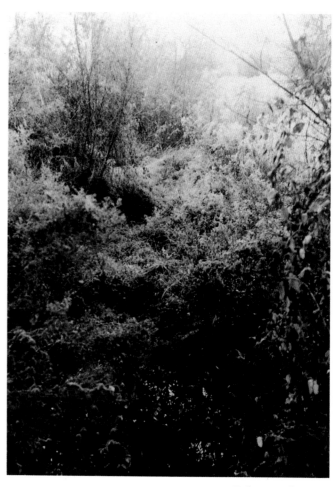

Reference photo for Symphony in Frost

Compositional sketches

—Day One

After sketching with charcoal and outlining with turp and yellow ochre, I mix different mounds of color on my palette with the painting knife. It is impossible in a painting as loose and impressionistic as this to tell exactly where I used a certain mixture, so I will give you the color mixtures that I used throughout the entire painting: cobalt blue and rose madder; ultramarine blue and burnt sienna; ultramarine blue, alizarin crimson, and raw sienna; cerulean blue and cadmium red light; cerulean blue and cadmium red deep; cerulean blue and alizarin crimson; ultramarine blue and flesh; viridian and cadmium red light; alizarin crimson and cadmium red light; raw sienna, Naples yellow, and flesh; cadmium orange, alizarin crimson, and flesh; cadmium orange, flesh, and Naples yellow; burnt umber, flesh, and cadmium orange; viridian, burnt umber, and yellow ochre.

I begin establishing the darks in the lower foreground and up the stream bed to the trees in the center, then come in with some middle and light values. The painting ground is a blue-gray middle value, so these lights will show up against it. The lightest lights are not put in this time; they will be scumbled over the darker underpainting later. I work all over the canvas now, except for the sky. All kinds of brushstrokes are used. The brush is pushed, pulled, and twisted into a variety of strokes. I am concentrating on capturing beautiful, flowing patterns without becoming "stiff."

The tree trunks are vaguely suggested and are designed to complement the overall composition of the painting.

I mix a peach color of cadmium orange and flesh and work this into a mixture of Naples yellow and white for the sky. Then a light mixture of cobalt blue with a touch of rose madder is brushed into this wet sky, using a size 4 bristle flat; the strokes are kept loose and complementary to the strokes in the rest of the painting. The sky flows into the trees, creating an indefinite transitional area. I go back into the trees for minor adjustments and then to other small areas until the entire canvas is covered. A dominant pattern flows from the lower right corner up to and around the trees and back down into the composition. The work has been done with sizes 2, 3, and 4 bristle flats.

—Day Two

The paint has dried and I oil in the entire painting. Using some of the same color mixtures (mostly cool grays, purples, and blues) and a size 2 bristle flat, I begin to reestablish and define the various patterns, starting with the darks near the base of the central trees. The overall abstract designs that appear in nature can be painted in a broad fashion with little or no detail, but I choose to go into them with an inter-mingling of color and textures—color over color over color, a fusion of color. At the same time, I try not to lose the large underlying designs.

I use the side and end of the brush with a variety of strokes. I am basically restating what I did on Day 1, defining the patterns more, and creating a solid base on which to overpaint. The sky is brushed over lightly with the broad side of the size 2 bristle flat. Raw sienna is added to the same colors used previously, and the sky is painted more golden. Color is brushed down into and over the trees, then they are restated in a vague manner. The darks at the bottom of the canvas are strengthened and form a strong contrast to the light sky. The whole canvas is now covered for the second time, and the paint must dry before I can begin the more time-consuming process of refinement.

Day Three

I brush medium over the top half of the painting with a size 8 Langnickel royal sable and, using the same colors as before, I rework the sky. A light blue is brushed on thinly, followed by light values of the other colors used on Days 1 and 2. These colors are scumbled over the trees to integrate the two areas and to give the appearance of a frosty morning with light streaming through the trees. I now have a soft, hazy effect.

With a size 6 sable round, I apply broken color in small, choppy strokes, beginning at the base of the trees. I am thinking primarily of design. The overall big pattern has already been established; now I work back into it with smaller patterns—patterns within patterns. The tip of the brush is used, along with the side, in order to get large and small strokes. Most of the color is lighter in value and is scumbled over the underlying darks. The bristle brush underpainting has created a slightly rough surface that is ideal for scumbling. The tree trunks, which have not been restated since Day 1, are now enveloped in the atmospheric haze and frost and are almost lost in the overpaintings. Everything is soft, beautifully flowing patterns.

Day Four

Today I continue working out the various patterns as I work down the canvas. Greens, purples, blues, pinks, and grays are woven into the frost-covered landscape. The overgrown creek bed is broken here and there with brushes and grasses and creates a pattern leading the eye into the picture. Most of this area is not in any direct light and is kept cool. I paint only a suggestion of weeds and grasses rather than hard-edged blades of grass. The viewer recognizes it as grass without the artist spelling it out. Frost looks similar to snow, but more of the underlying forms show through this frozen, transparent covering. A suggestion of the forms and colors that lie beneath the frost must be indicated; otherwise, it will look like snow.

Day Five

The top half of the canvas is oiled in, and now I begin to refine the trees, using a size 6 white sable round. Mixtures of rose madder and cobalt blue; ultramarine blue, alizarin crimson, and raw sienna; burnt sienna and ultramarine blue; and cerulean blue and cadmium red deep are used. I get frosty colors without going too dark and gradually pick out the trees from the misty image. Some areas are left obscure. I scrub on some tone for the tree mass with a worn size 6 white sable round, then go back with a good size 6 white sable round and pick out some branches. I keep the work loose and do not just paint solid limbs but allow them to be lost and found in the atmospheric morning. I dash some flesh mixed with cadmium orange and flesh mixed with Naples yellow into the branches and deliberately smudge the trunk and limbs. I slash in limbs without trying to connect them to anything or show their beginning or ending. Vines are pulled up into the trees. The atmospheric background trees are reworked and kept very simple. Distant tree trunks are barely scumbled over the canvas. Sky colors are stroked in for the sunlit frost at the base of the trees and then pure white is flicked over that. The most distant area of trees on the right is slightly reworked, but I decide to leave them until later. Sometimes areas like this, if just left alone until the painting is almost finished, will be satisfactory with very little work.

ultramarine blue,
alizarin crimson,
raw sienna

cerulean blue
mixed with
(clockwise from
top) cadmium red
deep, alizarin
crimson, cadmium
red light; lightened
with white

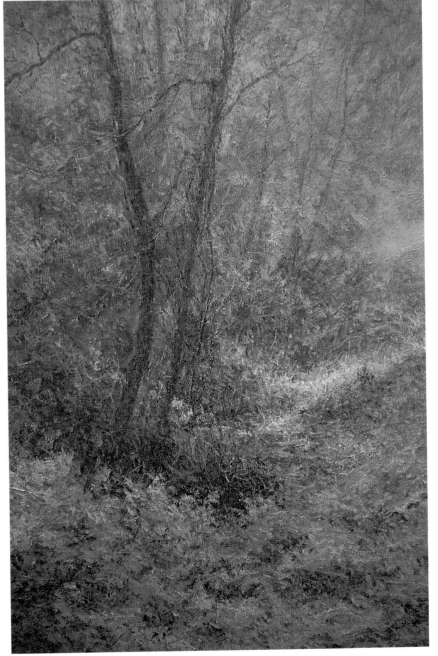

(clockwise from
top left) raw
sienna, Naples
yellow, white, flesh

The color mixtures for this painting are
given in the Day 1 text; bits and pieces of
these various colors are used throughout
the painting. The color mixtures that
accompany the details of this painting are
approximations of the colors used in a
particular area.

Notice the regression of detail, form,
value contrast, and color intensity as the
landscape melts away into the morning
atmosphere. The paint is brushed on in a
broader fashion on the first day. From
then on it is scrubbed on, scumbled,
dashed on, and flicked on with a variety
of small strokes.

(clockwise)
cadmium orange,
flesh, raw sienna,
white, Naples
yellow

In this detail, you can see the softness of the transition between sky and trees; you can't tell exactly where sky ends and trees begin. This is an extreme example of the atmosphere influencing the landscape. The colors are woven together, forming a winter tapestry. As I painted, I was thinking about pattern and design, not the identification of "things."

cobalt blue,
alizarin crimson,
white

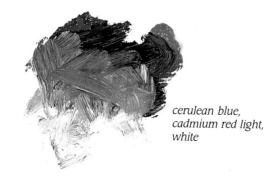

cerulean blue,
cadmium red light,
white

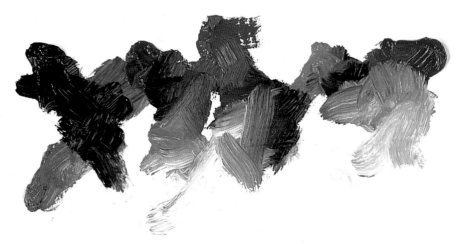

(clockwise from lower left) raw sienna, ultramarine blue, alizarin crimson, cerulean blue, cadmium red light, viridian, white, white

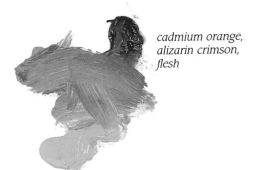

cadmium orange, alizarin crimson, flesh

Even here in the foreground, I do not attempt to identify "things" but concentrate on design instead. I give just enough information to let the viewer identify the grass and bushes. Enough form must be shown when painting frost, however, or it will look like snow.

The tree limbs entering from the right were left in the underpainted state until Day 8, then stroked on rather casually. Compare the slashing brushwork in the lower foreground bushes with the gentler strokes in the middle ground and background. All the strokes blend together to form a melodious mood, a ''symphony in frost.''

(top left) ultramarine blue, alizarin crimson, raw sienna

(bottom left) yellow ochre, white, cerulean blue, cadmium red light, viridian

(right) cobalt blue, rose madder, white

Day Six

Starting at the distant plane (the field), I stroke in a light, cool blue, then over that I brush warm mixtures of Naples yellow with flesh and cadmium orange with flesh. Yellow ochre is added to a mixture of viridian and cadmium red light for the light, atmospheric green grass. Some of the patterns on the background trees are adjusted, cooled, and pushed back (subdued). An atmospheric blue is scumbled over the distant horizon line to soften it. Frosty greens, purples, pinks, blues, and grays are scrubbed, scumbled, and dashed over the previous underpainting. The underlying colors are allowed to show through as the paint is applied sometimes tenderly, sometimes with flair, but always with sensitivity.

On the right, where the intruding trees and bushes enter the composition, I scumble the paint over the underpainting and allow a faint image of the underlying forms to remain.

Day Seven

The beautiful patterns are woven down into the lower part of the painting. The growth is brought over the stream, which is kept secondary to the frost-covered landscape. Slashing strokes on the right form a design of frost-covered brushes and grasses. A feeling of fluid movement is developed in these designs. Some sky color and some earth reds are reflected into the water of the stream in the foreground. A small sweetgum in autumn dress is painted near the stream. The entire surface of the painting has now been overpainted at least three, and in some areas four, times.

Day Eight

Raw sienna and white are mixed and thinned with medium and glazed over the left side of the sky with a size 6 white sable flat. Some of this is glazed over the trees as well. Next, I scumble a light mixture of cobalt blue and alizarin crimson over the tree mass for a more frosty look. Some areas of this mass need to be subdued and the designs adjusted. A size 6 white sable round is used to pick out the intruding limbs on the right from the vague underpainting. A suggestion is the desired effect, rather than a detailed study of limbs and leaves. Edges are kept loose and soft. Some of the smaller limbs are suggested in the mass of bushes at the lower right. More refinements are worked into the middle-ground grasses without going into too much detail. A hint of a burnt orange reflection is stroked into the stream.

Day Nine

I rework some of the patterns in the lower part of the canvas; some designs are altered and some values are changed. The grasses along the stream in the foreground are reworked and clarified. I bring them over the stream and also rework some of the darks in the stream itself. The red tree is subdued with frost color, and more indications of limbs and grasses are added. Leaves are flicked into this dark mass. The lights on the slope of the hill are lightened. A few adjustments are made in the design of the background and middle-ground bushes. At this stage, the final adjustments are made in value, design, color, and detail. Some areas are pushed back while others may be pulled out with strong highlights. These final touches are done with a size 6 white sable round.

Painting with love and sensitivity: I hope you can see these qualities in my work. When we have a subject we love to paint, we do better work. A cold, frosty morning like the one I have just painted is beautiful, and it's a challenge and joy to paint. I remember turning on classical music when doing this work and just letting the paint flow.

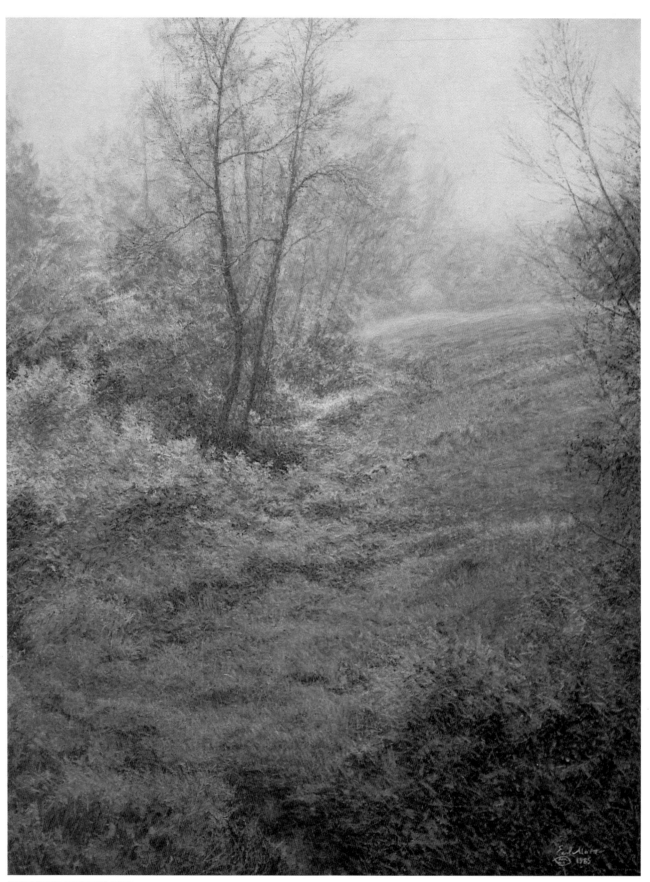

SYMPHONY IN FROST *Oil on canvas, 36″ × 28″ (91.4 × 71.1 cm), collection of Art Tailored, Ltd.*

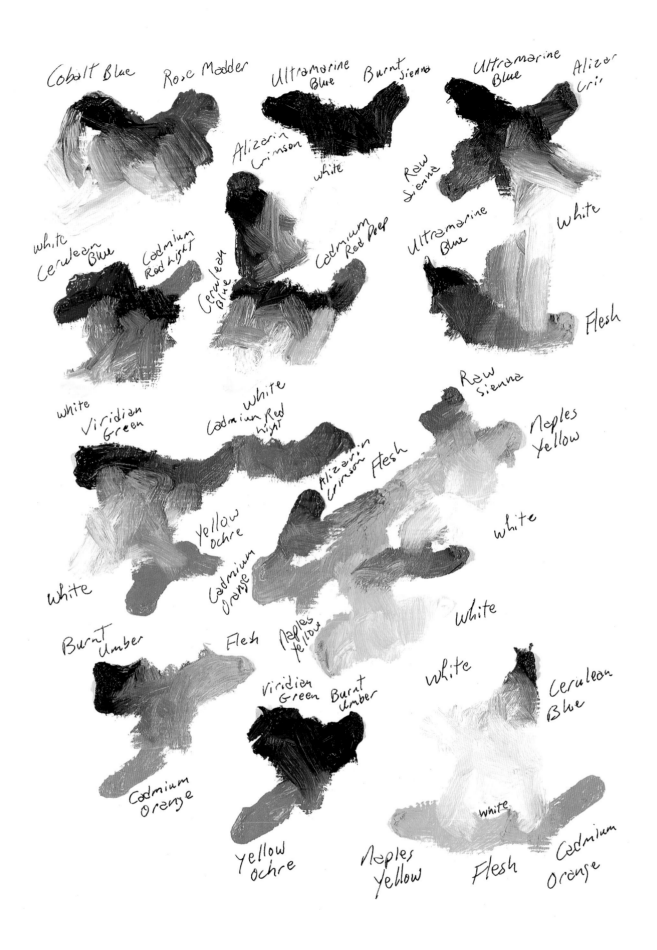

Cobalt Blue

Rose Madder

Ultramarine Blue

Burnt Sienna

Alizarin Crimson

white

Ultramarine Blue

Alizar Cri

Raw Sienna

Cadmium Red Deep

white Cerulean Blue

Cadmium Red Light

Cerulean Blue

Cerulean Blue

Ultramarine Blue

White

Flesh

white Viridian Green

Cadmium White Red Light

Alizarin Crimson

Flesh

Raw Sienna

Naples Yellow

Yellow Ochre

Cadmium Orange

Naples Yellow

white

White

White

Burnt Umber

Flesh

Viridian Green

Burnt Umber

White

white

Cerulean Blue

Cadmium Orange

Yellow Ochre

Naples Yellow

white

Flesh

Cadmium Orange

The Forest Giant

I was immediately intrigued by this giant old pine tree when I first saw it a few years ago. Its enormous size completely dwarfed me and all the nearby trees. I wondered how much history had passed during its lifetime, how many people had lived and died, yet it lives on, surviving the storms and perils associated with life.

Unlike most pines, this one has numerous limbs protruding from its trunk. Many of them are dead, and their skeletal remains hang precariously in the air. The one large limb, which I am emphasizing in this painting, is larger than many whole trees.

I have worked on location here four or five times, and once I got soaking wet when a thunderstorm lingered longer than expected. Another time, my presence flushed a covey of bobwhite quail from the underbrush. These are some of the inconveniences and joys of outdoor painting.

I attempted a studio painting of the pine, but it was unsatisfactory and I left it unfinished. Maybe the size of the huge tree intimidated me. Anyway, now I will make another effort, attempting to portray the character, weight, size, and strength of the tree. The huge limb will add to the heaviness as it snakes its way upward. Everything surrounding the tree will be simplified. The small saplings in the background will help emphasize the size of the giant pine. I may decide to include a figure to show its relative size. Since I want to stress the width rather than the height of the tree, I will work on a horizontal canvas.

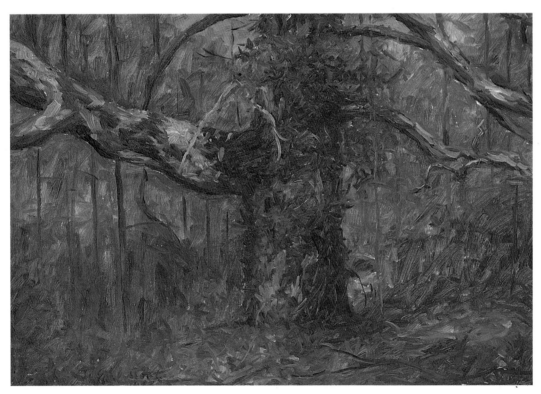

THE ROCKLAND PINE
Oil on mat board, 12" × 16" (30.5 × 40.6 cm), collection of James and Kathleen Baldwin

I will use this location painting, along with reference photographs, for the studio painting, The Forest Giant.

—Day One—

My ground for this painting is toned with burnt umber and ultramarine blue. With charcoal, I sketch the dimensions of the pine and the shape of the large limb. The other limbs are quickly sketched in, as are the slope of the land and the general shapes of the background pines. There's no need to carry the drawing any further, so I outline it with yellow ochre and turpentine, wipe off the leftover charcoal, and begin to paint.

Work is begun on the large tree with a size 3 bristle flat, stroking on darks mixed from ultramarine blue, alizarin crimson, and raw sienna and from ultramarine blue and burnt sienna. The middle tones are cerulean blue and cadmium red deep. At this point I'm not

concerned with painting the bark of the tree; I'm concentrating on blocking in the major light-and-dark patterns, which just happen to be tree bark. These same dark colors, with more purple, are brushed into the cast shadow on the ground. The pine needles in the light are loose mixtures of burnt sienna, raw sienna, cadmium orange, cadmium red light, and Naples yellow. The silvery gray light on the pine is cerulean blue, cadmium red deep, and yellow ochre. Some of the colors on the ground are stroked into the tree trunk.

Distant pines are suggested with viridian, burnt sienna, yellow ochre, and flesh. Cadmium yellow light is added for brighter greens. Viridian, burnt umber, and ultramarine blue are used in the darker pines. A few distant tree trunks are suggested with a size 1 bristle flat. Using a size 5 bristle flat with raw sienna and white, I stroke in the sunlit sky on the left. On the right, I use a mixture of cerulean blue and white and a mixture of alizarin crimson and ultramarine blue. I stop to photograph the half-completed underpainting.

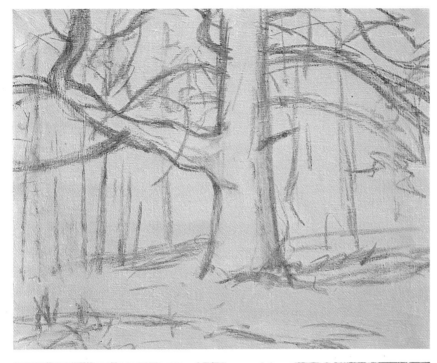

Day One: The charcoal drawing. I have sketched in the major shapes on a ground composed of burnt umber and ultramarine blue.

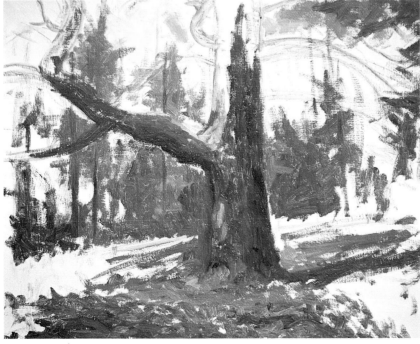

Day One: The half-completed underpainting. At this stage, I am working all over the canvas, laying in the designs in an abstract manner.

I resume painting the large tree with the same dark mixtures. Many of the limbs are dead, and I paint into the darks with cadmium orange, burnt sienna, and yellow ochre. I don't harshly outline the shapes; instead, I paint them softly.

With the greens mixed earlier, I paint in the background pines, working them in as a mass but showing form with different values of color. Using a size 5 bristle flat, I finish painting in the sky with raw sienna and Naples yellow; cerulean blue and white; and ultramarine blue and alizarin crimson. These colors are worked down into the pines for the sky holes. Then I bring the pines back up into this wet sky, leaving some of it showing through. A few more trunks and limbs are indicated.

I return to the ground area and continue covering it very loosely. Patterns of lights and darks are painted that will lead the eye to the tree and then into the background.

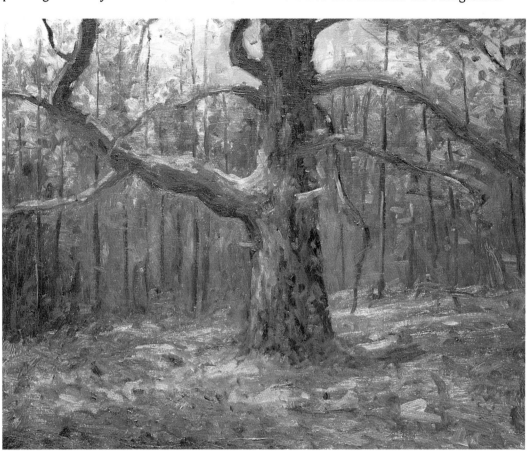

Day One: The completed underpainting. I continue working all over the canvas. The large tree is painted softly rather than being sharply defined with hard edges. I brush in some greens for the background pines, using color and value to indicate the forms. I finish the sky and bring the sky colors into the pines for sky holes, then repaint the pines over the wet sky. Patterns of light and dark are established on the ground to lead the eye toward the tree and then back into the forest.

—Day Two

The painting medium is brushed over the surface of the painting, restoring the sunken-in colors. This revitalization is necessary to judge colors and values. The medium helps reveal the full beauty of the colors and binds the layers of paint together.

I paint the golden glow on the left of the sky with raw sienna, Naples yellow, and white. This is brushed lightly down into the trees and scumbled with diminishing strength over the rest of the sky. Cerulean blue is mixed with a grayed purple obtained from ultramarine blue, alizarin crimson, and raw sienna. These colors are brushed into the sky toward the right. The golden color on the left is toned down with this gray-purple. The sky colors are brushed casually over the trees.

Using a size 2 white sable, I repaint the forest floor with the colors used on Day 1. My concerns are the patterns of light and dark, the sense of depth, and the richness of color, rather than painting individual pine needles. Greens of viridian, burnt sienna, and cadmium yellow light suggest grasses and a few bushes.

I scrub ultramarine blue and flesh over the lower section of the background trees. Viridian, burnt sienna, and yellow ochre are worked into this. The darker greens are viridian, burnt umber, ultramarine blue, and permanent green light. Darks of alizarin

crimson, ultramarine blue, and raw sienna are touched as accents in the distance, suggesting separation of land and trees. I try to paint a soft transition between the ground and the forest by bringing the colors of the forest floor up into the trees.

With a size 2 bristle flat, I work over most of the trunk of the large pine. More blue from the sky is painted in the shadows as the tree goes up into the sky. Stronger yellow ochre highlights are touched into the pine.

— Day Three —

Medium is brushed over the picture. I heighten the golden glow on the left with Naples yellow and raw sienna, drybrushing the paint over the surface as I work toward the right. Using a mixture of ultramarine blue, alizarin crimson, and raw sienna and a mixture of cerulean blue and white, I repaint the sky with a suggestion of clouds. You can see how painting an object or area beyond its boundaries can help produce soft edges. A size 6 white sable bright is used for work on the sky.

I rework the forest floor with a size 6 white sable round, using ultramarine blue, alizarin crimson, and raw sienna; cerulean blue, cadmium red deep, and raw sienna; burnt sienna, raw sienna, and cadmium orange; and Naples yellow and cadmium red light.

The colors are flicked on the canvas to suggest sunlight and shadow on pine straw. Dark accents suggest pinecones. A purple haze (ultramarine blue and alizarin crimson) is drybrushed horizontally over the distant ground; earth colors are brushed over it.

On the pine tree I use ultramarine blue, alizarin crimson, and raw sienna; ultramarine blue and burnt sienna; burnt sienna, raw sienna, and cadmium orange; and cerulean blue, cadmium red deep, and yellow ochre. I alternate between lights, darks, and middle tones as I paint the rough bark. The darkest darks are reserved for the shadow side of the tree and the deep grooves created by the bark. Strokes of yellow ochre and white are used in the sunlit areas.

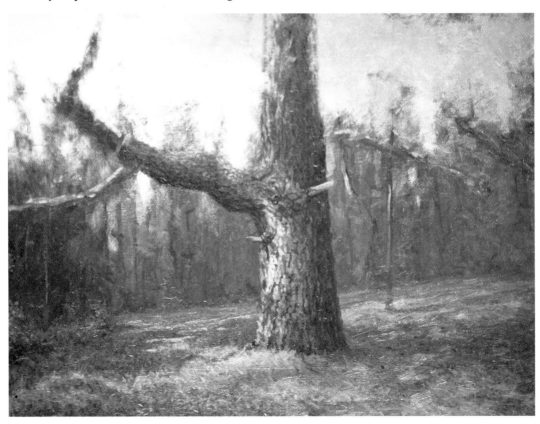

*Day Three:
I repaint the sky with ultramarine blue, alizarin crimson, raw sienna, and cerulean blue mixed with white, brushing the sky colors over the trees. I will restate them later; working back and forth this way produces forms with soft edges. I also refine the other areas of the painting.*

Day Four

After brushing the painting with medium, I start to work on the background pines with a size 6 white sable round and a size 2 white sable bright. I repaint the pines lightly, using viridian, burnt sienna, and yellow ochre. For a more atmospheric green, I add ultramarine blue. Flesh will give a grayer green. Much of the scumbled effect of the underpainting is left, creating a soft transition between sky and trees. With ultramarine blue and burnt sienna, I paint in the trunks of these background pines.

The limbs on the large pine are restated with ultramarine blue, alizarin crimson, and raw sienna; cerulean blue, cadmium red deep, and yellow ochre; ultramarine blue and burnt sienna; and raw sienna, flesh, and cadmium orange. The positions and shapes of some of the limbs are changed; others are removed by painting over them. Any unsatisfactory shapes painted today are removed with my finger until I get them in the position I want. I'm not detailing any of the limbs; they are merely being positioned. The tiny limbs on the background pines are painted in. I keep them softer and lighter in value than the foreground tree. The upper trunk and dominant limb of the large pine are restated, using more cool colors from the sky.

Day Five

After oiling in, I very delicately repaint the cool sky with a size 6 white sable bright, using ultramarine blue, alizarin crimson, raw sienna, and cerulean blue. This is very lightly scumbled over some of the greens. Raw sienna and Naples yellow are lightly brushed over the tops of the trees on the left. With flesh and ultramarine blue, I paint a bluish, atmospheric color into the pines to suggest distance and shadows. Then I rework the greens with viridian, burnt sienna, yellow ochre, and flesh. These colors will suggest middle tones and lights. This work is done with a size 6 white sable round; the brush is barely touched to the picture as I allow the underpaintings to show through.

With a mixture of burnt sienna and ultramarine blue and a mixture of ultramarine blue, alizarin crimson, and raw sienna, I repaint the trunks and limbs of the background pines. Blues and purples are added to the shadows of the larger trees. The edges are kept soft and indistinct. I remove and soften any harsh edges by touching my finger to the canvas.

Work is continued on the patterns of the green pines. Some areas are subdued, others are highlighted. Designs are altered. An atmospheric mixture of ultramarine blue and flesh is scumbled over the pines.

With the same colors listed on Day 4, I rework the numerous dead limbs hanging from the large pine. The warmth in these dead branches will provide relief from the greens in the background.

Day Six

I begin working at the top of the canvas on the large tree trunk, using the colors already mentioned. Applying the paint in bits and pieces with a size 6 white sable round, I work back and forth from dark to light. The top portion of the trunk is kept in shadow, which gives the tree a feeling of weight. This area reflects more blues from the sky, while in the lower part, I allow more of the warm burnt sienna to bounce up into the shadows. I don't try to delineate all the deep grooves in the tree but suggest the bark in a painterly manner. A light, cool gray-blue (cerulean blue, cadmium red deep, and white) is scumbled over some of the lights, then they are restated with yellow ochre. The edges of the trunk and branches are painted unevenly, rather than smoothly, to indicate the rough bark.

The limbs are reworked as needed. Notice that the limbs are not just stuck on in a harsh manner. The bark of the tree turns out in the direction of the limbs, and there is a slight enlargement where they join the trunk. Blues from the sky illuminate the limbs in shadow. I bring mixtures of cerulean blue, burnt sienna, cadmium orange, and flesh into the dead limbs, then paint the remaining bark that is still clinging to them. Touches of burnt sienna and cadmium red light are painted into this decaying wood. Yellow ochre highlights are stroked onto the limbs. Note the large dead limb on the right. I have emphasized the fork on the end that points back to the center of interest and deemphasized the one pointing out of the picture. This is one method of leading the eye to the "star" of the painting.

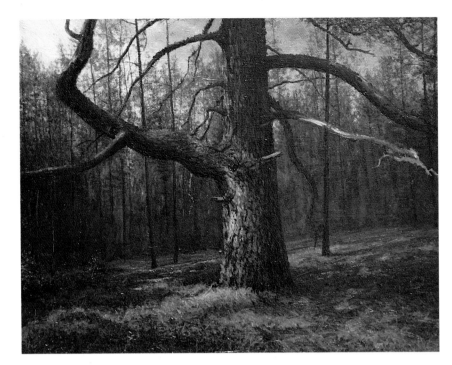

*Day Five:
I restate the trees that were overpainted with sky color. I adjust the limbs on the large tree until I am satisfied with their arrangement and develop the background pines, pushing them into the distance by scumbling over them with atmospheric color.*

I paint back into the sky to adjust the designs of the trees. The greens on the upper right side of the painting are reworked, showing a suggestion of needles on the nearer pines. The dark triangular shape on the left is repainted. This shape, along with the bushes, keeps the slope of the hill from sliding the viewer out of the picture. Pinecones are vaguely suggested on the background trees with light touches of the brush.

In the little remaining time, I flick some grays on the forest floor and paint a few vines up the large tree trunk.

Day Seven

The first thing I do is take a sketchbook and pen into the woods near my studio. After studying the various plants, bushes, vines, etc. and making a few quick sketches, I return to the studio and begin work on the forest floor. With the colors used on the large pine, I suggest fallen limbs, twigs, and pinecones. Grays and purples are scumbled over the underlying colors. Plants, grasses, bushes, and vines are suggested with greens of permanent green light, burnt sienna, raw sienna, cadmium yellow light, and flesh. Darks are viridian, burnt umber, and ultramarine blue. These greens are scumbled horizontally over the ground in the distance.

The colors of the pine straw are stroked up the lower portion of the pine. There is a buildup of needles at the base of the pine and a gradual transition from tree to straw. I heighten the light at the base of the tree with Naples yellow and cadmium red light; these colors are touched into the highlights on the lower section of the tree and scumbled lightly over the distant lights on the ground.

With Naples yellow and raw sienna, I intensify the light of the sky on the left. I paint over a pine in this area to lower it, altering the design, and I paint over the pines on either side of the large pine. Lowering the trees on the left will point the eye down to the large pine, which is the center of interest. The major directional lines in a painting should enhance and lead the eye to the focal area. The tree on the right is painted over because it interferes with the large pine and suggests a vertical movement contrary to the width and weight I want to convey.

With a size 6 white sable round, vines are dragged up the large tree and around the dead limb on the right. Squiggly brushstrokes give a feeling of movement without outlining every vine. More greens are stroked in the vines. Fallen pine needles that have lodged in the vines and bark are suggested. Yellow ochre is used for the final highlight on the trunks of the pines. Ultramarine blue and flesh are scrubbed diagonally over the pines on the left to faintly suggest sunrays. The painting is finished.

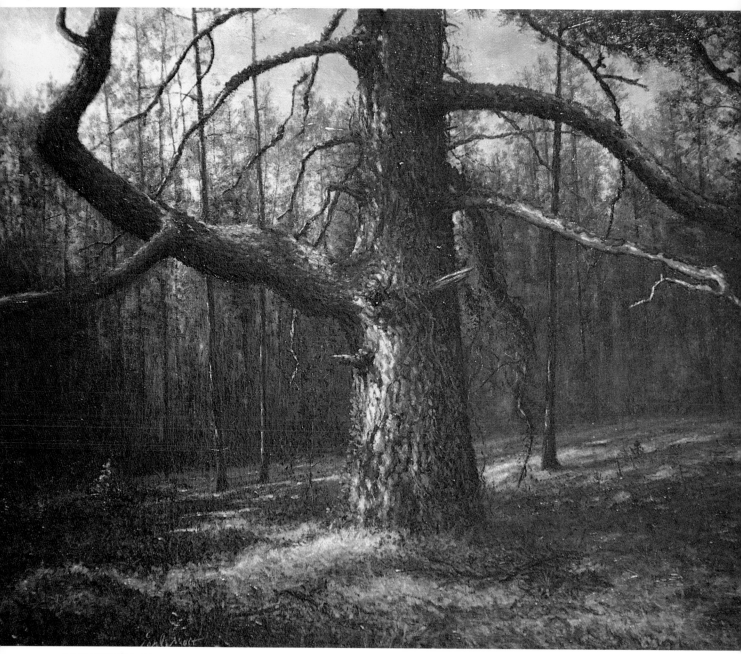

THE FOREST GIANT *Oil on canvas, 16" × 20" (40.6 × 50.8 cm), collection of Mr. Travis A. Taylor*

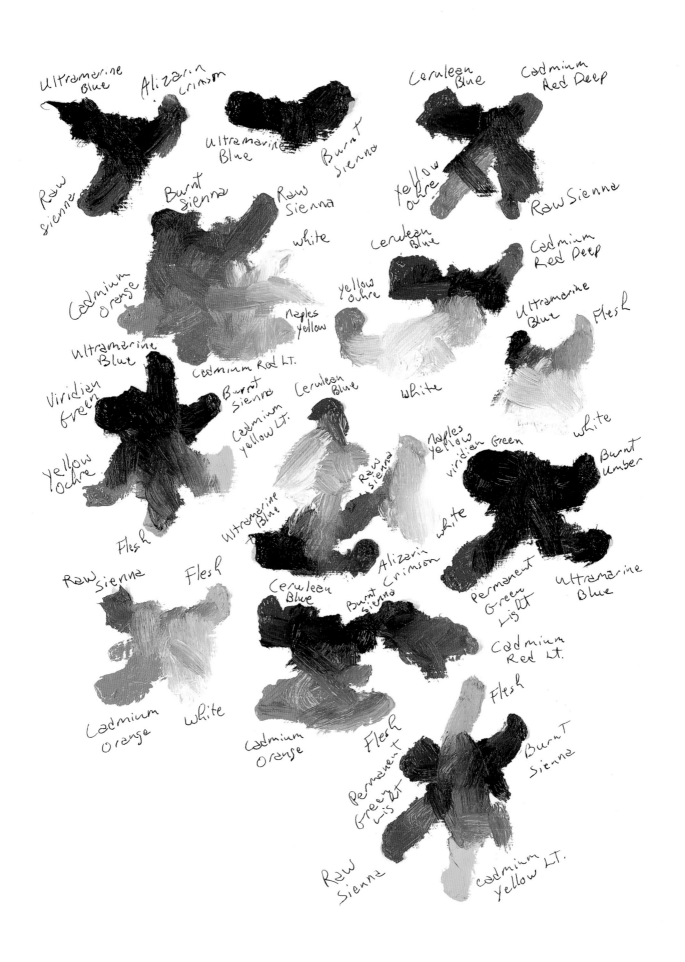

Ultramarine Blue

Alizarin Crimson

Ultramarine Blue

Burnt Sienna

Ceruleen Blue

Cadmium Red Deep

Raw Sienna

Burnt Sienna

Raw Sienna

Yellow Ochre

Raw Sienna

white

Cadmium Orange

Ceruleen Blue

Cadmium Red Deep

yellow ochre

Naples Yellow

Ultramarine Blue

Flesh

Ultramarine Blue

Cadmium Red LT.

white

Viridian Green

Burnt Sienna

Ceruleen Blue

Cadmium Yellow LT.

Yellow Ochre

Naples Yellow

Viridian Green

white

Burnt Umber

Flesh

Raw Sienna

Ultramarine Blue

white

Permanent Green Light

Ultramarine Blue

Raw Sienna

Flesh

Cadmium Red LT.

Cadmium Orange

White

Ceruleen Blue

Alizarin Crimson

Burnt Sienna

Flesh

Cadmium Orange

Flesh

Permanent Green List

Burnt Sienna

Raw Sienna

Cadmium Yellow LT.

Sunrise at Sam Rayburn Lake

I have painted at this spot and near here many times. I have seen and painted the lake shrouded in fog and have watched the sun burn through as the fog cleared. The mood I want is a misty morning with a light fog. Forms will be dissolved in the morning light. The lake is calm, the scene quiet. Maybe there will be an early morning fisherman, a camper's fire on the distant shore, or even some ducks on the water (which I observed when painting on location). The sources of inspiration for this painting are the outdoor work and firsthand observation. The small ink sketches helped me compose the painting.

The luminist paintings of the nineteenth century appeal to me quite a bit, and the mood and feeling of this painting will be similar to those evident in that work.

Compositional sketches for Sunrise at Sam Rayburn Lake

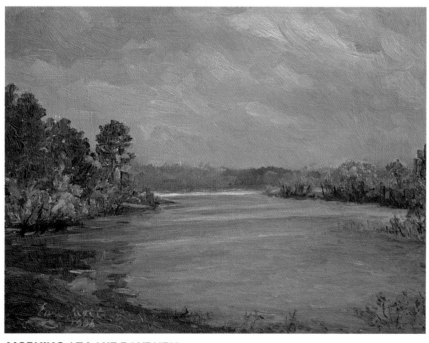

MORNING AT LAKE RAYBURN *Oil on mat board, 11" × 14" (27.9 × 35.6 cm)*

I have done several paintings at this location, which enabled me to get the feel and mood of the place and greatly helped in doing the studio work.

Day One

My first concern is the overall design of the picture as the drawing is sketched in with charcoal. I don't get involved in the small details of the painting at this stage, but concentrate on the large shapes and patterns: where I want the horizon line, the shorelines, and the vertical division of the tree masses. This is an important phase of the work and should not be done carelessly. When the drawing is complete, it is outlined with yellow ochre and turp and the excess charcoal is dusted off.

A mixture of viridian, burnt umber, and ultramarine blue gives me a basic dark for the pines on the left. Into this I bring permanent green light and sometimes raw sienna, using a size 3 bristle flat. After indicating a few darks in this area, I establish a value and color for the water in the near foreground with cerulean blue and black. As usual, when I use black, it is made of ultramarine blue, burnt sienna, and a bit of alizarin crimson. A mound of this color is mixed thoroughly with the palette knife and placed along the outside perimeter of the palette with the tube colors.

I use a size 4 bristle round in the water and, with the same brush, mix a purple of ultramarine blue and cadmium red light for the clouds. Yellow ochre and flesh are worked into this in places. For the clouds and atmosphere toward the right, I use cerulean blue, black, and yellow ochre. The lower parts of these clouds are gradually lost in the fog over the lake as the upper sections break away to the open sky.

Since I now have darks and middle values on the canvas, I turn my attention to the lights as I paint the sun and surrounding warmth with a size 6 bristle flat. I work in a light gray-blue (cerulean blue and black) at the top of the canvas and bring this on down into the light area (which consists of Naples yellow, cadmium yellow light, and flesh). I go back to the clouds and finish painting them, using a pastel study done on location as a reference. These various designs and patterns are roughed in with the approximate colors and values.

I completely cover the sky, then return to the pines on the left and finish painting them. These are treated as a mass and not as individual trees. They are not painted flat, however, but with depth and form. I brush some of the blue-gray atmosphere (cerulean blue and black) into the pines. Everything must tie together, and a good way to do this is to repeat colors.

I move over to the right bank and begin establishing a pattern of trees shrouded in morning atmosphere, using Naples yellow, permanent green light, flesh, raw sienna, and cadmium yellow light. I don't cover the area completely but go to the most distant plane, which is simply cerulean blue and black lightened with white. With a mixture of cerulean blue and cadmium red deep and a mixture of ultramarine blue, alizarin crimson, and raw sienna, I paint in the distant shore on the left. Most of this area is in shadow and is painted about the same value as the pines. The reflection of the near pines is painted with the same colors as the pines, of course. The reflections are painted more obscurely and with broken color so they won't compete with the pines.

The water in the open lake is worked in with the same colors used in the sky. There are soft, gentle, rolling waves coming to the shore. These waves are given form by simple light-and-dark patterns. The nearer side is in shadow while the top of each wave picks up light from the sky. The sun's reflection across the lake is painted with the same warm mixtures used in the sky. The strokes in the open water are mostly horizontal, but it is by no means painted like a flat wall! Wind ripples break up the reflections of pines on the left. Yellow ochre, permanent green light, and flesh are used to paint in the scum on the water toward the right. Sky color and the warm sunlight colors are dashed into this.

Alizarin crimson and cadmium orange are worked into the trees on the right, and burnt sienna on the left, for a touch of autumn. A couple of small islands are indicated. On the near shore I use cadmium orange and cerulean blue; cerulean blue and cadmium red deep; and ultramarine blue, alizarin crimson, and raw sienna. This area is painted in thickly with broken color. Lights are indicated on some of the distant trees with Naples yellow, permanent green light, and flesh. With a size 1 bristle flat, I paint a few sky holes into the pines on the left. White is worked into the sun to make it more distinct. The canvas is now covered.

—Day Two

The painting is brushed with painting medium. I begin working in the grayed blue at the top of the sky, using the same color mixtures as on Day 1. A light blue is painted in, then a light yellow (Naples yellow and flesh) is painted into the blue. Cadmium yellow light is used nearer the sun. The clouds are then developed, creating various patterns as they break away and rise into the sky. I further establish the glow from the sun by strengthening the surrounding yellow, but I don't rework the actual sun now. A size 8 Langnickel sable has been used for this work.

I paint over the distant plane, bringing a touch of ultramarine blue and flesh into the gray of black and cerulean blue. Yellow ochre and Naples yellow are introduced. The edges are kept soft and atmospheric. The same colors are brought down into the water as it takes on the colors of its surroundings. Sky colors (purples and grays) are drybrushed over the trees. I use a size 2 bristle flat for this.

The patterns of the waves are reworked and refined without going into a lot of detail. The tree reflections are reworked with the same colors as before. Here the strokes are kept small, choppy, and broken as the reflections are broken by the movement of the water. The near shore is repainted. I pile the paint on here for a textured effect that will contrast with the peaceful, smoother water.

—Day Three

The entire painting is oiled in again. With a size 4 Langnickel royal sable, I begin refining the dark, atmospheric pines on the left. Viridian, burnt umber, ultramarine blue, permanent green light, and raw sienna are used for this. These tones are generally dark. A combination of ultramarine blue and flesh, followed by a combination of black and cerulean blue, is worked in for atmosphere. Later, I will scumble some lights over these pines. I leave some of the sky showing through. With a size 6 white sable round, I restate the reflections of these trees. The colors are applied in bits and pieces to give a feeling of movement. Wind ripples are used to break up the reflections still more.

I paint in more warm yellow (Naples yellow, cadmium yellow light, and flesh) around the sun and add more white in the sun itself. These same colors are drybrushed down from the sun for sun rays. I lighten the distant water where the sun is hitting, using pure white for the lightest area, directly under the sun. The warm yellow from the sky is brought down into the water. Near the shore, darks of black and cerulean blue are dashed in, followed by cerulean blue and white and then the yellows for a choppy effect as the waves hit the shore.

With a size 6 white sable round and a size 4 royal sable, I rework the trees on the right. Naples yellow, permanent green light, flesh, raw sienna, and cadmium yellow light are used in the willows. For the pines behind the willows, I use the same colors that were used in the pines on the left of the painting. A few willow tree trunks are indicated. I move quickly to repaint the reflections and the algae and scum on the water. The same colors used in the trees are now repeated in the water. The gentle sunlight (Naples yellow, cadmium yellow light, and flesh) is touched on the trees, scum, water, and shore.

*Sun:
(clockwise) Naples
yellow, cadmium
yellow light, white,
flesh*

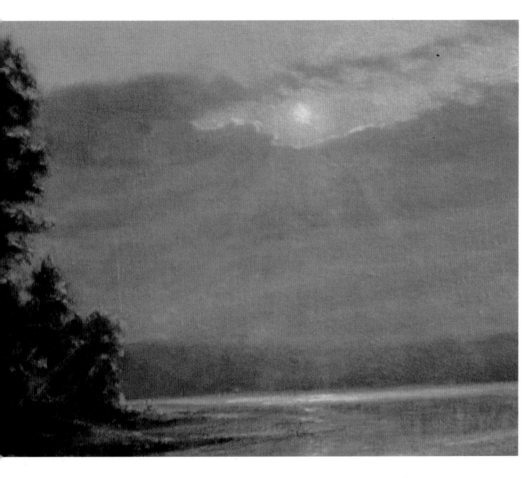

The approximate colors and values were roughly painted in on Day 1 and restated with a little more refinement on Day 2. More light from the sun was introduced in the sky, distant plane, and water; warm yellow sunrays were scrubbed over the dry underpaintings. White was applied to the distant highlight. Later, the light rays were strengthened even more and the yellow light was rubbed horizontally over the water. Light on the water was intensified again on Day 6 with scumbles of white.

*Sky, water, and
distant plane:
(clockwise from
top left)
ultramarine blue,
cadmium red light,
white, black
(ultramarine blue,
burnt sienna,
alizarin crimson),
white, ultramarine
blue, flesh, yellow
ochre, white,
Naples yellow,
cerulean blue,
yellow ochre,
white*

*(clockwise from top left)
cerulean blue, black, yellow
ochre, cadmium red light,
ultramarine blue, white*

*(clockwise from top left)
Naples yellow, permanent
green light, raw sienna,
cadmium yellow light, flesh*

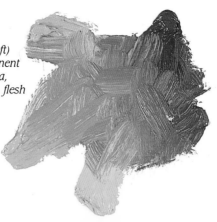

*In this detail, you can see how color is dragged over
color several times to achieve a depth and richness
that is sometimes missing in paintings that are done
alla prima.*

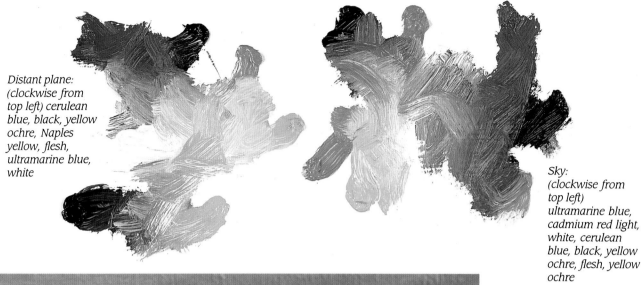

Distant plane:
(clockwise from
top left) cerulean
blue, black, yellow
ochre, Naples
yellow, flesh,
ultramarine blue,
white

Sky:
(clockwise from
top left)
ultramarine blue,
cadmium red light,
white, cerulean
blue, black, yellow
ochre, flesh, yellow
ochre

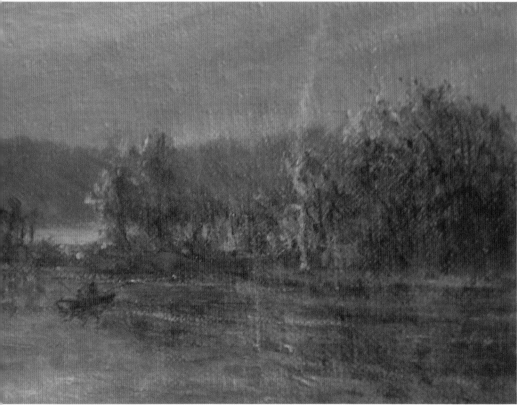

I worked on this particular area every day except Day 5. The design and colors were generally stated on Day 1, then slightly refined on the second day. The trees were almost completed on Day 3, while I concentrated on the light-and-dark patterns. Atmospheric grays were scrubbed over the surface on Day 4, and light from the sun was scrubbed in lightly. The boat, figures, and camp were painted. On Day 6, the lights on the trees were intensified and more fog color was scrubbed over these. Warm light was rubbed over the water; white was used for the strongest highlights. These fog and sunlight colors were painted into the picture from the beginning, then I adjusted them by scumbling, which also adds to the depth and realism.

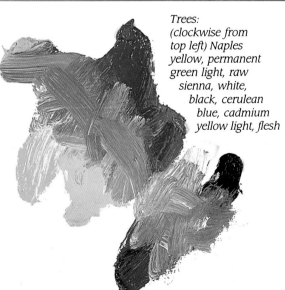

Trees:
(clockwise from
top left) Naples
yellow, permanent
green light, raw
sienna, white,
black, cerulean
blue, cadmium
yellow light, flesh

Scumbles of light
over water:
(clockwise from
top left) Naples
yellow, cadmium
yellow light, flesh

Day Four

The sky is brushed with medium. A size 6 Langnickel sable is used to delicately repaint the blue sky. I bring alizarin crimson into the cerulean blue and gray this with black and white, mixing these colors on the palette and lightly brushing and scumbling over the surface, allowing the underpaintings to show through. The value is darkened and grayed slightly and scumbled down nearer the sun. The yellow is too strong around the sun, so this area is repainted with more white. Light is stroked on the undersides of the cloud patterns above the sun. An old size 2 white sable is used to scrub in the light rays more distinctly. The area near the sun, down to the water, is scrubbed with this warm light, which is also stroked horizontally over the distant water and parts of the trees. The gray atmospheric color is scrubbed over the trees. Highlights are applied to the pines on the left with the colors used previously (their basic colors) and Naples yellow and flesh. A campfire and tent are painted in on the right bank. A boat and figures are painted very suggestively, as the landscape will dominate over the human interest. A light value of cerulean blue and black is stroked in vertically on both sides of the lake and in the distance for the effect of fog rising off the water.

Day Five

With a size 6 Langnickel sable, I gently restate the water in the foreground. Then, with a size 6 white sable round, I highlight the tops of the waves. Following this, I scumble over the near shore with lights and darks of the same colors used on Day 1. Grasses are worked in at the water's edge. The patterns of growth in the water are restated. A few dead trees and limbs are introduced. Reflections are repainted. Some areas are subdued, while others are highlighted.

Day Six

I brush medium over the entire canvas, since I plan on working all over it; I will finish the painting today. I intensify the yellow around the sun and put pure white into the sun itself. The highlights on the clouds are heightened. With an old size 2 white sable, I scrub the subtle yellow (Naples yellow, cadmium yellow light, and flesh) out around the sun, allowing the underlying colors to show through. I bring up the yellow in the water a bit. Fog color (cerulean blue and black) is scrubbed over the tree areas, and vertical strokes on the water indicate the fog burning off as the sun shines through it.

I rework the pines on the left; I don't want to bring out individual trees, so I leave them as a mass, only vaguely indicating the tree trunks. Some light areas are intensified, and a few lights are picked out of the trees on the right. White is used for the strongest highlights on the water. I repaint the distant bank on the left, allowing the trees, bank, and water to melt into one another. Some of the warm light is scrubbed over the water. Fog color is touched over the boat, the figures, and the camp. Wind ripples are highlighted with white. The work is now finished.

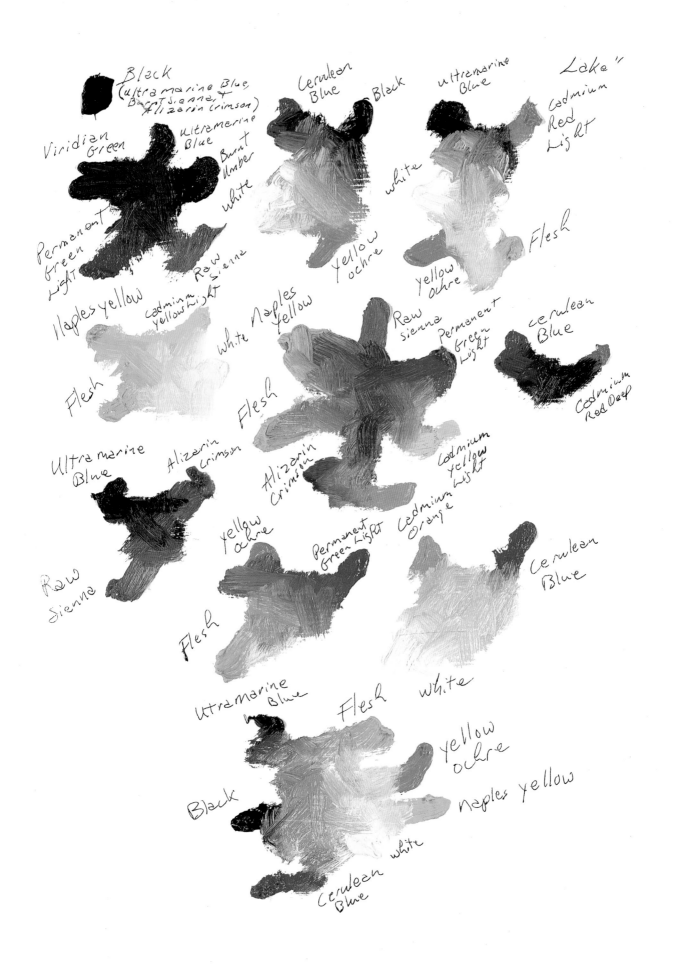

Black
(Ultramarine Blue,
Burnt Sienna, &
Alizarin Crimson)

Cerulean
Blue Black

Ultramarine
Blue Lake"

Viridian
Green Ultramarine
 Blue Cadmium
 Burnt Red
 Umber Light
 white
Permanent white
Green
Light Raw Flesh
Naples yellow Sienna
 Cadmium Yellow
 Yellow Light Yellow Ochre
 ochre
 White Naples
 Yellow
Flesh Raw Permanent Cerulean
 Sienna Green Blue
 Light
 Flesh
 Cadmium
 Red Deep
Ultramarine Alizarin Cadmium
Blue Crimson Yellow
 Alizarin Light
 Crimson

 Yellow Cadmium
 ochre Orange
Raw Permanent
Sienna Green Light Cerulean
 Blue
 Flesh

 Ultramarine Flesh white
 Blue
 Yellow
 ochre
Black Naples yellow

 Cerulean white
 Blue

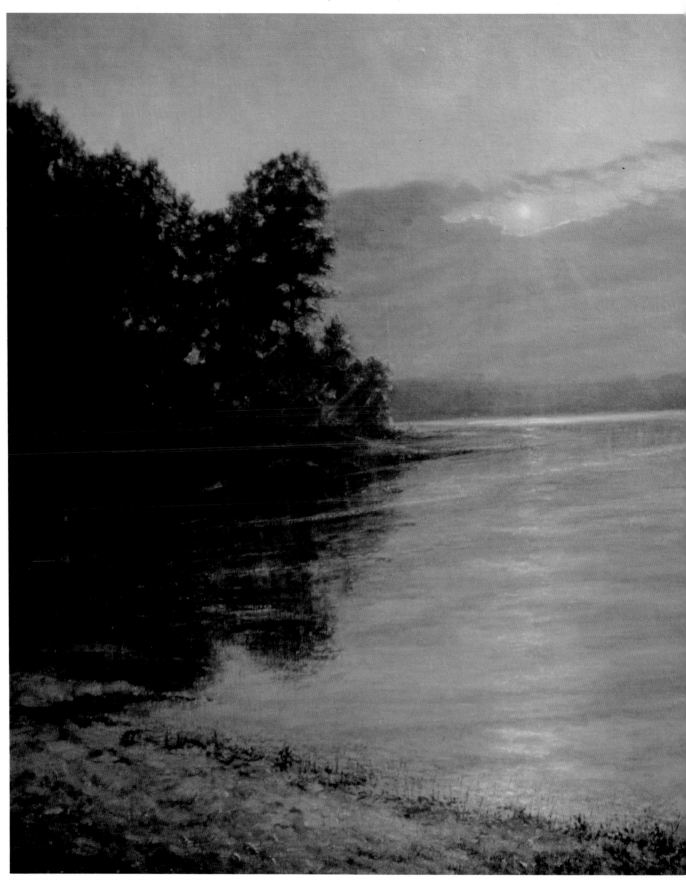

SUNRISE AT SAM RAYBURN LAKE *Oil on canvas, 18" × 30" (45.7 × 76.2 cm), collection of Mr. Travis A. Taylor*

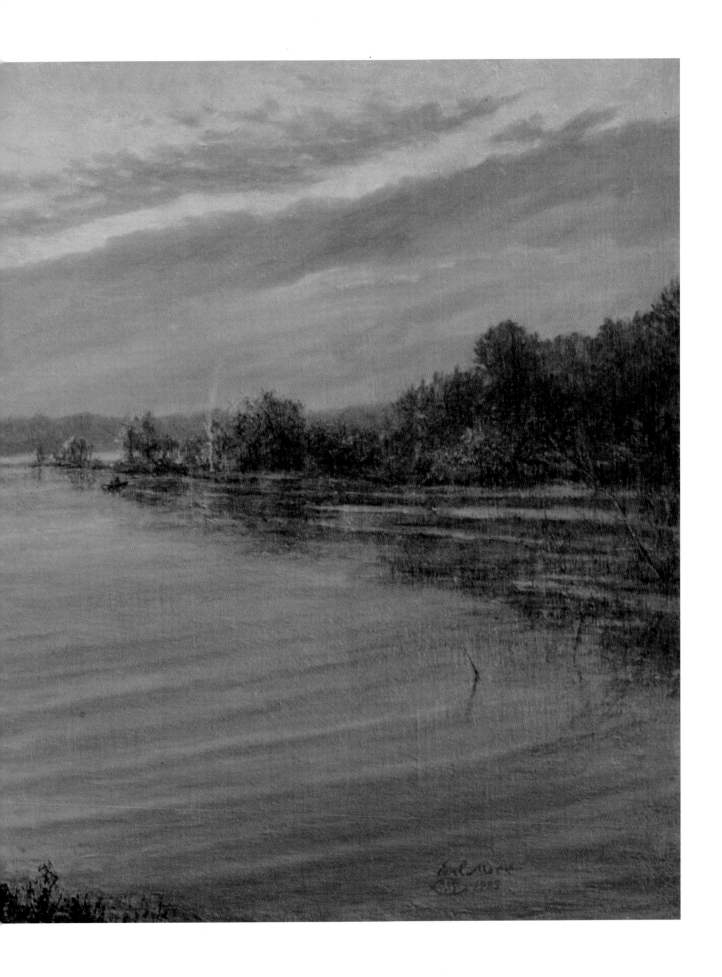

Seasons of Change

Near my studio is an old dwelling that is typical of houses built several years ago. There's a main structure with additional rooms added on through the years. Nothing fancy—just ordinary, for ordinary folk. I've been thinking of including it in a painting someday. My thoughts go to autumn— changing seasons, changing times. A mellow mood. Homey, neighborly. The foreground will be thrown into shadow as the sun creates strong contrasts on the house. Cool autumn winds blow clouds across the sky and scatter leaves across the landscape. The house and a nearby figure burning off dead grass and raking leaves will be the center of interest.

Autumn here in east Texas is not uniform; some trees will have beautiful colors and some will not. It's hard to find nice autumn trees in one spot. When I do a painting like this, I use photos I've taken of various trees as references and place the trees in the painting for a more desirable composition.

Compositional sketches for Seasons of Change

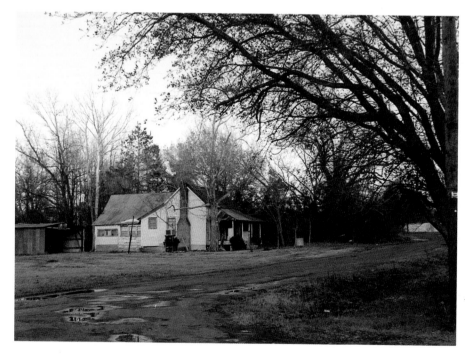

Reference photo

As usual, I begin by sketching with charcoal, holding the charcoal stick at about a thirty-degree angle to the canvas. This helps me to stroke the charcoal on broadly. I hold it, not between the fingers, as in writing, but under the hand, and draw with sweeping strokes using full arm movement. I'm not afraid of making mistakes; I simply dust them off with a paper towel. The finished drawing is outlined with turpentine and yellow ochre, and the remaining charcoal is dusted off the canvas.

I could begin painting any of the darker tones. I choose to start with the darks on the house; cerulean blue and cadmium red deep make a nice, dark gray tone here. I use a size 3 bristle flat and brush this cool tone over the shadowed roof as well. I work burnt sienna and raw sienna into this for the rusty roof color and brush on a lighter value of cerulean blue and cadmium red light for the sunlit roof. I mix a small batch of cadmium orange and Naples yellow to stroke beside the shadowed front wall. This is done to check the value contrast.

The house is left at this stage for now. I begin to brush some autumn colors on the trees around the house using the following mixtures: alizarin crimson, raw sienna, and ultramarine blue; cadmium orange, cadmium yellow light, and flesh; alizarin crimson, ultramarine blue, and flesh; and cerulean blue and cadmium red deep. I'm painting, not specific trees, but patterns that suggest trees. Some of these colors are stroked into the foreground.

Darks mixed from ultramarine blue, alizarin crimson, and raw sienna and from burnt sienna and ultramarine blue are brushed in for the road. Usually I paint dirt roads, but this time I'm going to paint the oil-top road that's actually there. The grays from the house and the autumn colors are brushed into the road. The curve at the peak of the hill points the eye back into the picture.

Alizarin crimson, viridian, and raw sienna combined make a gray for the garage, and the dark interior is the color used on the road. Variations in value applied with a bristle brush can suggest the rough, weathered boards. The paint is not smoothed out but applied roughly.

I now have a few strokes of color on different areas of the canvas. I go back to the large tree on the right and begin establishing darks and lights. Ultramarine blue and alizarin crimson are used in the shadows. The lights are cadmium orange, cadmium yellow light, and flesh. I'm using a size 4

bristle round; this work is done very loosely and casually. The foliage on the left of the house is painted in completely with the color mixtures mentioned earlier. Ultramarine blue and flesh establish a distant plane on the right.

The sky is brushed in with a size 6 bristle brush. Cerulean blue and white are grayed with the foliage colors (which are allowed to mingle with the sky when I paint near the trees) and stroked into the trees for sky holes. Ultramarine blue, cadmium red light, and raw sienna are used for the clouds, which are highlighted with cadmium orange and Naples yellow. The directional force of the clouds gives the impression that they are driven by the wind. Sky colors are painted over the spot where the foreground tree will be placed.

I come back to the foreground area with the size 4 bristle round. Permanent green light mixed with yellow ochre and raw sienna; ultramarine blue, alizarin crimson, and raw sienna; and touches of the other foliage colors are used here. A variety of strokes are brushed on and left. Sometimes the brush is used like a painting knife. This area is completely covered and kept darker because it is in shadow. The burned-off area, fire, and smoke are indicated.

The darker foreground tree is brushed in with no detail, using alizarin crimson, ultramarine blue, and raw sienna. I lighten the trees behind it to create more contrast. The tree trunk is painted with a mixture of ultramarine blue, alizarin crimson, and raw sienna and a mixture of cerulean blue and cadmium red deep. The other tree trunks are now brushed in suggestively.

I return to painting the house, using a size 2 bristle flat. A light gray (cerulean blue and cadmium red light) is worked into the more predominant mixture of cadmium orange and Naples yellow for the sunlit walls of the house. The house is not just painted flat; a variety of values and brushstrokes are used to suggest boards. Shadows under the eaves and by the chimney are painted with the darker, cooler gray. Windows are indicated with a minimum of detail, using only a few darks and lights. Cadmium red light and yellow ochre are used for the sunlit side of the chimney, and ultramarine blue, alizarin crimson, and raw sienna are used in the shadow. The corrugated tin roofing is painted in at the bottom of the house.

The garage roof and the roof on the house are painted in with grays of cerulean blue and the two cadmium reds. Burnt sienna and raw sienna are worked into the roofs.

Different pieces of tin roofing are suggested by different colors and values. A fence is casually indicated on the right, near the large tree. The canvas is now covered. The mood, design, color, and values are established. Later, a figure raking and burning leaves will be painted, but there's plenty of refining to do first.

I did not mix stand oil with the fresh paint that I put on the palette for this under-painting. Therefore, this painting will have more texture than some of the others. You can control the texture in a painting with the amount of medium used as well as with the type of brushes—the bristles will give more texture, the sables less.

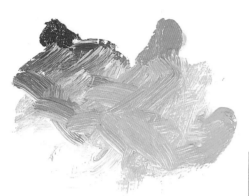

Sky:
cerulean blue, cadmium
orange, flesh, white

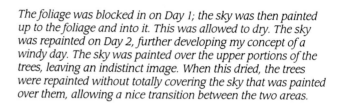

The foliage was blocked in on Day 1; the sky was then painted up to the foliage and into it. This was allowed to dry. The sky was repainted on Day 2, further developing my concept of a windy day. The sky was painted over the upper portions of the trees, leaving an indistinct image. When this dried, the trees were repainted without totally covering the sky that was painted over them, allowing a nice transition between the two areas.

Clouds:
(clockwise from top left)
ultramarine blue, cadmium
red light, raw sienna, flesh,
Naples yellow, cadmium
orange, white

Autumn Trees:

ultramarine blue,
alizarin crimson,
raw sienna

cadmium orange,
cadmium yellow
light, flesh

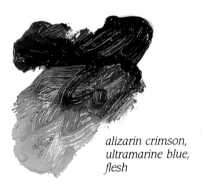

alizarin crimson,
ultramarine blue,
flesh

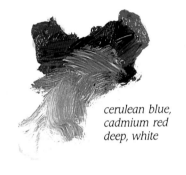

cerulean blue,
cadmium red
deep, white

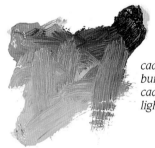

cadmium orange,
burnt sienna,
cadmium yellow
light

cadmium yellow
light, white, flesh,
raw sienna

Roof:
(clockwise from top left) burnt sienna, raw sienna, cadmium red light, white, yellow ochre, cerulean blue

Ground:
(clockwise) ultramarine blue, alizarin crimson, white, cadmium orange, raw sienna

Here you can see the casual approach given to one of the secondary areas of interest. The lights are more subdued and the contrasts are not as great as those on the house. Much of the roughness of the underpainting is retained to better capture the true nature of the old building.

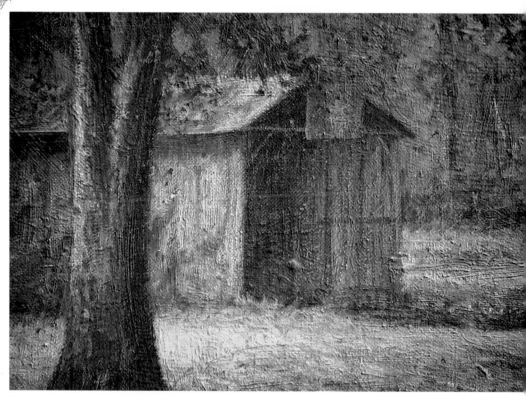

Garage:
(clockwise from top left) alizarin crimson, viridian, white, white, cerulean blue, cadmium red light, yellow ochre, burnt sienna, ultramarine blue, alizarin crimson, raw sienna

Day Two

As usual at this stage, I brush painting medium over the entire surface. I begin to rework the sky with cerulean blue, cadmium orange, and flesh, using a size 8 Langnickel royal sable. The sun is over toward the left, so of course this area is lighter and warmer — more cadmium orange and flesh. On the right, the grayed blue of the sky is scumbled over the underpainting, allowing the underpainting to show through. Ultramarine blue, cadmium red light, and raw sienna are mixed for the clouds. I try to retain the freedom of the underpainting by avoiding hard edges. Spontaneity is the desired effect. The sky colors are brushed right over the trees, leaving a nebulous image.

With the earth colors used on Day 1 and a size 3 white sable bright, I work over the ground area. A pattern is developed that shows the burning off of the dead grass and leaves. A suggestion of fire is flicked on with upward strokes of oranges and yellows. The grass is painted, using a variety of strokes — crisscross, vertical, and horizontal — all very casual and natural.

I move on to the oil-top road with darks mixed from ultramarine blue, alizarin crimson, and raw sienna and from burnt sienna and ultramarine blue. Over this I work cerulean blue and cadmium red deep, plus colors from the grass. Form and texture are suggested by the different colors and values scumbled over the textured underpainting. I repaint the grass patch on the right without bothering with detail. A purple atmospheric haze of cadmium red light and ultramarine blue is drybrushed over the lower section of the trees.

The garage walls are restated with viridian, alizarin crimson, and raw sienna; cerulean blue, cadmium red light, and yellow ochre; and burnt sienna and ultramarine blue. A size 2 white sable bright is used. The roof is repainted with cerulean blue, cadmium red light, and yellow ochre. Even though I'm working more slowly and carefully than on Day 1, this is still not the time for detail; that will come at a later stage of the painting.

The house is restated with basically the same colors as on Day 1. Today's work is a restatement of the first underpainting with a small step upward in refinement.

Day Three

Medium is brushed over about two-thirds of the canvas, from the bottom of the trees down. I'm going to use a brush not listed in Part I, a size 2 red sable flat. With the same mixtures I used in the previous underpaintings, I begin to refine the house. The shadow side is lightened somewhat with strokes that generally follow the horizontal boards of the house. A few dark accents are placed here and there on the house and roof. I do nothing to the windows. The light side is heightened in value as the paint is dragged on, allowing the underpaintings to show. The tin around the bottom of the house is repainted, along with the tin roof. The various colors are scumbled into and over each other to get a mottled, rusty appearance.

Color is dragged over the garage in vertical strokes to create a rugged, weathered effect. A shadow is splashed over the garage for more interest.

With a size 2 white sable bright, I scumble various mixtures of colors over the ground area: permanent green light mixed (in separate mixtures) with Naples yellow, yellow ochre, raw sienna, burnt umber, and burnt sienna; cadmium orange and burnt sienna; yellow ochre and burnt sienna; cadmium yellow light and cadmium orange; cerulean blue, cadmium red light, and cadmium red deep; alizarin crimson, ultramarine blue, and raw sienna; cadmium red light and ultramarine blue; and viridian and alizarin crimson. These colors are stroked on the ground in bits and pieces to indicate leaves, grass, dirt, etc. The burned-over area is repainted with darks mixed from cerulean blue and cadmium red deep and from alizarin crimson, ultramarine blue, and raw sienna. Some areas are just lightly scumbled over. I don't develop the fire and smoke very much now — I just dash in a few flicks of red, yellow, and orange for fire and cerulean blue and cadmium red light for smoke.

Purple is touched over sections of the background trees. Autumn colors are scumbled on near the right side of the house. A distant house is indicated. The grass in the right foreground is repainted with light scumbles of previous colors. More gray earth colors are dragged over the dirt road as it joins the oil-top road.

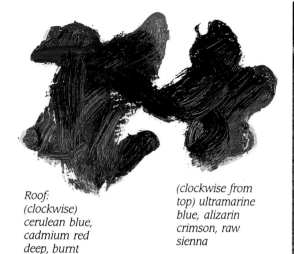

Roof:
(clockwise)
cerulean blue,
cadmium red
deep, burnt
sienna, raw sienna

(clockwise from
top) ultramarine
blue, alizarin
crimson, raw
sienna

Oak tree:
cadmium yellow
light, flesh, white,
cadmium orange

(Clockwise)
cadmium orange,
ultramarine blue,
alizarin crimson

Shadowed wall:
cerulean blue,
cadmium red deep

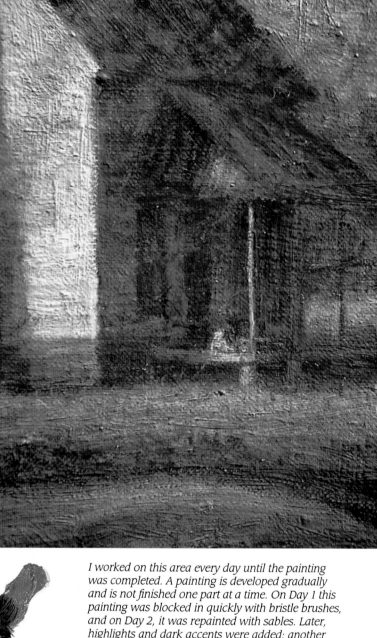

Sunlit wall:
(clockwise from
top left) cerulean
blue, cadmium red
light, Naples
yellow, cadmium
orange, white

I worked on this area every day until the painting
was completed. A painting is developed gradually
and is not finished one part at a time. On Day 1 this
painting was blocked in quickly with bristle brushes,
and on Day 2, it was repainted with sables. Later,
highlights and dark accents were added; another
day, leaves were dashed in and smoke scrubbed
over the surface. Different aspects of the work were
done on different days, building the painting
gradually to completion.

Day Four

The area of the trees is brushed with painting medium. Using a size 4 Langnickel sable, I begin to carefully rework them, using autumn colors obtained from a color pool of alizarin crimson, ultramarine blue, raw sienna, cadmium orange, burnt sienna, and cadmium yellow light. I apply the colors softly, using the brush to obtain the look of leaves. These are not painted solid. The sky that was scumbled over the trees on Day 2 is allowed to show through. Parts of the foliage with the sky painted over them are left in this condition to unite these two areas. Don't paint the sky only as a backdrop for a landscape. It has a great influence on the entire landscape.

Tree trunks and limbs are pulled up into this mass with a size 6 white sable round. The bare sunlit limbs are painted with raw sienna, cadmium yellow light, and flesh. Grays and purples are introduced into the foliage (cerulean blue and cadmium red deep; flesh, ultramarine blue, and alizarin crimson).

A worn size 2 white sable flat is used to paint in the texture and appearance of the leaves on the foreground tree. This tree is painted dark against the lighter background, using ultramarine blue, alizarin crimson, and raw sienna. The edges of the foliage patterns are not painted hard and solid. Some leaves are painted as if they were detached from the tree, and the background trees and sky are allowed to show through. The limbs and tree trunk are painted with these same colors plus cerulean blue and cadmium red deep.

Deeper reds, purples, and blues are stroked in on the shadow side of the oak on the right. I alternate between these darks and the lights (cadmium orange, cadmium yellow light, and flesh), working them into and over each other. The same colors used on the other tree trunks are used here as the limbs and trunk are stroked in and other background trees are suggested. Tree limbs entering the picture from the right are painted. The fence is scumbled softly with darks and lights. With the tip of the worn size 2 white sable, I go back to the trees and smudge and subdue some of the limbs with the colors of the leaves.

Day Five

Refer to Day 1 for the colors used today. I begin by refining the house, barely touching the brush to the canvas. Some boards are grayed and weathered; others are highlighted. I don't try to paint boards, but merely create an illusion of boards. The roof is delicately scumbled over, which builds up the pigments and adds to the depth of color. The windows are painted very simply—darks and lights of the predominant colors in the painting. There is no need to paint all the windowpanes; only a suggestion is enough. The front of the house needs very little work. The posts and steps are suggestively painted. The chimney is painted with ultramarine blue, alizarin crimson, and raw sienna for the darks and cadmium red light, yellow ochre, and raw sienna with bits of cadmium orange for the lights. The bricks are suggested with vertical and horizontal strokes of these various colors. I make no effort to paint individual bricks; when I look at a brick wall, I don't see every brick, I see a mass of bricks.

The tin around the bottom of the house is scumbled over with more of the rusty reds. Using an old size 2 white sable, I scrub in more smoke with grays obtained by adding white to the darks used earlier. I lightly rework the patterns in the grass and the burned-off area of the yard. Yellows and oranges are flicked on for fire. The road is lightly scumbled with the colors used on the first days.

The garage walls and roof are scumbled lightly with lights and darks of previous colors, allowing the underpaintings to show through. The construction timbers in front are painted in, and a basketball net is suggested on the backboard.

The old size 2 white sable used for texturing is now used to rework the large oak on the right. The whole tree is lightened; the old brush gives the illusion of leaves.

House:
(clockwise from top left) cerulean blue, cadmium red light, cadmium orange, Naples yellow, white

Roof:
(clockwise from top left) cerulean blue, cadmium red light, yellow ochre, burnt sienna, white

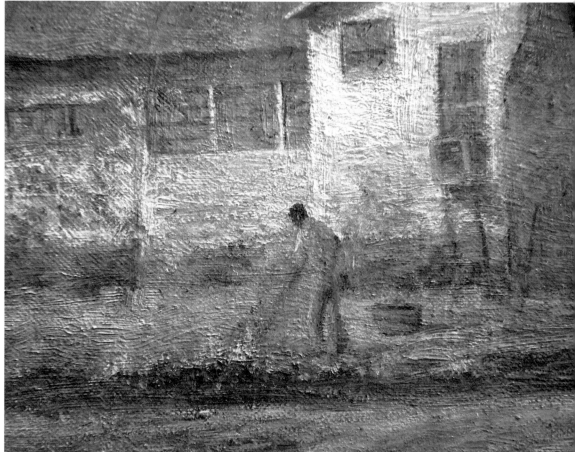

All areas of a painting should work together to express the desired mood. The figure and the windblown smoke and leaves in this detail add to the feeling of a windy autumn day.

Day Six

There are many small things to do today. A size 6 white sable round will be used. Chairs and other items are suggested on the porch. The large side window is lowered. The front windows and the door are raised. An air conditioner, a tub, and a man are painted; all of these are suggested instead of being done in hard-edged detail. The tree trunk on the left is repainted with a little more detail. Falling leaves are dashed over the painting. Tree shadows on the house are splashed on and made to look "airy." A mailbox leaning into the picture on the right is painted. This helps to act as a stop for the road. The tree limbs entering the picture on the right are strengthened; they also act as a stop. The bluish atmosphere in the background is scrubbed over with ultramarine blue and flesh, using the worn size 2 white sable. Leaf patterns overhanging the road are reworked. The fence is darkened.

Yellows and oranges are flicked over the fire, and the smoke is scrubbed in again. Scumbles of the previous colors are touched here and there on the ground. Grass and fallen limbs are suggested at the base of the foreground tree. More orange is dashed into some of the windows of the house.

I am tempted to paint the smoke in completely, but the paint is still slightly wet from yesterday, so I must wait. At this point, I am almost finished, so I go ahead and sign the painting with the intent of coming back and finishing up tomorrow.

Day Seven

The smoke is scrubbed transparently over parts of the picture. It appears to be blown by the wind. The edges are soft as the smoke loses itself in the air. I frame the painting, then stand back and view it. The sunlit limbs above the house are lightened in value. A few more lights are touched over the large oak. More falling leaves are flicked over the painting. Lights on the chimney are raised. A few purples are dashed into the shadows on the house, some more lights are stroked in, and the painting is finished.

Fire: (clockwise from top left) cadmium orange, cadmium yellow light, white, cerulean blue, cadmium red deep, raw sienna, ultramarine blue, alizarin crimson

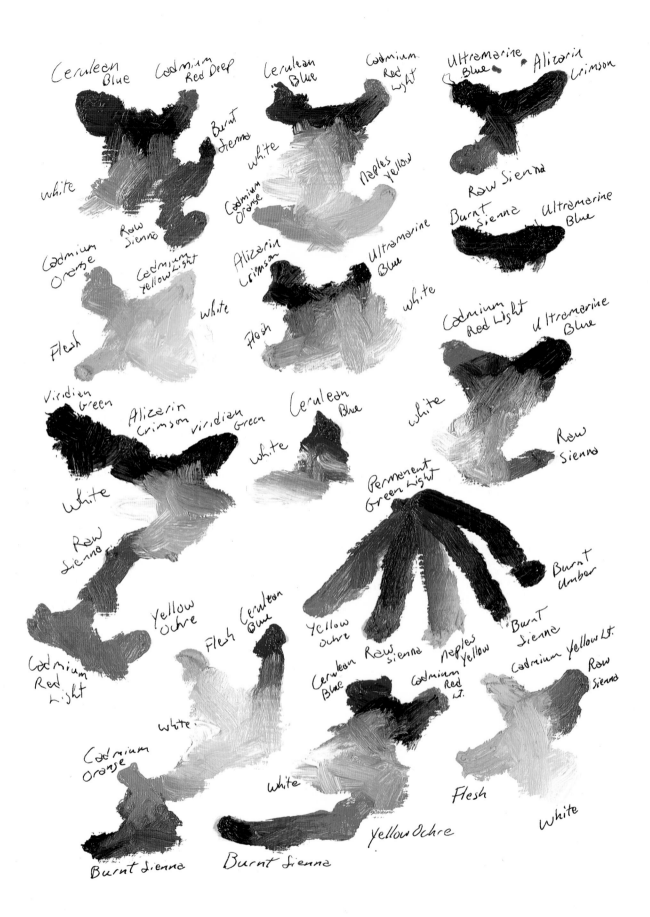

Cerulean Blue

Cadmium Red Deep

Burnt Sienna

white

Row Sienna

Cerulean Blue

white

Cadmium Orange

Naples Yellow

Cadmium Red Light

Ultramarine Blue

Alizarin Crimson

Row Sienna

Burnt Sienna

Ultramarine Blue

Cadmium Orange

Cadmium Yellow Light

Alizarin Crimson

Ultramarine Blue

white

Cadmium Red Light

Ultramarine Blue

Flesh

white

Flesh

white

Viridian Green

Alizarin Crimson

Viridian Green

Cerulean Blue

white

white

White

Permanent Green Light

Row Sienna

Row Sienna

Yellow Ochre

Flesh Cerulean Blue

Yellow Ochre

Burnt Umber

Cadmium Red Light

white

Cerulean Blue

Row Sienna

Naples Yellow

Burnt Sienna

Cadmium Yellow Lt.

Row Sienna

Cadmium Orange

Cadmium Red Lt.

Flesh

White

White

White

Yellow Ochre

Burnt Sienna

Burnt Sienna

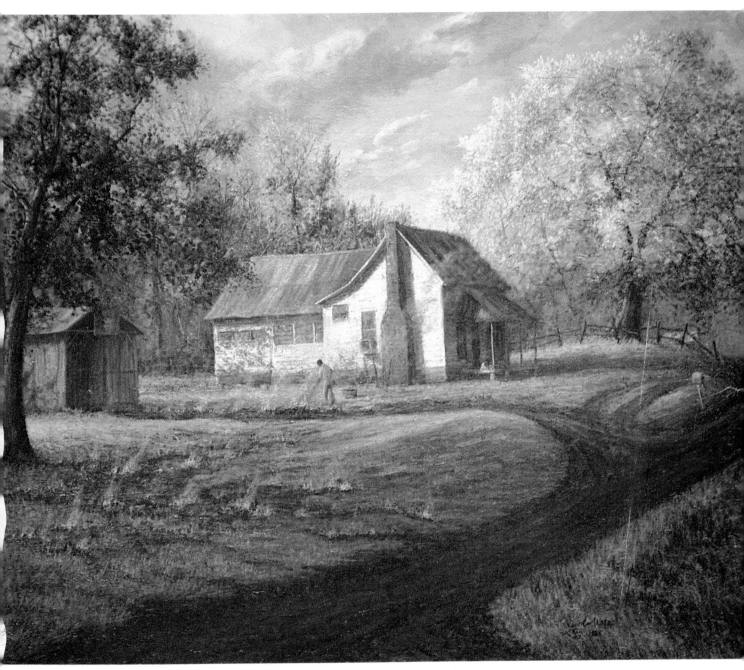

SEASONS OF CHANGE *Oil on canvas, 22" × 28" (55.9 × 71.1 cm)*

Winter at the Barge Farm

About a thousand feet from my studio there's an interesting area that has caught my attention on many occasions. Situated near the entrance to our little town of Zavalla, this spot has a nice composition of trees, a pond, and a barn. Usually some ducks are there and cows are grazing in the meadow. I have painted this scene twice before—once in late summer and once during a winter frost. It was late autumn when I made a quick pastel sketch to refresh my memory and to become better acquainted with the place. However, I am not going to paint autumn; instead, I will paint a winter snow scene.

The scene I visualize is early morning. The sun is breaking through the clouds to form soft cast shadows on the field, but there is still enough cloud cover for a light snowfall. The air is cold. The morning is still and quiet. The subtle light is touching some of the foreground field and the pond; the distance melts away in the morning atmosphere. Perhaps I will paint some cows in the scene, but that decision can be made later.

The viewer's eye will be led down the valley to the barn, around to the pond, and off into the distance. The intruding tree on the left, the foreground hill, and a darker sky on the left will balance the trees and barn on the right.

I stand before the blank canvas, staring at it, meditating on what I want to paint and attempting to visualize the finished painting. I'm now ready to begin.

Pastel sketch of the Barge farm. This sketch helped me to become more familiar with the farm. In the studio, I will use experience, imagination, and photos to change the scene to winter.

Day One

I'm working on a canvas toned with a blue-gray mixture of ultramarine blue and burnt umber. I quickly sketch the major shapes and designs onto the canvas without fussing with details. There's no need to get too involved with small things, since they would be covered during the first underpainting anyway. Many of the smaller designs in a painting can best be worked out as the painting progresses, so I don't go beyond a very simplified drawing.

My usual practice is to begin with the darks, so I mix ultramarine blue, alizarin crimson, and raw sienna and begin blocking in the shape of the barn. Grays of cerulean blue and cadmium red light are worked into this, along with viridian, alizarin crimson, and raw sienna. The brushstrokes are mostly vertical and only suggest boards.

I establish the values of the nearby bushes and the distant hills, using a size 3 bristle flat. Remember, at this stage I'm not concerned at all with "things." Even though I use terms like "barn" and "hills" to describe the work, I am really thinking of design, values, and color.

I brush in the sky with big strokes of a size 5 bristle. I begin with burnt umber and ultramarine blue for the darker tones; as I work down the canvas and to the right, I use more cerulean blue and cadmium red light. Ultramarine blue and yellow ochre are used for a lighter, grayer color nearer the sun, and even more yellow ochre is added for a break in the clouds.

Without covering any area completely, I move on to the evergreens using viridian, burnt umber, and raw sienna, graying these with colors from the sky. I brush in the barn roof with cerulean blue and cadmium red light, with burnt sienna added for a hint of the rusty tin showing through the snow.

With a size 4 bristle round, I stroke in some snow near the barn, using the same grays as in the sky. In the foreground, yellow ochre and flesh indicate sunlight.

After stopping to photograph what I have accomplished, I come back to the sky and finish painting it. The winter sky is painted down into the trees, and its colors are repeated throughout the picture. This will help to unify the painting and will also convey the feeling of a cold winter morning.

The trees are then pulled back into the sky. A touch of autumn color (cadmium orange and alizarin crimson) is added to the trees as I finish painting them and the distant hill. The pond is painted with the grays used elsewhere. The barn is completely painted in, along with the foreground field. A fence near the barn is indicated.

Notice that because the barn is in a valley, our eye level is above the barn. Therefore, all the perspective lines will go up to a vanishing point somewhere on the horizon line.

The first day's work is completed and the basic design, values, colors, and mood have been established.

Day One: The charcoal drawing. I keep my initial sketch simple; details can be worked out later.

Day One: The half-completed underpainting. At this stage, I'm concerned with design, values, and color, not the literal identities of the objects.

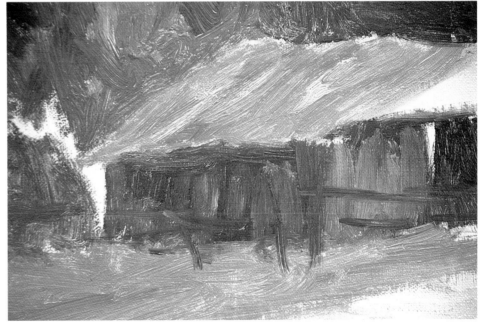

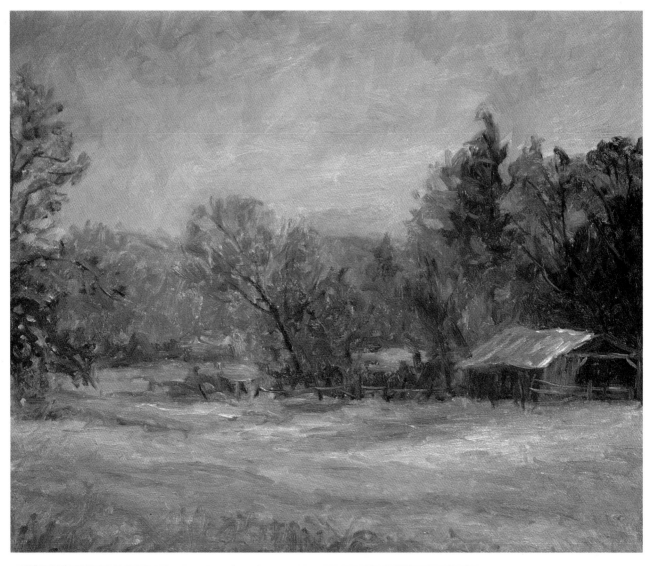

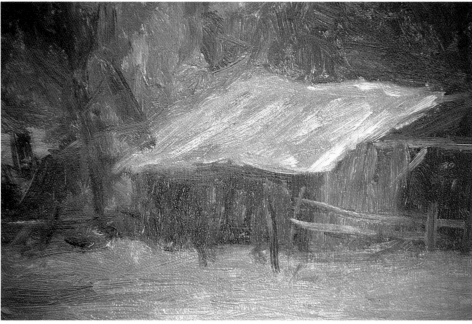

Day One: The completed underpainting. The basic design, values, colors, and mood have been established. The barn is now completely painted in, and the nearby fence is indicated with individual brushstrokes.

Day Two

Due to circumstances beyond my control, I have been unable to work on the painting in almost three weeks. Normally, I work on a painting steadily until its completion; this way my initial reason for doing the painting stays fresh. However, my interest hasn't diminished, and I am confident that I can successfully finish the painting.

I oil in with medium and begin to repaint the sky, using a size 8 Langnickel royal sable. The colors used today will be the same as those used on Day 1, as I deliberately limit the palette for this picture.

I begin in the upper left area of the sky with the darker grays of ultramarine blue and burnt umber. As I work down the canvas and to the right, I bring in lighter grays of cerulean blue and cadmium red light. Farther to the right, a warm gray of ultramarine blue and yellow ochre gives a faint hint of sunlight. My brushstrokes go in a variety of directions and are not just swished back and forth horizontally across the canvas. The paint is applied thinly because I *feel* less texture in the sky than in the land.

I work carefully on the sky, mixing the subtle value and color variations as I attempt to get as close as possible to the finished sky. I don't like to say "finished," because I don't divide a picture and finish a part at a time. A "finished" sky can be repainted if necessary. Think of the sky as being more than a background, because it really is. To a certain degree, it will color the landscape. In a scene like this, the sky seems to reach down and envelop the land, holding it in its cold, wintry grasp. Its colors are casually brushed over the tops of the trees and hills. This helps to form a soft transition between the sky and land.

With a size 6 Langnickel royal sable, I bring the sky colors down into the snow in the foreground. Ultramarine blue, alizarin crimson, and raw sienna are used to suggest grass. This area is treated casually as I work out a pleasing design in the grass and snow. The entire field is covered the same way it was on the first day.

Using a size 2 bristle flat, I restate the barn with the colors used previously. Next, using the side of the bristle brush, I roughly repaint the trees, hill, and pond. The tops of the trees are not repainted. A hay bale, left as feed for the cows, is indicated. Cows may be added later.

Day Three

Medium is brushed over all the painting except the sky. With a palette knife, I mix the various grays that I listed on Day 1.

The barn is repainted with ultramarine blue, alizarin crimson, and raw sienna for the darks. A mixture of viridian, alizarin crimson, and raw sienna and a mixture of cerulean blue and cadmium red light are used for the lighter tones. The strokes, made with a size 6 white sable round, are mostly vertical, following the direction of the boards. Lighter grays are scumbled over darks for a more wintry look. Snow is scumbled over the roof, and the underlying colors are allowed to show through. Snow is suggested on the crossbeams and on some of the broken boards in front. A fence is indicated near the barn.

With a size 3 white sable, I rework the pattern in the field. The paint is lightly applied to the canvas. The darks underneath suggest earth and grass beneath the snow. The edges of shadows and grass are softened by scumbling the paint over the surface. In the foreground grass, darks are scumbled over lights and lights over darks. Then I come back with a size 6 white sable round and softly suggest grass. I change the pattern in the grass to lead the eye to the right and into the scene.

The mass of the bare willow tree near the center is brushed on very lightly and softly. Then I move on to the distant hill to the left of the tree, working with a size 3 white sable. I use the sky colors to suggest distant trees with mostly vertical strokes.

With the size 6 round brush, I return to the willow and indicate some limbs and repaint the main trunk. The outer limbs grow lighter as they reach toward the sky and are only light scumbles of paint. Snow is suggested on some of the larger limbs. The tree seems to be too dark and harsh, so I drag snow over parts of it. I slap it with the brush to soften it and suggest clumps of snow in the mass and smaller limbs nearer the base.

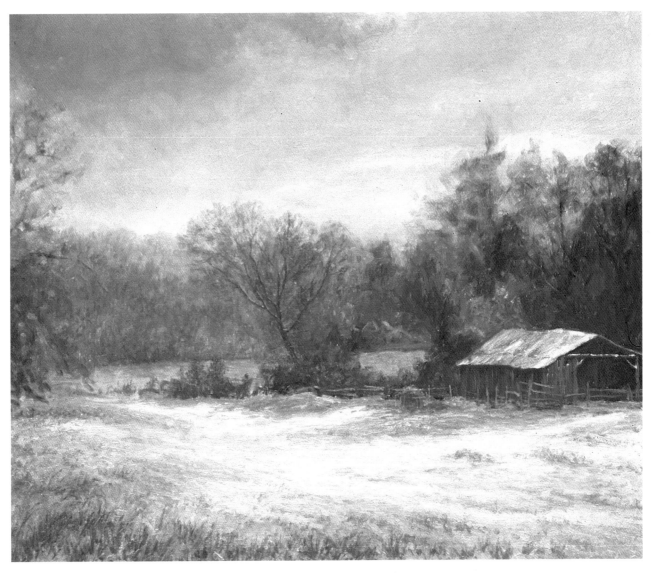

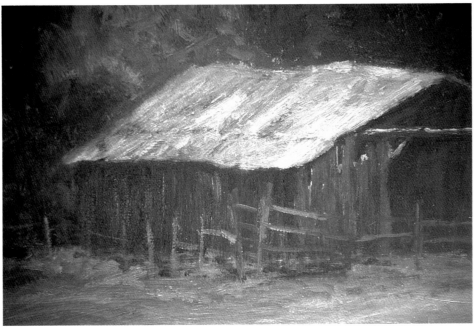

Day Three: I bring sky colors into the treetops, the hills, and the foreground snow, to show the influence of the sky on the landscape. The barn is repainted with the same colors used on Day 1. The brushstrokes are more refined, but they are still vertical and still suggest boards. I scumble lighter grays over the dark colors. Snow is scumbled on the roof and suggested elsewhere.

Day Four

Painting medium is brushed over the entire canvas. With a mixture of viridian, burnt umber, and raw sienna grayed with ultramarine blue and burnt umber, I restate the pines. They have just enough snow to bend the tops and branches downward. Very little emphasis is placed on these pines; they are simply part of the design of the middle-ground trees. I work back and forth between the pines and the designs of the other trees using a size 3 white sable bright. The large basic design is already on the canvas. I work back into this with smaller patterns and try not to make the area too busy. Tree trunks and limbs are softly indicated; there is no need to outline every branch. My aim is to have this entire area work together as a unit and in unity with the rest of the painting.

The evergreen on the left is repainted with the same mixture as in the pines. Grays from the sky are worked into it. I paint the foliage first, making it darker than it will be in the final picture, then stroke in the limbs with a size 6 white sable round. Snow is dragged over the limbs and spotted into the foliage. The foliage is lightened more on the upper section of the tree and around the edges, as these would receive more light than the lower branches.

The distant hills are softly repainted, keeping this area very vague. To indicate more depth, I paint a design of snow on the ground as seen through the trees near the pond. A few tree trunks are indicated.

The pond is scrubbed over with the same grays used in the sky and warmed with raw sienna. The fence near the barn is casually restated. A bush in the left foreground is painted, but I decide not to use it so I paint over it again.

Day Five

Today's work will be the finishing touches—accents, strengthening of lights and detail, softening of edges. After oiling in with painting medium, the first thing I do is very suggestively paint in some cows feeding around the large hay bale. I use photos I've taken as a reference, but I try for a soft, poetic quality instead of a harsh, photographic effect. The colors are ultramarine blue, burnt sienna, and yellow ochre.

When painting, the approach should be to proceed from large to small and from undetailed to as much detail as desired. This is true even on something as small as these cows. I lay in the basic shapes with a size 6 white sable round, then add just enough detail to identify them as cows. I drag darker

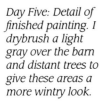

Day Five: Detail of finished painting. I drybrush a light gray over the barn and distant trees to give these areas a more wintry look.

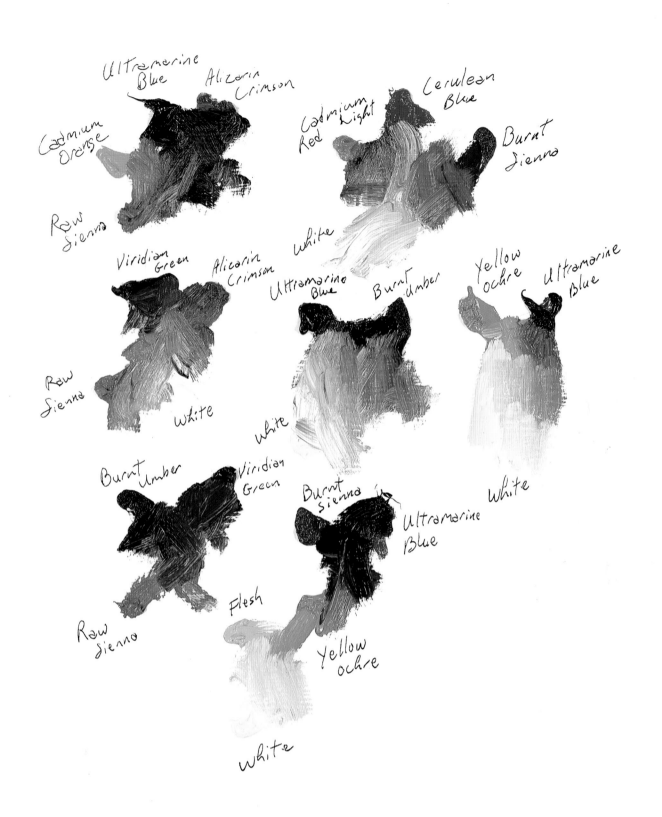

Ultramarine Blue

Alizarin Crimson

Cadmium Orange

Cadmium Red Light

Cerulean Blue

Burnt Sienna

Raw Sienna

White

Viridian Green

Alizarin Crimson

White

Ultramarine Blue

Burnt Umber

Yellow ochre

Ultramarine Blue

Raw Sienna

White

White

Burnt Umber

Viridian Green

Burnt Sienna

White

Ultramarine Blue

Raw Sienna

Flesh

Yellow ochre

White

colors over the ground where they are standing to suggest dirt and hay. The hay bale is repainted and slightly reduced in size.

A silvery light made of yellow ochre and ultramarine blue is touched lightly to the cloud where the sun is breaking through. With an old size 2 white sable, I lightly scrub yellow ochre and white over the right side of the sky to increase the amount of light.

Snow is dragged over the fence near the barn. I "winterize" the barn and trees behind it by drybrushing lighter grays over both these areas.

The tree on the left receives a few dark accents of viridian, burnt umber, and ultramarine blue. Next, I work over the grass in the foreground and make the detail just a bit sharper. Notice how the pattern in the grass leads the eye down the hill to the right. The eye goes to the barn and cows, then on to the pond, which directs the viewer back into the picture. You will find that many of the designs in nature assume weaving, zigzag patterns like these here.

As a final touch, I thin a gray of cerulean blue and cadmium red light with painting medium and, using a toothbrush, splatter snowflakes over the scene. I don't want the flakes to be too large, but even snowflakes have perspective—some are smaller than others, suggesting depth. I thicken the paint to get flakes of a different character. The large wet ones that have landed in the trees are quite interesting, so I leave them. Snowflakes add a nice wintry charm and contribute to the mood and feeling I'm trying to convey. The painting is now finished.

With the completion of this painting, the Diary is completed also. I sincerely hope that the preceding detailed accounts of the painting process have been and will continue to be of great help to you and a source of inspiration.

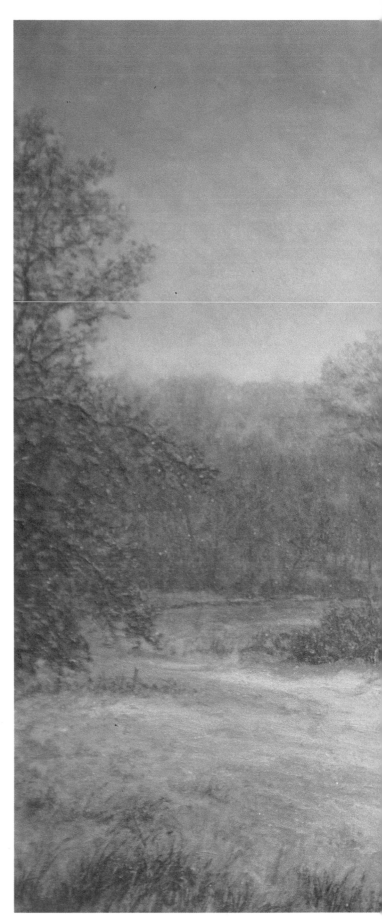

WINTER AT THE BARGE FARM
Oil on canvas, 20" × 24" (50.8 × 61.0 cm),
collection of Mrs. Anda Armstrong Erwin

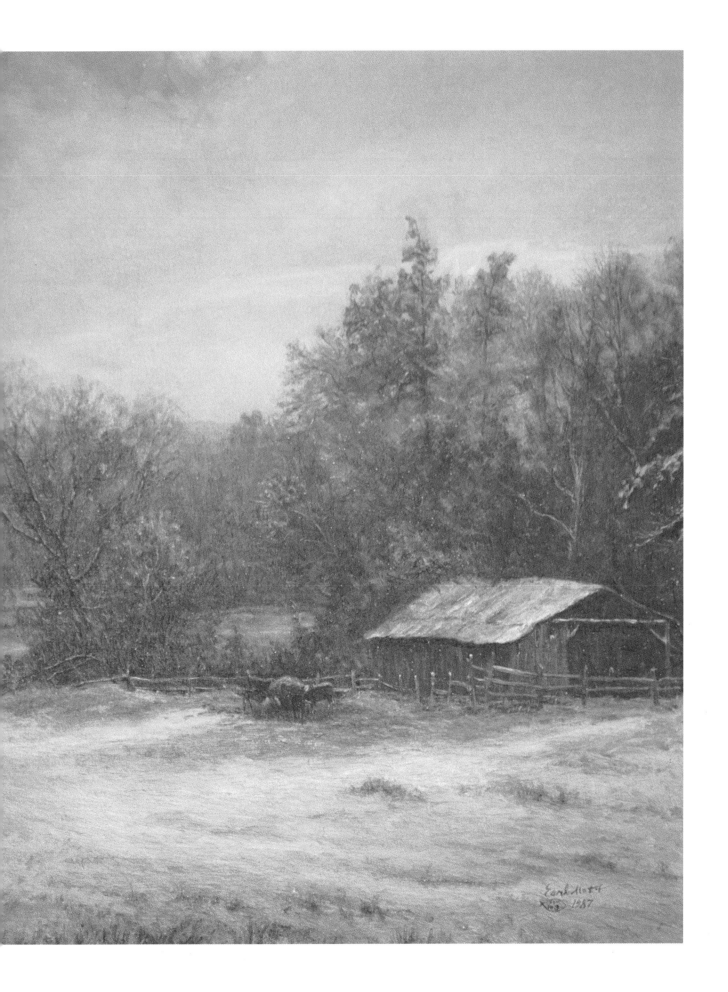

Final Note

Once again, I would like to stress the importance of painting with feeling. When your conceptual ideas begin coming together and forming mental images for a painting, you should have a mood or feeling to express. Whether it's cold and gray, bright and sunny, hazy, or foggy, try to express this characteristic throughout the work. Don't paint it in spots. For example, if you're painting a foggy morning, don't paint a clearly defined, hard-edged building in a blanket of fog. Envelop the scene with varying degrees of the fog color, soften the edges, etc. Select your mood, let it be evident all over the canvas, and paint it so the viewer *feels* it. Do more than simply attempt to transpose a piece of the landscape to a piece of canvas.

YESTERDAY'S HARVEST *Oil on canvas, 40" × 30" (101.6 × 76.2 cm), collection of Art Tailored, Ltd.*

Bibliography

Blake, Wendon, *Creative Color for the Oil Painter*. New York: Watson-Guptill, 1983.

Caddell, Foster, *Keys to Successful Landscape Painting*. New York: Watson-Guptill, 1976.

Carlson, John F., *Carlson's Guide to Landscape Painting*. New York: Sterling Publishing Co., Inc., 1958.

Clifton, Jack, *The Eye of the Artist*. Cincinnati: North Light Books, 1973.

Cooke, Hereward Lester, *Painting Techniques of the Masters*. New York: Watson-Guptill, 1972.

Fabri, Ralph, *Artist's Guide to Composition*. New York: Watson-Guptill, 1970.

Greene, Daniel E., *Pastel*. New York: Watson-Guptill, 1974.

Henri, Robert, *The Art Spirit*. Philadelphia and New York: J. B. Lippincott, 1960.

Pellew, John C., *Oil Painting Outdoors*. New York: Watson-Guptill, 1971.

Index

Page numbers of illustrations are in italics

Aerial perspective, 64–65
After an Evening Rain, 62–67, *68–69*
Alla prima, 20
Atmospheric color, 17, 48, 62, 63, 66, 72,
 104, 114
Autumn, 26, 70–79, 118–29
Autumn at Bear Creak, 70–78, *78–79*
Autumn at Rockland Church, 26

Barn at Rockland, 32
Blackmon, Virginia, 8–9
Brushes, 12, 16, 120

Caddell, Foster, 9
Canvas
 preparing, 14
 stretching, 12–13
 types of, 12, 20
Central Texas Homestead, 80–87, *88–89*
Clouds, 26, 28, 43, 45, 58, 72, 75, 109, 120
 shadow of, 48, 49
Colors
 mixing, 17
 palette, 16

Damar varnish, 14

Easel, 12
Evening at the Gibson Place, 24

Figure, 24, 81, 86, 87
Flowers, 26, 44, 45, 46
Fog, 53, 54, 56, 58, 108, 109, 113, 114, 140
Foggy Morning at Rayburn, 34
Forest floor, 102–3, 105
Forest Giant, The, 100–107, *106*
Frost, 90–99

Geese, 64–65
Gesso, in preparing canvas, 14
Glaze, 17, 74, 75
Grasses, 44, 45, 46, 48
 angle and length of, 53, 55, 57
 dew-covered, 53, 54, 55, 57
 at water's edge, 72, 78, 97, 114
Ground, toned, 14

Hill Country Spring, 27
House, 24, 31, 80, 81, 84, 118–29
House at Rockland, 31

January Snow, 30

Knife, 14

La Grange Farm, 28
Lake. *See* Water
Long Journey, The, 25

Mat board, 20
Meadow Light, 26
Meadow Near Lott, 35
Medium
 basic recipe, 14–15
 crawling or trickling, 15
 with stand oil, 15
 storage of, 15–16
Morning Dew, 52–59, *60–61*

Oil painting
 materials and supplies for, 12–17, 20
 procedures in, 17
Outdoor painting, 20–37
 as basis for studio work, 21, 23, 41, 70, 100
 conceptual ideas in, 21–22
 hazards in, 20
 materials and supplies for, 12, 20
 procedures in, 20

Rabbit-skin glue, 14
Rockland House, 31
Ruins of Old Aldridge, The, 37

Seasons of Change, 118–28, *129*
Sketchbox-easel, 12, 20
Sketch, compositional, 17, 22
Sky, 24, 63, 73, 74, 75, 82, 113, 114
 fog-covered, 53, 54, 56
 around foliage, 81, 83, 119, 120
 geese in, 64–65
 reflected in water, 72, 74, 76
 winter, 131, 134, 135
 See also Clouds; Sunlight
Snow, 130–39
Spring at Ryan Chapel, 33
Stream. *See* Water
Summer Clouds, 28
Sunlight, 32, 48
 through clouds, 62, 66, 110
 through mist, 76
 sunrise, 35, 108, 110, 111, 113, 114
Sunrise at Sam Rayburn Lake, 108–15, *116–17*
Sunset Over Hayfields, 23
Symphony in Frost, 90–99, *98*

Texas Spring, A, 41–51, *47*
Trees, 47, 48–49, 110
 autumn foliage, 118, 119, 120, 121, 124, 125
 distant, 53, 56, 62, 87
 foliage, 81–82, 83, 84
 with frost, 92, 96
 mass, 114
 pine tree, 100–107
 trunks and limbs, 57, 63, 66, 74, 85, 86, 91,
 92, 96
 in winter, 63, 131, 134, 136, 138

Underpainting, 17
Under the Oaks, 36

Varnish(ing), 14, 16

Water
 flowing, 73, 74
 reflections in, 72, 73, 74, 76, 97, 109, 110
 waves in, 109, 110
 wind ripples in, 78, 109
White, 17
Windows, 24, 84, 125
Winter, 29, 30, 63, 130–39
Winter at La Grange Farm, *29*
Winter at the Barge Farm, 130–38, *139*

Yesterday's Harvest, *141*

Edited by Brigid A. Mast
Graphic production by Hector Campbell